Symbols of Ideal Life

Symbols of Ideal Life

SOCIAL DOCUMENTARY PHOTOGRAPHY IN AMERICA
1890–1950

MAREN STANGE

Clark University

The right of the
University of Cambridge
to print and sell
all manner of books
was granted by
Henry VIII in 1534.
The University has printed
and published continuously
since 1584.

CAMBRIDGE UNIVERSITY PRESS
CAMBRIDGE
NEW YORK PORT CHESTER MELBOURNE SYDNEY

Published by the Press Syndicate of the University of Cambridge
The Pitt Building, Trumpington Street, Cambridge CB2 1RP
40 West 20th Street, New York, NY 10011, USA
10 Stamford Road, Oakleigh, Melbourne 3166, Australia

First published 1989
Reprinted 1989

Printed in the United States of America

Library of Congress Cataloging in Publication Data
Stange, Maren
Symbols of ideal life.
Bibliography: p.
Includes index.
1. Photography, Documentary – United States.
2. United States – Social life and customs – 19th century
– Pictorial works. 3. United States – Social life and
customs – 20th century – Pictorial works. I. Title.
TR820.5.S69 1989 778,9'997391 88–9527

British Library Cataloguing in Publication Data
Stange, Maren
Symbols of ideal life : social documentary
photography in America, 1890–1950.
1. American photography. Special subjects.
United States. Social conditions 1890–1953
I. Title 779'.997391

ISBN 0 521 32441 6

CONTENTS

CONTENTS

ILLUSTRATIONS

vii

ACKNOWLEDGMENTS

I have received help in finding and reproducing photographs from archivists and librarians at the Museum of the City of New York, the New-York Historical Society, the Prints and Photographs Division of the Library of Congress, the International Museum of Photography at George Eastman House, the Roy Emerson Stryker Collection at the University of Louisville, and the Dorothea Lange Collection at the Oakland Museum. I would like to thank Bernarda Bryson Shahn for permission to quote from oral history interviews with Ben Shahn held at the Archives of American Art.

Marla Wallace and Edward McDermott at Goddard Library, Clark University, and Roberta Geier at the library of the National Museum of American Art helped me locate photographs in long-discontinued periodicals, and photographers Stephen DiRado and Grant Kester reproduced them for me.

Janelle Zauha and Darcy Johnson Tell have provided intelligent and indispensable research and clerical assistance; Janelle Zauha compiled the index. Ceil Gallagher at the National Gallery of Art in Washington, D.C., was more than a word processor, and Theresa Reynolds and Rene Baril of Clark University were prompt and impeccable.

My appointment jointly as a Fellow of the Institute on Government, Society, and the Arts, George Mason University, and a Visiting Scholar at the National Museum of Art, Smithsonian Institution, Washington, D.C., enabled me to begin crucial archival research. Subsequent funds from the American Council of Learned Societies program for Recent Recipients of the Ph. D., in part made possible by a grant from the National Endowment for the Humanities, and an appointment as a Visiting Senior Fellow at the Center for Advanced Visual Studies of the National Gallery of Art supported further progress. A Mellon Foundation Faculty Enrichment Grant from the Maryland Institute, College of Art, reduced my teaching load, and grants from the Faculty Development Fund and other sources at Clark University

and from the Kaltenborn Foundation provided indispensable funds for photographic reproductions, travel, and word processing. Residencies at the Virginia Center for the Creative Arts and at Yaddo were high points when energy normally sapped by everyday demands could be used instead for composition.

Garnett McCoy, Senior Curator at the Archives of American Art, Washington, D.C., generously transformed a professional relationship into something much more; he offered wisdom and support throughout this project. Cathy Alexander, Stephen Amberg, Pete Daniel, Patricia Hills, Lawrence W. Levine, Leo Marx, Michael L. Smith, and the late Warren Susman were kind enough to take time from their own work to read and discuss parts of the manuscript with me. Mark Benson offered expert proofreading. Charles Hobson showed his generosity and support in ways beyond number.

Bruce S. Wine of Washington, D.C., has assisted me with memorable generosity in ways no less crucial because they related only indirectly to the manuscript, and my parents, Patricia Knowlton and G. Robert Stange, have provided important help of various kinds.

At Cambridge University Press, Elizabeth Maguire, Katharita Lamoza, and Alex Geisinger have provided consistently patient and thoughtful editorial support.

To Alan Trachtenberg, who first showed me the possibilities of what I wanted to write about, and whose revelations continue unabated, go my acknowledgments of greatest intellectual debt and gratitude.

INTRODUCTION

The photographs examined here were made and originally viewed as publicity for specific social reform campaigns; most of the images were made by photographers employed as staff members of reform organizations. Like other twentieth-century enterprises, social reform evolved ever more rationalized, specialized, and professional structures and goals. Photography, uniquely documentary and mass reproducible, became particularly useful to reformers intent on communicating a worldview that stressed their expertise and organization. In order to assert more or less explicitly that their images presented viewers with the truth, reformers relied on the photograph's status as *index* – that is, as a symbol fulfilling its representative function "by virtue of a character which it could not have if its object did not exist," in a standard semiotic definition.[1] But they also realized that the codes of photographic realism could be used to associate reform with individuals' humanitarian impulses as well as with the social engineering institutionalized by reform movements. At the turn of the twentieth century, social documentary began to distinguish itself from other forms of photographic expression, exploiting conventions that would come to include black-and-white prints, uncontrolled lighting, and informal composition. Throughout the century, the documentary mode testified both to the existence of painful social facts and to reformers' special expertise in ameliorating them, thus reassuring a liberal middle class that social oversight was both its duty and its right.

Although this book considers the work of important documentary photographers including Jacob Riis, Lewis Hine, Walker Evans, Dorothea Lange, Ben Shahn, and Russell Lee, it is not organized around the work of individuals. Concerned rather with the dissemination of photographs as reform publicity, it gives attention to the work of the editors, text writers, and organizers who presented the photographs in the lantern slide lectures, exhibitions, pamphlets, magazines, and books where they appeared. In

some cases, they are the same people: Riis, variously writer, photographer, and performer, composed and narrated the lantern slide "exhibitions" where he first showed pictures of "The Other Half, How It Lives and Dies in New York," and from them came the texts for his many books. Lewis Hine wrote text and designed layouts and exhibitions for the National Child Labor Committee and the Pittsburgh Survey. Others, however, who organized and disseminated documentary photography were not themselves photographers. Lawrence Veiller of the Charity Organization Society (COS), mastermind of the seminal Tenement House Exhibition of 1900, which used 1,100 photographs, was a dedicated "technician of reform" who became known as a planner, writing the pioneering New York metropolitan zoning ordinance of 1916 and the nationally applicable Standard State Zoning Act in the 1920s. Roy Stryker, chief of the Farm Security Administration (FSA) Photography Project during the New Deal, was trained as an economist, teacher, and social worker. Even Edward Steichen, though famous and successful as a photographer for most of his life, admitted that, by the time he had become head of the Photography Department at the Museum of Modern Art (MOMA) in the 1940s, he didn't "give a hoot in hell" about promoting photography as one of the fine arts.[2] Indeed, the terms used recently to characterize Steichen's operating procedures for the famous series of exhibitions he organized for the Museum in the 1940s and 1950s describe as well the aspirations, if not always the actual achievements, of earlier documentary editors. It was Steichen's specialty, writes photographic historian Christopher Phillips, "to prise photographs from their original contexts, to discard or alter their captions, to recrop their borders in the enforcement of a unitary meaning, to reprint them for dramatic impact, to redistribute them in new narrative chains consistent with a predetermined thesis."[3]

Not the photograph alone then, but the image set in relation to a written caption, an associated text, and a presenting agency (such as the reform organization or, later, the museum) constituted the documentary mode shaped by these men. For the sponsor and the audience of the documentary exhibition or publication, the photograph necessarily took on meaning within a particular rhetorical framework created by its interaction with caption, text, and agency, even though the photographer and his or her subject did not always intend such a meaning or share its ideology. Editorial and exhibition practices, relying on photography's presumed immediacy and transparency to help legitimize the ideological underpinnings of the reformist vision, often distorted or obscured the social and

esthetic significance that the photographs held for their makers or (more conjecturally) for their subjects. Even during the FSA, the subjects and experiences documented by photographers were often more subversive, their implications more radical, than any message they conveyed under the auspices of an increasingly technocratic and professionalized reform movement. My argument proposes that documentary, a central mode of communication, has assisted the liberal corporate state to manage not only our politics but also our esthetics and our art.

Chapter 1, on the work of Jacob Riis and Lawrence Veiller, discusses each reformer's contribution to the innovations that established the documentary mode. Riis's lectures were filled with anecdotes and stories about both the subjects of the photographs he showed and the circumstances of their making; he used these narratives to feature himself – the intrepid reporter–photographer – as a model of humanitarian investigation and enlightened reformist zeal. Though some images Riis showed were police mug shots and charity records, his spoken texts encouraged viewers to see such surveillance photographs as entertainment. Simultaneously titillating his audience with photographic versions of conventional urban subjects and exhorting them to take up tenement reform as a basis for class solidarity, Riis affirmed middle-class privilege, associating the images he showed with both entertainment and ideology.

Though Veiller used some of Riis's photographs in the Tenement House Exhibition, Veiller's presentation of photography stressed its value as information, simply one of many kinds of data to be found among the dossiers that charity bureaucrats regularly amassed. Rather than narrative pleasure, the Tenement House Exhibition offered viewers a gridlike structure to decipher; entering into a process of comparison, analysis, and cross-reference analogous to that of the reformers themselves, viewers came to appreciate the extent of the COS's expert and thorough knowledge of tenement problems on the Lower East Side of New York.

The Pittsburgh Survey, the subject of Chapter 2, sought to apply a similarly penetrating and interlocking analysis to an entire industrial community, which the surveyors saw as indicative of future urban centers dominated by corporate enterprise. Eschewing both the factitiousness and the narrative mode of his predecessors, Lewis Hine, as project photographer, achieved a documentary style flexible and responsive to its subject and yet readily identified and associated with social welfare experts and expertise. But more than this, Hine practiced an insistently interrogatory and self-reflexive camera work. Deploying the elements of the four-part mode

against themselves, he created documentary that included in its revelation of social fact an acknowledgment not only of its own constructed rather than transparent nature, but also of the multiple meanings of reform.

Roy Stryker used Hine's pictures in *American Economic Life and the Means of Its Improvement*, the textbook he edited with Rexford Tugwell in the 1920s. Nevertheless, as Chapter 3 shows, Tugwell, Stryker's mentor, and Stryker himself promoted a more technocratic, pro-corporate ideology than did Hine. The New Deal FSA project, directed by Stryker and employing Walker Evans, Dorothea Lange, Ben Shahn, and Russell Lee among others, was the culmination of the documentary movement. Nevertheless, the FSA's dependence on bureaucracy and its attempts to reach the large readership of the newly emerging mass picture magazines mandated a new graphic rhetoric. Familiar documentry elements were used in the thirties to create realistic, yet visually appealing images – "symbols of ideal life," in philosopher John Dewey's phrase – and formal complexity as well as radical content were suppressed in the pictures that became popular.

As Stryker himself perceived, his move to the Office of War Information in 1943 made him little more than an "administrative operator" and turned government-sponsored documentary into wartime propaganda.[4] Nevertheless, several key institutions sponsored and promoted documentary work in the 1940s and 1950s. Chapter 4 examines the role of MOMA's spectacular photography exhibitions curated by Edward Steichen in popularizing the documentary style, and it discusses Stryker's (ultimately unsuccessful) work for Standard Oil Company of New Jersey (SONJ) from 1943 to 1955. The move to SONJ was "a smooth continuation of his earlier governmental project," photographic historian Ulrich Keller contends.[5] Indeed, Stryker's easy transition from publicizing the government's programs on behalf of the rural "lower third" to corporate public relations for Standard Oil suggests that his editorial practices had been adapted from the beginning to such purposes.

In the 1950s, American cold war cultural imperialism made global use of visual art ranging from Steichen's famous "Family of Man" exhibition to Abstract Expressionist painting. In the United States, the decade marked the advent of television, which usurped forever photography's prime place among the media of communication. Robert Frank's *The Americans* responded to the new order. Like Hine, Frank was self-critical, adopting a stance that clearly dissociated him from aspirations to immediacy and transparency. Working, however, in the midst of an image-saturated culture, Frank could generalize in ways inaccessible to earlier documentari-

ans. Insisting on photography as synecdoche for all the visual media, he raised the possibility that his medium, like any other, might purvey falsification and distortion. Frank's work defined new relations among ideology, esthetics, and technology, displacing irrevocably the worldview that had enabled the documentary mode.

Chapter One

FROM SENSATION TO SCIENCE: DOCUMENTARY PHOTOGRAPHY AT THE TURN OF THE CENTURY

Born in Denmark in 1849, Jacob A. Riis emigrated to the United States in 1870 and died here in 1914. Riis found no steady job upon his arrival, and it was not until 1877 that he took up the journalistic career that became his lifework. Assigned to police headquarters by the New York *Tribune*, Riis covered "all the news that means trouble to someone"; his work acquainted him with New York's tenement districts and with various secular and religious reform organizations.[1] Familiar with photography and the many applications of the magic lantern current in the nineteenth century, Riis began in 1887 to explore the possibility of using photography to dramatize and publicize the situations he encountered. His first experiments in social photography were illustrated lectures; the success of these lantern slide "exhibitions," as they were called, led to illustrated newspaper and magazine articles and to a series of popular books, of which the best known is the first, *How the Other Half Lives: Studies Among the Tenements of New York*, published in 1890. In his autobiography, *The Making of an American*, published in 1901, Riis disparaged his photographic skills, and it is certainly true that the period of his photographic activity was brief. Although the Riis Collection housed at the Museum of the City of New York holds 412 glass plate negatives, only 250 are estimated to be by Riis; the others he collected from various sources to illustrate the social problems discussed in his lectures and writings.[2] Nevertheless, since Alexander Alland's recovery of Riis's archive from family attics in the 1940s, Riis's position at the origin of American social documentary has been secure; only recently have some photographic historians begun to question not only Riis's motives and accomplishments, but also those of the documentary tradition itself.[3]

Riis's photographs were described by contemporaries as "pictures of reeking, murder-stained, god-forsaken alleys and poverty-stricken tenements," sensational language that later documentary presentations would

1

neither earn nor deserve, and his dramatic written and spoken narratives seem a far cry from the carefully "scientific" and statistical texts and captions we find in the Progressive Era. Like those later projects, however, Riis's work exploited what Lewis Hine was to call the "added realism" of the photograph, which gives it "an inherent attraction not found in other forms of illustration." Riis's lectures, filled with apparently personal anecdotes, entertaining stories of how he got his pictures, and brief, usually moral, narratives purportedly concerning the people in them, relied on that attractive "realism." However, the lectures embedded the evidentiary image in an elaborate discourse offering simultaneous entertainment and ideology, and from this the photograph, no matter how seemingly straightforward its reference, never stood apart. Allowing his meanings to emerge only as photographs were appreciated in a rhetorical framework created by their interaction with captions, texts, and with his authority as presenter and narrator, Riis made each image a rich carrier of specific ideological messages.[4]

Crucial to his enterprise was the fact that many of the photographs Riis showed represented imagery already current in urban visual culture, and his text often rehearsed familiar responses to such scenes. Thus, cast in their novel photographic form, but embedded in Riis's rhetoric and presented in the familiar slide-lecture format, these historically and culturally resonant images connected social photography, and the complex of attitudes Riis attached to it, to a traditional and familiar panoply of popular visual displays and diversions enjoyed by urban middle-class audiences. In a way that perhaps no other form of visual imagery had done before, the photographs Riis presented came to symbolize for audiences a public statement of class sensibility, solidarity, and morality.

The presentations Riis offered were stereopticon lectures; they used two projectors that created images about ten feet square, and they featured a dissolve mechanism for showing slides in sequence. Illuminated, in the days before electricity, by oxygen and hydrogen gases burned against a pellet of lime, the system made it possible to spotlight a speaker on stage who narrated the sequence of slides.[5] By the 1880s, such exhibitions were a familiar feature among the large array of photographic applications. Riis himself had used them in an advertising scheme that mixed advertisements for Brooklyn merchants with attractive "colored views," and slide dealers urged consumers to think of lantern slides as "a refined and pleasing entertainment for the drawing-room." Magazines for amateur photographers were replete with information on techniques for making perfect lantern slides, and amateurs' associations featured regular slide shows, exchanges

2

of slides among cities, and international exchanges. There was even a magazine, the *Exhibitor*, which served the interests of those using "the Magic Lantern for amusement, instruction, or profit."[6]

But in addition to these newly developed commercial and leisure-time uses, the magic lantern had long been associated with both moral lessons and spectacular entertainments. Hand-drawn or painted slides had been seen in Europe since the seventeenth century; in the eighteenth century traveling exhibitors used them to tell traditional stories or to narrate biblical parables, and by the end of that century techniques had been developed to represent movement and ghostly special effects that earned exhibitions the name "phantasmagorias." An entry in William Hone's diary gives the flavor of a Christmas slide show in England in 1818:

[The showman] 'compassed a motion of the Prodigal Son'; by dancing his transparencies between the magnifying glass and candle of a magic lanthorn [sic], the colored figures greatly enlarged were reflected on a sheet spread against the wall of a darkened room. The prodigal son was represented carousing with his companions at the Swan Inn, at Stratford; while the landlady in the bar, on every fresh call, was seen to score double ... The Gallantee-showman narrated with astonishing gravity the incidents of every scene, while his companion in the room played country-dances and other tunes on the street organ, during the whole of the performance.[7]

When photographic slides were developed in the mid-nineteenth century, both the size and cost of slides were reduced. The projected photographic image was much sharper than its painted predecessor, and the new smaller-sized apparatus made projection easier. These technical advances made "dissolving view" lectures even more popular, and sets of slides on numerous educational and religious subjects and "moral themes" were available from many dealers for use by professional lecturers and educators. Many reform and evangelical religious groups opened their own circulating libraries of slide shows, complete with prepared lectures on their causes,[8] and in England an enterprising minister commissioned in the 1880s a set of slides of the "waifs and poor" of his own parish for use in his lectures and sermons.[9] Nor did reformers hesitate to incorporate entertaining features into their presentations. In New York a well-known temperance orator proposed a slide show using magnesium flash powder to photograph "the interiors of noted places in this city, to illustrate a story to be called 'The Prodigal Son,'" according to a report that ran in the *Photographic Times* soon after its note on Riis's exhibition. Boasting of his modern methods, the orator described his intention "to add to the spec-

tacular part of it" with "singing and instrumental music of various kinds and recitations, while the thread of the story of the Prodigal Son will run through the whole performance, winding up like the story in the Bible with the killing of the fatted calf."[10]

Riis's autobiography, in chronicling his emigration from Denmark and his years of poverty and isolation before his career got under way, conveys the essence of the ideological message that informed his lectures and later reform texts. He was on the road throughout the 1870s – years of depression and high unemployment that saw a huge increase in the proportion of immigrant industrial workers and mounting tension between labor and capital, culminating in the violent nationwide railroad strike of 1877.[11] Riis's offhand account of the strike as an encounter between "the citizens" and the "mob"– a "quarrel" that the strikers should have sought to resolve by "discussion" rather than violence – indicates a remarkable refusal to articulate social and political issues that touched the lives of North Americans of all classes.[12] In view of his experiences as a day laborer, coal miner, tramp, and hired hand, not to mention his later career as a reformer, Riis's autobiographical account of this period, silent on all but the most subjective aspects of his life and work, also suggests how unerringly – and from the very start – he recoiled from workers and working-class culture, especially when he saw that culture's potential for solidarity in opposition to the individualist and entrepreneurial values of the middle class.

How the Other Half Lives, written on behalf of tenement reform in New York, addressed its message directly to the propertied middle class. Dismissing "tardy enactment of law" and "political expedient," Riis placed the solution to the tenement problem squarely in the hands of private capital: "neither legislation nor charity can cover the ground," he said, and "the greed of capital that wrought the evil must itself undo it." Model tenements, with profits held at five percent and much personal involvement by the Christian landlord, were the solution he proposed.[13] His conclusion reiterated that the "lion's share" of dealing with the tenement problem must fall to "private enterprise" or "conscience, to put it in the category of duties, where it belongs." And, Riis's final paragraphs insisted, this is a duty that the middle class owed first and foremost to itself: the law and philanthropy, when powerfully aided by "conscience," would preserve it from the effects of disastrous social upheaval. "The sea of a mighty population, held in galling fetters, heaves uneasily in the tenements," Riis warned. "If it rise once more, no human power may avail to check it." There was, however, a bridge to "carry us over safe," and it was "built of

4

human hearts," he avowed, ending the book with a monitory couplet from James Russell Lowell: "Think ye that building shall endure/ Which shelters the noble and crushes the poor?"[14]

Already a consummate publicist, Riis was proposing in essence that conscientious personal philanthropy might function both as good public relations and as self-improvement, reaffirming the benignity of middle-class values, and of wealth itself, even as the respectable classes girded themselves anew against the threat breeding in the slums. That such a "solution" in no way challenged capitalist social and economic relations, Riis himself tacitly admitted when he compared "the extra trouble of looking after . . . tenement property" to a penance or "penalty" exacted for "the sins of the fathers." Far from radical, Riis's solution affirmed the centrality and social worth of traditional individualist and entrepreneurial values even as it specified a new class duty, and the enthusiasm of his wide readership affirmed that his proposal had struck a responsive chord.[15]

There was, as well, an ethnic dimension to Riis's plan. At the time he wrote, a system for building tenement houses as speculation was well entrenched in New York. The existence of middlemen made tenement ownership possible for a relatively small investment of $5,000 to $15,000, which was within the reach of many small tradesmen among the Irish, Italians, and Jews. However, the speculative nature of both building and ownership involved the assumption of various loans and mortgages, so that tenements were shoddily built and landlords did all they could to maximize their profits. "Years ago we all had American landlords, who went once a month to every room and collected rents, and looked to see if the rooms were clean and how the people were," a witness for the Tenement House Committee testified in 1900. "Now the landlord cares only for the rent."[16]

Thus, rather than addressing the majority of actual landlords, Riis's texts proposed to the wealthy that they take up tenement ownership as a form of philanthropy. Such an initiative would introduce a new group, "wealthy owners with time to spare to look after their tenants," into an arena increasingly occupied by "foreign" speculators. Although the book never spells out the point, Riis's audience might easily have understood his plan as proposing a method to restore control over tenement housing to "Americans."[17]

Riis was settled in Brooklyn and had been a police reporter for ten years when, encouraged by the recent invention of magnesium flash powder, he assembled and delivered for the first time in 1888 his exhibition on "The Other Half, How It Lives and Dies in New York." Generally using over a

5

hundred slides, Riis presented material which, contemporary accounts would have it, provoked "many a shudder" in "the more sensitive of his hearers," especially outside New York.[18] Yet, as a Buffalo reporter perceived, "running through" Riis's "racy description of the infected district there was a vein of earnestness that lifted the lecture quite above the level of a mere passing away of the time." A part of the lecture concerned "what we [are] going to do to protect ourselves," noted the Washington *Post*.[19]

As such reports suggest, Riis carefully pitched his presentation to middle-class fears and concerns, and he often tailored his material to particular audiences. Though his first lecture, to the New York Society of Amateur Photographers, was reported (perhaps by Riis himself) to be an "ingenious" set of "Pictures of Police life" enlivened by "a vein of humor,"[20] he quickly revised his approach. Adopting the more reformist perspective observed in Buffalo, he succeeded in interesting religious reformers in his material. He went on to give the majority of his early lectures as benefits for evangelical Christian churches, so that his efforts were associated with their programs to promote missions among the city's "unsaved masses."[21]

In the famous "Flashes from the Slums," an illustrated article that appeared in the New York *Sun* on Sunday, February 12, 1888, two weeks after Riis's initial lecture, Riis described his role as "guide and conductor" for a party of amateur photographers "experimenting with the process of taking instantaneous pictures by artificial flashlight"; the resulting slides of "Gotham's crime and misery by night and day" would illustrate talks he planned to give at churches and Sunday schools.[22] The men whose interest in photography had prompted them to join Riis's party in the late fall of 1887 were Dr. John T. Nagle of the health department, Dr. Henry G. Piffard, consulting surgeon to the New York City Hospital, and Richard Hoe Lawrence, a gentleman banker and clubman, later president of the Iconophile Society. Both Piffard and Lawrence were active in the Society of Amateur Photographers of New York; Lawrence was chairman of the society's lantern slide committee, and Piffard, chiefly interested in learning to manipulate the newly developed magnesium flash powder, gave a lecture and demonstration on the subject to the society on October 11.[23] Lawrence seems to have retained the greatest interest in photography, and he is apparently the only one besides Riis who has left behind a body of work, now held by the New-York Historical Society. The society's Richard Hoe Lawrence Collection consists of copy prints made from Lawrence's lantern slides, which were donated to the society by his widow in 1950; captions on the backs of the prints were copied from the slide mounts.

Though many of Lawrence's photographs are trite and undistinguished,

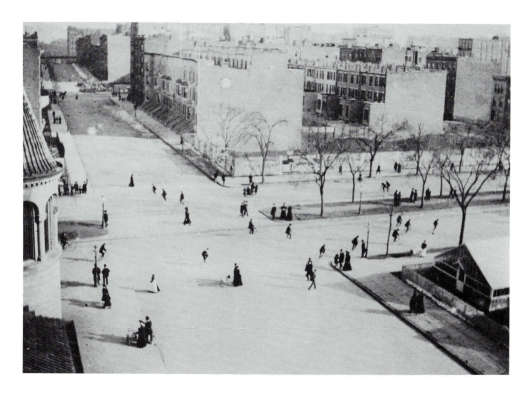

Figure 1.1. Richard Hoe Lawrence, *View from Window*, 1880s. Courtesy of the New-York Historical Society, New York City.

some show an interest in experimenting with the urban subject that perhaps explains his desire to participate in the nighttime expeditions (see Figure 1.1). In fact, thirty-one Lawrence photographs are exact duplicates – sometimes cropped differently – of images in the Riis collection at the Museum of the City of New York. These include such classics as *Bandit's Roost* (Figures 1.2 and 1.3), seen here with horizontal cropping that retains the two female figures on the left who slightly soften the menace of the scene; *The Tramp* (Figures 1.4 and 1.5), with a closer crop that suggests the photograph be taken more as a picturesque character study than as the bleak environmental portrait Riis's wider cropping implies; *A Downtown Morgue* (Figure 1.6), for which both men used the same cropping; and several well-known images of opium smokers. Some of the Lawrence images, such as one of a policeman holding a shawl-wrapped foundling while "the sergeant record[ed] the facts," and another of "Nellie," a "pretty

7

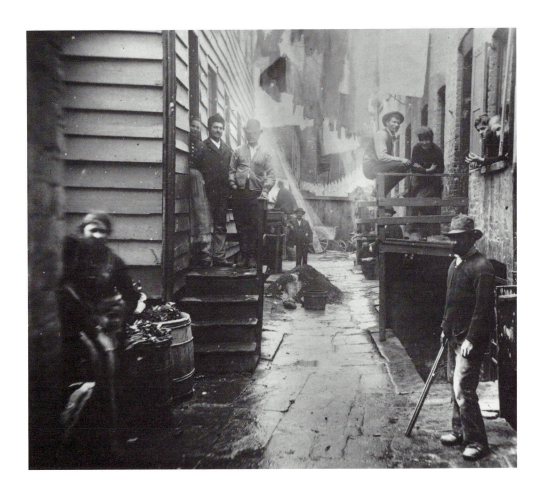

Figure 1.2. Richard Hoe Lawrence, *Bandit's Roost, 59½ Mulberry St.; Scenes in the Lower East Side Slums*, 1887. New-York Historical Society, New York City.

little opium fiend,'' are mentioned in accounts of Riis's lectures, though they have not survived with the rest of the Riis collection of lantern slides at the Museum of the City of New York.[24]

Some images in Riis's collection, such as those of model tenements, are obviously from other sources, and as we have seen, Riis's writing implicitly credits other photographers. On the evidence of his autobiography, it was not until January 1888 that he bought and learned to use his own camera. "The slum and the awkward hours [soon] palled upon the amateurs," he explained, and "I found myself alone just when I needed help the most."[25]

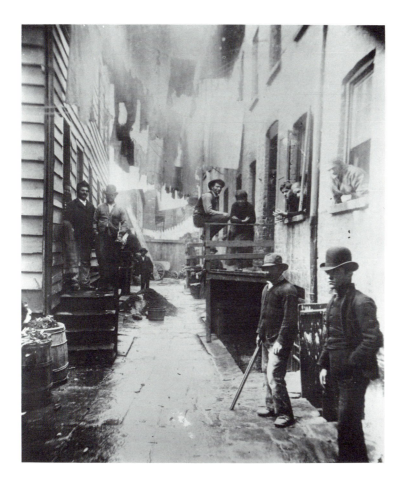

Figure 1.3. Jacob A. Riis, *Bandit's Roost, 39½ Mulberry St.*, 1887. Museum of the City of New York.

Though virtually the opposite seems true – the amateurs evidently partic-
ipated generously, offering critical manpower, photographs, and a lecture
opportunity – Riis's lectures and books never, as far as I can determine,
credited other photographers outright for images he showed; and he told
stories of his photographic exploits that describe the making of photo-
graphs in the Lawrence collection as if they were his own. This situation
prevailed despite the fact that from the beginning some of his audience,
particularly those in the Society of Amateur Photographers, were appar-
ently aware that Riis was not the sole author of many of the photographs
he showed. Whether, as it seems, Lawrence (and Piffard) willingly let Riis

9

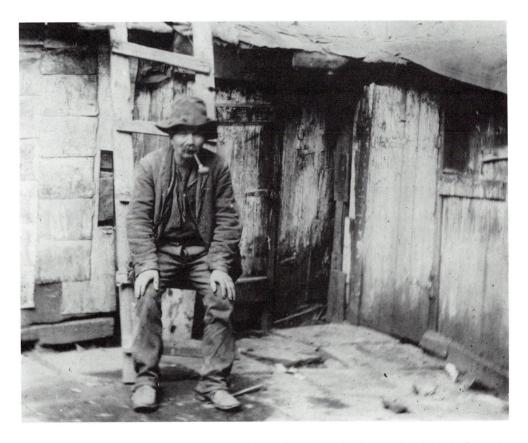

Figure 1.4. Richard Hoe Lawrence, *Tramp in Mulberry Street Yard*, 1887. New-York Historical Society, New York City.

take sole credit for photographs evidently made by themselves, and if so, why, remains, for the moment, a mystery.[26]

Relying on a variety of representational and narrative strategies to get their message across, the lectures serve as a testing ground upon which Riis worked out both his techniques and his ideology. They turned out, when assembled, to hold only a small number of images – perhaps one-fourth to one-third – hailed as the pioneering flash photographs. Many images were posed – such as Lawrence's *Bandit's Roost*, his portrait of the tramp, or his tableau showing young boys picking the pockets of a drunk, which imitates a similar image in woodcut that appeared in the *Police Gazette* in the 1840s (Figures 1.7 and 1.8).[27] Lawrence's *22 Baxter Street*, a

10

Figure 1.5. Jacob A. Riis, *Tramp in Mulberry Street Yard.* Museum of the City of New York.

tenement court, took its iconography from scenes such as well-known il-
lustrator William A. Rogers's *Ragpickers' Court*, done in 1879; ragpicker
subject matter was familiar at least from the 1860s and probably earlier.[28]
Even the flashlit "night pictures," though "realistic" in their unposed im-
mediacy, must have seemed to their audiences, in some respects at least,
much more conventional and less startling than we might think, because
many of them rehearsed imagery familiar to any reader of illustrated pe-
riodicals. For example, a *Harper's* artist had drawn police station house
lodgers in 1869, and Winslow Homer had gone to station houses and to
opium dens for the magazine in 1874. In 1880, *Harper's* artist C.A. Keetels
sketched a "Bottle Alley" saloon (Figure 1.9); his composition resembles
Lawrence's well-known *A Downtown Morgue* and again suggests photog-

11

Figure 1.6. Richard Hoe Lawrence, *A Thompson Street Black and Tan Dive; Scenes in the Lower East Side Slums [A Downtown Morgue]*, 1887. New-York Historical Society, New York City.

raphers' reliance on pictorial conventions governing the representation of such scenes. Riis's photographs of the newsboys' lodging house, which included washroom and night school, re-presented scenes that appeared in *Harper's* in 1867 (Figures 1.10 and 1.11). Like the illustrations they were modeled on, a number of the slides are in decorative circular vignettes rather than square frames, and some are handcolored.

As I have suggested, however, the interest and impact of individual slides was not dependent solely on visual appeal, for in the course of a lecture the slides never appeared unmediated. Various dramatic devices and Riis's accompanying narrative identified and named, or captioned, individual images, directing viewers to assign them specific meanings consonant with

Riis's larger text – the representation of "Gotham's crime and misery." In Brooklyn, Riis used music, reported the Brooklyn *Times*, and the pathos evoked by a slide of boys asleep in the street, "a touching scene," was "greatly heightened by a cornet duo played in the wings of the stage – "Where Is My Wandering Boy Tonight?"[29] A typical anecdote, repeated and elaborated in his book, purported to describe the origin of Lawrence's tramp, who poses, of course, with a clay pipe. The lecture narrative called him a "tramp and thief" because, offered ten cents to pose for Riis's camera, the old man removed his picturesque pipe and "struck," Riis claimed, demanding another five cents (an amount increased to a quarter in the book) before agreeing to replace it for the picture.[30]

As the lectures proceeded, slides were related to each other in pairs or groups for which Riis's remarks served as "relay," moving audiences along through story-telling sequences of images like those encountered in comic strips or films. He "had a fancy" for contrasting the opposites of New York life, wrote one reporter, so that "the most dismal alley or filthiest dive was often followed by a brown-stone mansion on Fifth Avenue."[31] He put photographs of "saved" children, such as those shown at prayer in the Five Points House of Industry, to good use as a foil for other images of less well-tended children, and he showed "portraits of children side by side, of how they looked when taken from their hovels, and cruel and wretched parents, and after they were cleaned and cared for by Mr. E. Gerry's 'Society for the Prevention of Cruelty to Children,' " reported the *Photographic Times*.[32] In Washington, where his lecture was preceded by scripture reading, prayer, and gospel music, Riis organized his slides of children to portray the life of the homeless "street Arab" from "his birth in a dive to his burial in an unknown grave on Hart's Island," a technique borrowed from the reformer Charles Loring Brace, whose *The Dangerous Classes of New York and Twenty Years' Work Among Them*, published in 1872, was illustrated by a similar series in woodcut (Figures 1.12 and 1.13).[33]

These narrative and rhetorical strategies functioned in several ways. Humorous or adventuresome anecdotes imposed a reassuring order on content whose "crime and misery" might otherwise overwhelm. They also confirmed the privileged position of the viewer by implying that he or she had a right to be entertained by an encounter with such material even while absorbing Riis's moral strictures. Riis's actual physical presence as mediator between the audience and the photographs virtually embodied the overseeing "master" narrator familiar to readers of realist literature. Not only were the pleasures of reading recalled, but also the ostensibly incontrovertible authority of such a "point of view" was evoked on Riis's

13

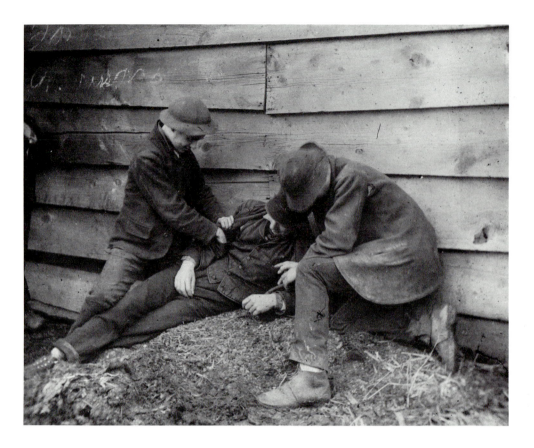

Figure 1.7. Richard Hoe Lawrence, *Robbing a Lush*, 1887. New-York Historical Society, New York City.

behalf, dismissing any possibility that the photograph itself might offer an alternative, or even oppositional, meaning to his. In the same way, Riis's blunt title, framing his content as "the other half," simultaneously designated his audience as "this half," thus assigning to them a relation to the proceedings that offered an attractively secure and collective point of view from which to survey the show.[34]

As Riis's project developed, he spoke of it in language that affirmed his regard for the supposed universal benignity of middle-class interests and social perspectives, and he specifically associated the powers and pleasures of photography with them. As Riis explained to an interviewer early in 1888:

14

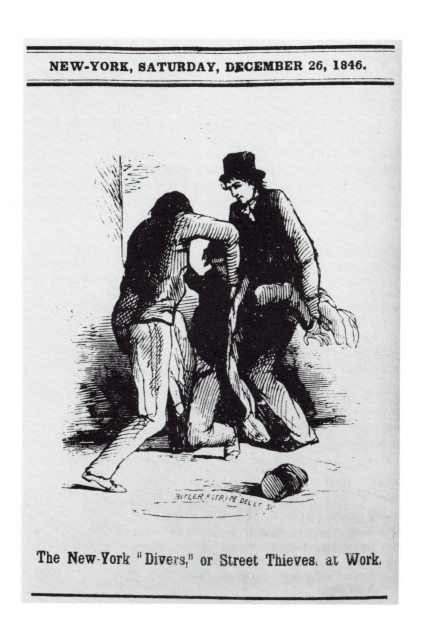

Figure 1.8. *The New-York 'Divers,' or Street Thieves, at Work,* from the *National Police Gazette,* December 26, 1846.

Figure 1.9. C. A. Keetels, *A "Bottle Alley" Saloon*, reproduced from *Harper's Weekly* (February 28, 1880).

The beauty of looking into these places without actually being present there is that the excursionist is spared the vulgar sounds and odious scents and repulsive exhibitions attendant upon such a personal examination.

A revealing rhetoric, which Riis elaborated in *How the Other Half Lives*, this language of tourism seems to owe more to literature than to the ideas of earlier reformers.[35] The literary convention of an urban landscape so fragmented as to make quarters of the city "another country" was of course well established in the press and popular literature of the 1880s. "The other half" was not least among a battery of well-worn tropes evoking "nether" regions that presented an "excursionist" with scenes so alien, forbidding, or disgusting that they required the mediation of journalists or artists. William Dean Howells remarks of a "wretched quarter," for example, that "in a picture it would be most pleasingly effective, for then

16

you could be in it and yet have the distance on it which it needs"; but actually to be there was to experience

the stenches of the neglected street and . . . that yet fouler and dreadfuler poverty-smell which breeds from the open doorways . . . [and] to see the children quarreling in their games and beating each other in the face and rolling each other in the gutter like the little savage outlaws they are.[36]

Riis's comment implied just such a distinction. But more than this, he rephrased the claims of countless earlier exhibitors who offered urban "excursionists" vicarious travel to exotic, unknown, and distant territory. Forbears among such purveyors may have been the entrepreneurs who emerged during the craze for moving panoramas of the rural South and the unsettled West that swept the country in the 1850s. Such exhibitions were often intended to simulate for audiences a steamboat trip down the Mississippi. Imbued with patriotism and imperialist sentiment, their pur-veyors sought ultimately not to mystify but to domesticate the western territories. Panoramas showed the wilderness "giving way to commerce and settlement," and in addition to entertaining and exhorting, they func-tioned as a form of surveillance, offering potential settlers a reliable "visual inventory of objects in the [western] landscape." Helping to bolster ur-banites' courage and desire to settle the distant places, they implied that their "aesthetic appropriation prepare[d] the way for physical coloniza-tion" of the West, according to art historian Angela Miller.[37]

Like slide shows, these edifying spectacles featured music and were nar-rated by authoritative "professors" or "directors" who vouched for the verisimilitude of the painters' renditions. Audiences were solicited to enjoy the pleasures of vicarious westward travel in language much like Riis's: "Whilst storing the mind with information never to be effaced, the viewer congratulates himself at not being actually exposed to the dangers and inconveniences of so extended a pilgrimage," promoters enthused, noting "how much more convenient and pleasant it is to sit comfortably amid the beauty, fashion and intelligence of our great metropolis for two or three hours and view this mighty river as it flows past, than it is in reality to boat . . . up and down it."[38]

As an "exhibitor," Riis stood closer to the panoramists who would do-mesticate than to the journalists who would mystify, and his evocation of spectacle and tourism in regard to New York's slums used the rhetoric and its associations for purposes akin to those of the western imperialists. Riis's representation of the touristic point of view offered a "respectable" perspective on the photographs he showed; in addition, it helped him

Figure 1.10. *The Newsboys' Lodging House*, reproduced from *Harper's Weekly*, 1867.

further flatter his audience, implicitly assuring them that they were the "half" designated by history and progress to colonize and dominate. Just as the panorama promoters' fulsome congratulation of their audience affected to assume not only their curiosity, but also their privileged position as those who would soon colonize the uncivilized landscape, so Riis's phrases convey his understanding that his "excursionist" is at once tenderly refined and sternly reform minded. He or she deserves both the information needed to transform or control the slums, and the security and privilege of distance that obviates the "vulgar, odious and repulsive" experiences that the actual slums would inevitably present. By conflating the language and perspective of geographical inventory and settlement with that of social surveillance and control, Riis was able to imply as well that his audience's mobile and "colonial" position in relation to the slums it "visited" was a natural one.

As a police reporter, Riis understood surveillance. It had been the theme

Figure 1.11. Jacob A. Riis, *Washing Up in the Newsboys' Lodging House*, 1880s. Museum of the City of New York.

of his first lecture, and it remained explicit in his use of photographs from police and charity files. A section of the lectures featured "noted thiefs [sic] and forgers, both male and female," and "celebrated 'crooks' and murderers, . . . noted confidence men and bunco steerers."[39] Their portraits, showing faces "as of animals, the souls being gone," Riis said, were taken directly from "the big wooden album called the Rogue's Gallery" at Police Headquarters.[40] This gallery police superintendent Thomas Byrnes called "probably the most complete criminal directory in the country," and its revelations had become a form of entertainment – a tourist attraction, wrote Riis, "more frequently heard of than the Cooper Institute or the Metropolitan Museum of Art," so that "strangers from all parts of the country who never heard of these places come far to see it, and esteem it a privilege to be permitted to do so."[41] Some images Riis showed had also been published shortly before in *Professional Criminals of America*, an ex-

Figure 1.12. Jacob A. Riis, *Street Arabs in Sleeping Quarters*, 1880s. Museum of the City of New York.

pensive portfolio of mugshots with text assembled by Byrnes that promised to make "Everyone...his own Detective." Riis showed as his own *The Inspector's Model* (Figure 1.14), which he used to illustrate a chapter of the book explaining the benefits of photography to police work. The posed photograph offered Riis's audience a "comical" moment: with Byrnes on the left, "four or five detectives [were] holding a refractory thief while he was having his photograph taken," according to the *Photographic Times*.[42]

The police had begun to use photography at the earliest practical moment in the 1840s, and other institutions dealing with the delinquent, poor,

Figure 1.13. F. Beard, *The Fortunes of a Street Waif*. Reproduced in Charles Loring Brace, *The Dangerous Classes of New York, and Twenty Years' Work Among Them* (New York: Wynkoop & Hallenbeck, Publishers, 1872).

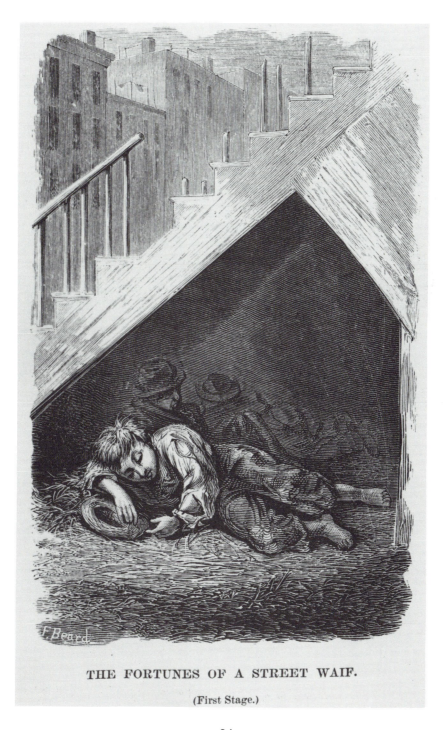

THE FORTUNES OF A STREET WAIF.

(First Stage.)

21

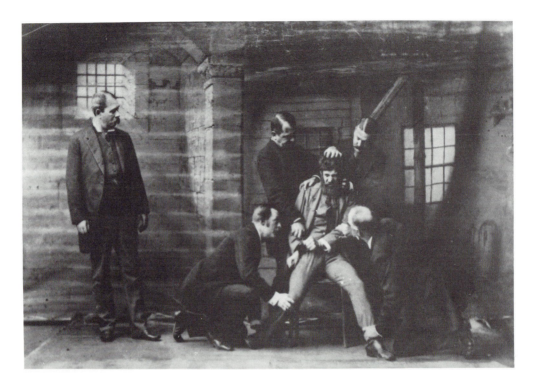

Figure 1.14. Photographer unknown, *Photographing a Rogue; Inspector Byrnes Looking On [The Inspector's Model]*, n.d. Museum of the City of New York.

and outcast quickly followed suit. By the 1880s, as a joke like *The Inspector's Model* testifies, knowledge of, and resistance to, the use of photography to control those who might threaten the respectable classes was longstanding. The Gerry Society, for example, in addition to rescuing victims of child abuse, supported laws to outlaw child begging and to bar juveniles from saloons, theaters, and brothels, where they often worked.[43] Collaborating with the police, officers of the society had child beggars and vagrants arrested and sent to asylums or protectories; but first, all rescued and apprehended children were "registered in the [Society's] great books" and photographed ostensibly "as found" and "after a day in the Society's care."[44] Some of these "before and after" photographs were published in the society's headquarters in "an arrangement" which the society itself describes as "like that of the Rogue's Gallery at the Police Headquarters."[45] Resisters may have come to suspect that any camera turned on them by middle-class operators might result in a photograph used for purposes

22

ultimately no more friendly than those of the police, and their suspicions were not generally ill founded.

In his autobiography, Riis claimed that police protection for his expeditions was "hardly needed," since his party, armed with the pistols then used to ignite flash powder, "carried terror wherever it went" and "it was not to be wondered at if the tenants bolted through windows and down fire-escapes."[46] Nevertheless, their efforts did meet resistance, which when described was made the occasion for condescending humor. In the Hell's Kitchen district, noted the *Photographic Times*, the photographers were "attacked by some of the women with brickbats, which broke one of the plate-holders." An account in a Long Island newspaper, titled "Perils of Photographers," explained, apparently from Riis's remarks, that

Among the Italians hands would be sometimes placed on knives and stilettos when the party disturbed the rest of the owners. They could be appeased by being greeted with smiles, for an Italian will almost always return a smile and be put in good humor. Then the powder would be exploded and the photographers take to their heels without waiting to witness the surprise of the victims.[47]

The photographs made in this way by Riis, Lawrence, and Piffard have been taken to exemplify, in a then-novel and relatively accomplished way, photography's unique claim to "realism." Modern admirers, in crediting Riis with initiating the documentary tradition, have assumed that the flashlit "vividness and accuracy" of his images was intended to serve not only verisimilitude, but also the humanitarian ideology that the ensuing century of documentary practice has attached to social photography. Yet, when we look at Riis's and Lawrence's photographs in the context suggested here, the grounds for such an evaluation seem open to question. It is not at all clear that Riis intended to distinguish "his" photographs from other visual discourses, including the photographic surveillance and social control practiced by Superintendent Byrnes and the Gerry Society, and it seems likely that the reported distrust and dismay on the part of Riis's and Lawrence's subjects was an appropriate response to attitudes and intentions Riis himself expressed. The idea of photography as surveillance, the controlling gaze as a middle-class right and tool, is woven throughout Riis's lectures and writings. Not only did Riis make use of others' surveillance photography, and deploy the insiders' humor that affirmed its power, but he also, and quite consistently, valued his own images in similar terms. We have seen the invidious caption he fixed on Lawrence's image of the tramp and the domineering, touristic, even voyeuristic perspective he encouraged toward his lectures as a whole. When he spoke specifically

23

about his flash photographs, they were valued neither for their candor and immediacy, nor for the poignant drama they bestowed upon the suffering of his subjects; instead, they were seen as ways to extend the very surveillance, inventory, and description – from which the accolade "documentary" intends to distinguish them – yet further into working-class life. In articles and interviews Riis drew attention to the novelty of "his" flash photography, and as he suggested in the *Sun*, one reason that his exhibitions were attractive was that "instantaneous" pictures taken with magnesium flash powder had not been seen before on exhibition screens. However, what Riis actually said about specific flashlit photographs does not evoke the qualities that we now describe as their "intimacy" and "intense living quality," in Ansel Adams's representative words.[48] Even when Riis seems about to evoke such immediacy, describing "night pictures" such as Lawrence's *Waked up by the Flashlight," The Lodging Room [for Women] of the Thirtieth Street Police Station* (Figure 1.15) as "faithful and characteristic, being mostly snap shots and surprises," his reading serves ultimately to categorize and distance his subjects rather than to dramatize and bring them closer. The photograph portrays "three different types of the [police] station house lodger," he wrote in the *Sun* (where it appeared in woodcut). "One is shown in sodden or brazen indifference, one in retiring modesty and averted face, and the third in angry defiance of camera and visitors."[49] The features which we today find so interesting and affecting – the stockings hung up to dry against the whitewashed wall, the women's hair and clothes, and not least their inevitably ambiguous expressions of resignation (they were, after all, "waked up by the flashlight," as Lawrence's title tells us) – were not granted significance by Riis. Rather, his reading, seemingly concerned particularly to justify the making of the photograph, stresses its potential value for social control as a useful record of representative "types"; as a consequence, his text objectifies its subjects, denying them whatever dignity and individuality they might muster in the extraordinary situation that the camera's presence has created for them.

It is not my intention especially to discredit or unmask Riis – tempting as that may be, after so many years of hagiography. Rather, in attempting to reconstruct the historical context and meaning of his work and to recover the authorship of photographs he showed, I have hoped to represent Riis's actual photographic practice and to place it at the beginning of the complex process by which social documentary gradually emerged as a photographic discourse distinct from other forms of urban visual culture and other photographic practices. Clearly, these origins were complicated, and less

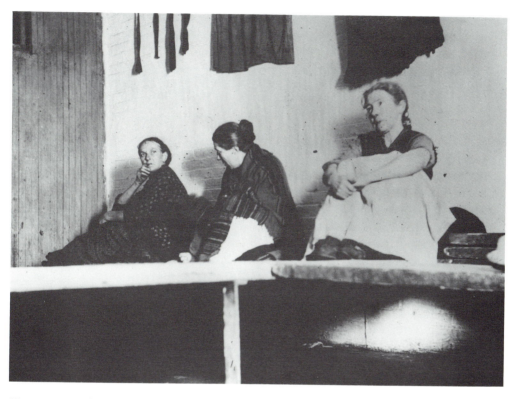

Figure 1.15. Richard Hoe Lawrence, *"Waked Up by the Flashlight," The Lodging Room (for Women) of the Thirtieth Street Police Station*, 1887. New-York Historical Society, New York City.

benign and straightforward than we may have thought; and for reasons that may now be evident, Riis is not an altogether reliable guide to them.

In this connection, it is interesting to note that Riis claims in his autobiography never to have understood the enormous popularity of *How the Other Half Lives*.[50] Ever the skillful publicist, he did not justify his annexation of documentary photography to middle-class interests by asserting photography's unique claim to verisimilitude. Rather, he insisted on linking his appreciation of the medium, and of his subject, to current notions of refinement and estheticism. Riis does take pains to distinguish his interest in the slums from "the delight of the artist"; nevertheless, he subtitled his book "studies among the tenements," and he uses the metaphors of art to embellish his text. "Why complete the sketch?" he concludes a typical vignette.[51] More than this, Riis specifically associates photography

25

with the traditionally sanctioned "magical" powers of art and poetry rather than with innovation and social insight:

I do not want [photography] explained to me in terms of ...formulas, learned, but so hopelessly unsatisfying. I do not want my butterfly stuck on a pin and put in a glass case. I want to see the sunlight on its wings as it flits from flower to flower, and I don't care a rap what its Latin name may be. Anyway, it is not its name. The sun and flower and the butterfly know that. The man who sticks a pin in it does not, and never will, for he knows not its language. Only the poet does among men.[52]

Even Riis's somewhat disingenuous assertion of bumbling incompetence with the camera serves to dissociate his use of the medium from official record keeping or social control, as well as from other uses of photography. "I am no good at all as a photographer, [but] I would like to be," he wrote in his autobiography, and the remark seems to identify him as a connoisseur and appreciator of photography rather than as a producer.[53] Just as Riis firmly rejects the status and ambitions of a professional, he also disengages himself from the practice of a leisured amateur such as the patrician Richard Hoe Lawrence. His studied admission may even be construed as a belated and backhanded acknowledgment or apology to Lawrence and others whose images Riis had appropriated into his enterprise – obliquely crediting them, and not himself, for any visual impact to be found in the materials. At the same time, as a consumer rather than a producer, Riis could draw closer to the mainstream of his middle-class audience, who were not photographers or patricians either, and use himself as a model to enact for them, once again, a role of properly distanced spectatorship in relation to the alarming possibilities presented not only by the images, but also by the society, that confronted them.

In the decade that followed the publication of *How the Other Half Lives*, advances in both camera technology and techniques for halftone reproduction exponentially increased the use of photography in all kinds of journalism and publishing. Although Riis continued his lecture tours until 1914, the year of his death (see Figure 1.16), the kinetoscope and successive motion picture technologies diminished the appeal of such exhibitions. The apparently seamless transparency of filmic narratives far surpassed anything the old "dissolving views" might offer in the way of entertainment, even though some early motion pictures did adopt the same themes and topics (see Figure 1.17).[54]

In the sphere of reform, editors of newspapers, magazines, and reports

26

Figure 1.16. Photographer unknown, lantern slide advertising lecture "The Battle with the Slum," n.d. From the Jacob A. Riis Collection, Museum of the City of New York.

Figure 1.17. From the forty-second 1904 film, "Photographing a Female Crook." Reproduced from *Before Hollywood: Turn-of-the-Century American Film* (Hudson Hills Press, in association with the American Federation of Arts, 1987).

learned quickly to exploit photography as a medium newly flexible – with the advent of Kodaks, roll film, and flash – and newly legitimized by events both technological and art historical. They were not blind to the legitimacy photography gained when film usurped the place of dioramas, dissolving views, and stereopticons among popular spectacles, and they appreciated the seriousness increasingly bestowed upon the medium by artistic practitioners in Europe and America. By 1910, one reviewer of annual reports urged restraint in the use of images, noting that "the public soon wearies of pictures of destitute children or desolate tenement interiors."[55]

Despite the implications of such a plaint, the most significant and influential event for the development of social documentary photography in these years was actually an exhibition whose 1,100 images contained more tenement exteriors than interiors and scarcely a destitute child. The Tenement House Exhibition of 1900 was sponsored by the Charity Organiza-

28

tion Society (COS), a private charitable agency that maintained an elaborate and bureaucratic surveillance network as extensive as that of the police, yet nominally humanitarian rather than punitive. The organization sought to publicize not only its reformist vision, but also this remarkable tool of social control, in ways that emphasized their professionalism and propriety.

The exhibition, which represented the agency's first efforts to address a mass audience, avoided both the drama that Riis bestowed on the practice of surveillance and the self-important sensationalizing that a Thomas Byrnes or Eldridge Gerry brought to it. Sober and antiesthetic, the exhibition created a discourse that presented photography as not only a validation of, but also an occasion to experience, the arduous labyrinth of bureaucratic organization. Its successful representation of social welfare professionalism set a precedent for other reform groups seeking to publicize their visions of a well-regulated society in the years before World War I.

Though organizationally sponsored, the exhibition expressed, like Riis's work, the guiding vision of one man, the "professional altruist" Lawrence Veiller. His project was "planned and developed," he wrote, "to prove to the community the fact that in New York City the working-man is housed worse than in any other city of the civilized world, notwithstanding the fact that he pays more money for such accommodations than is paid elsewhere."[56] Calling New York "the city of living death," Veiller used over 1,000 photographs (none, apparently, by himself) and included an "historical exhibit" of tenement development in New York City, an "exhaustive study of existing modern improved tenements," a "library of works on economic housing," a model tenement design competition for architects, and a "series of conferences and public discussions on subjects relating to economic housing" to make his point and to support his proposals for reform (see Figures 1.18 and 1.19).[57] Veiller proposed a new code that prohibited further construction of the "dumbbell" tenement, with its inadequate twenty-eight-inch airshaft, thus creating the distinction between "new law" and "old law" tenements in New York. The code required windows and doors to be cut in existing "old law" tenements and also included a variety of sanitary and fireproofing measures. In addition to the code itself, Veiller formulated an organizational scheme for a separate tenement house department to oversee enforcement, replacing the previous division of responsibility among the building, health, fire and police departments.[58]

The thorough and thoroughly successful exhibition was well received in

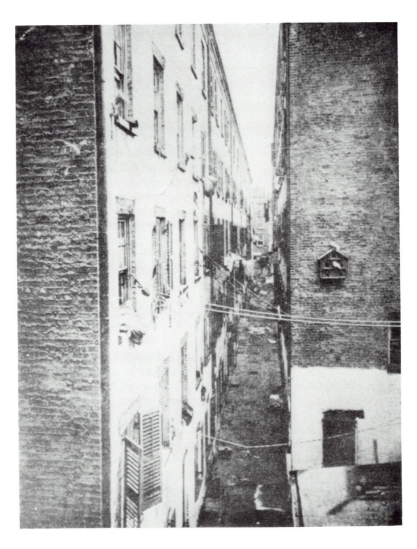

Figure 1.18. Photographer unknown, *Notorious "Gotham Court."* Reproduced from Robert W. De Forest and Lawrence Veiller, eds., *The Tenement House Problem*, vols. 1 and 2 (1903; New York: rpt. Arno Press & The New York Times, 1970), I, facing page 78. Also in the Local History Room, New York Public Library: print number M-12, captioned, "Gotham Court – New York. Now torn down. One of the worst tenement houses the world has ever seen. Here typhoid fever, poverty and crime raged for years."

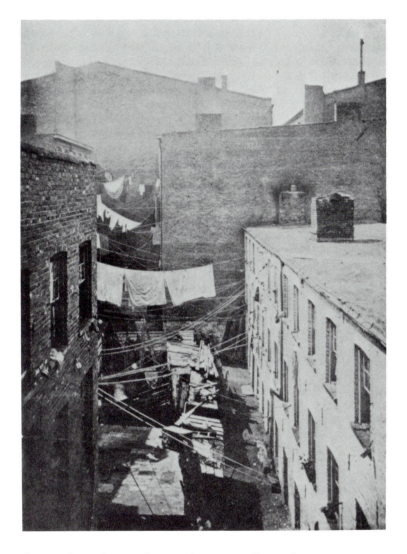

Figure 1.19. Photographer unknown, *"Perpetual Fever Nests" – Washington Street Tenements, 1864*. Reproduced from De Forest and Veiller, eds., *The Tenement House Problem*, I, facing p. 92.

many quarters; it signaled to many observers that the COS was moving beyond its narrow policy of "warring against pauperism" to stake out a newly expansive position as an articulate and activist participant in progressive reform. The agency claimed attendance of 10,000 in a two-week period, including "persons of all classes, from the millionaire to the poor-

est, unskilled laborer," who came to see the COS's "novel object lesson" crammed into five rooms in the Sherry Building in midtown rather than, as they might have, journeying downtown to experience the tenements themselves.[59] All of Veiller's measures were passed by the state legislature in April 1901, due in large part to the publicity generated by the exhibition, and this victory – well timed to occur midway in a hotly contested mayoral campaign – helped to bring Seth Low, the candidate of the reformist Citizens' Union coalition, into office. Low promptly appointed Veiller to be deputy commissioner of the new Tenement House Department, thus ensuring him scope and power to carry out his reforms.[60]

From its inception the COS had sought to fuse longstanding concerns for urban moral order and social control with newer principles of scientific and professional organization. When Josephine Shaw Lowell founded the New York chapter in 1881, she gathered statistics from sixty-six charitable organizations in the city – only a fraction of the total number – showing that in 1880, $546,832 was given as charity and about 525,155 cases were reported as having received some form of charitable relief. "So important a business as the administration of charity has become in New York City," she argued, "requires to be carried on on business principles." The new organization would coordinate and rationalize the work of all charitable agencies in the city, providing a means for amassing and exchanging information on charity applicants in order to prevent duplication of services, waste, and "indiscriminate alms-giving."[61]

Seeing itself as a group of cool professionals dealing bureaucratically with both the charitable benefactor and the real or potential object of charity, the COS made the twin goals of curbing both "indiscriminate almsgiving" and its consequence, "chronic pauperism," foremost among its aims. If, as the COS held, poverty resulted chiefly from the moral flaws and personal failings of poor people, the cure for such moral illness was not a charitable dole but rather honest work, wise advice, and moral leadership. Supervised public relief given within poorhouses and hospitals must be restricted to the "chronically homeless and unemployed," and only after all efforts at rehabitation have failed. "Friendly visiting" by the COS worker to needy families who had asked for relief was the agency's chosen method to strengthen the values of family, thrift, and work and to prevent the demoralizing effects of too easily obtained charity. "Not alms, but a friend," the COS vowed, and the friendly visitor attempted to set an inspiring example within the tenement home.[62]

However, such a visitor also followed the "fundamental law" of charity organization, which commanded her above all to "investigate." At her dis-

trict office, after her visits, she filled out carefully devised forms and schedules with data collected on each family, and she supervised the circulation of additional forms to referees including landlords and employers. Viewed by their perpetrators as the crucial feature that made COS work "scientific," as "essential in dealing with the case as a diagnosis in a case of sickness," these inquiries into the "worthiness" of the needy were actually extremely judgmental in their preoccupations, concerned to assess the "industriousness," "temperance," and "social and moral condition" of families.[63] District agents reported daily to the central office, where, in New York in the mid-1890s, data was held concerning 170,000 families or individuals. Unseen, of course, by the families themselves, these records, "preserved with a thoroughness that can only be obtained by writing, and extending beyond the lifetime of any one individual," as one observer noted, were circulated not only to charitable agencies and interested individuals, but also to prospective employers and landlords, to banks, and to the police.[64] For cooperating member charities the society published a monthly confidential bulletin, "just as commercial agencies do their books of commercial ratings," naming worthy and unworthy applicants. Taking a cue from police operations, a COS spokesman urged in 1894 that the agency develop its own standardized telegraphic code in order to facilitate intercity communication.[65]

High hopes were held out for COS methods in the 1880s. The severe depression of the 1890s, however, which threw hundreds of thousands of willing workers into poverty and onto relief rolls to avoid starvation, necessarily undercut the authority of the COS's strictly characterological explanation of poverty. The settlement house movement, on the rise as charity organizations drew criticism in the 1890s, was more open to consideration of environmental effects on morality and behavior. Settlement residents took action on environmental and preventive, rather than individual and curative, remedies. The settlement workers felt "a fellowship with the people about them," noted Robert Hunter, a sometime settlement resident and acute observer; they were "filled with earnestness and warmth of purpose," and "not too much of question."[66]

Despite such differences of method and temperament, however, the two movements shared underlying principles with "a far higher degree of continuity," historian Paul Boyer has suggested, than either might have cared to admit. Indeed, a settlement resident might be seen as simply a friendly visitor "who actually took up residence in the poor neighborhood," performing the same role of moral model and counselor as the COS volunteer. Settlement workers, too, based their goals and methods on minute inves-

tigation and the steady accumulation of facts. They sought, as one resident wrote, to create through investigation a "photographic reproduction" of their tenement neighborhoods; and her metaphor shows a belief in the transparent realism of both their "facts" and their photography, a belief common to "investigators" of all stripes.[67] Nevertheless, as Boyer points out, settlement workers differed from COS volunteers in tending to study not individuals or families, but rather larger units – the neighborhood, political ward, or industry – and thus the "insistent probing" and "personal impertinence" inevitably involved might be justified by the anonymity of presentation and by the broad, preventive scope of remedies proposed.[68]

The results of settlement investigations were readily displayed to the public. By the time she or he visited the Tenement House Exhibition, an interested observer might have encountered the work of well-known individuals including Riis, the Reverend Charles H. Parkhurst, and the novelists Josiah Strong and William Stead, and, equally likely, be familiar with *Hull-House Maps and Papers*, from Jane Addams's famous settlement, and with the essays collected by Robert Woods, of South End House in Boston, in *The City Wilderness*, which covered similar topics. She might have studied the U.S. Labor Department's *Special Investigation of the Slums of Great Cities*, undertaken in 1893, and if a New Yorker, have read with interest the 1895 *Report* of the state-appointed Tenement House Committee chaired by Richard Watson Gilder. A quest for precedents to which such investigative volumes made homage might have led to Charles Booth's pioneering *Labour and Life of the People* and Seebohm Rowntree's survey of York, two English works that deeply influenced the Americans. A reader with an interest in graphic and methodological techniques could have noted in those volumes examples of the types of detailed maps and charts which, along with photographs and architectural drawings, the American books used to illustrate their own findings.[69]

Prior to the Tenement House Exhibition, however, the COS had made little contribution to the discourse of social investigation. Before 1897, when it founded the weekly magazine *Charities*, its publications, though numerous, were primarily annual reports, handbooks outlining methods of friendly visiting, or explanations of "wiser methods of charitable effort." For, unlike the data collected by settlements or appointed commissions, those resulting from COS surveillance necessarily violated privacy in a way that might provoke evasion or resistance if published; their value to reform work depended on their secrecy. Such a self-imposed silence – intimately linked, of course, to the agency's narrow policy of "warring on pauperism" – left it defenseless against increasing public criticisms of just

that policy. Although Veiller's proposal was in no way a direct response to this situation, it did offer to ameliorate its difficulties. According to Veiller, it was only "very experimentally" that the organization granted him the mandate to establish the Tenement House Committee and undertake the exhibition. Nevertheless, there may be some truth in Robert Hunter's account, which holds that COS secretary Edward Devine "dissuaded [Veiller] from organizing a separate association" in favor of instituting a committee within the COS. In any event, Veiller submitted a memorandum proposing such a permanent committee in April 1898, and the COS voted to approve it in December of that year.[70]

Once having voted, however, the COS evidently lost no time in recognizing that it needed not only to depart from previous policy but also to signal that departure. It was fortunate in having the observations of Robert Hunter, who seemed acutely tuned to COS events; his responses to every signal seem to be those of an ideal reader. That the agency mounted such an exhibition at all indicated a shift in its emphasis from individual surveillance to consideration of environmental and social causes of poverty, Hunter noted, and such a shift was filled with significance that "perhaps mark[ed] an epoch in this country in the policy of philanthropic organizations." Hunter saw the Tenement House Exhibition as an exemplary step initiating new preventive measures because it publicized "certain social causes of poverty" related to or caused by the tenement house environment. Hunter also noted that Veiller's ideas about housing arose as a result of his settlement work but were carried out by the COS. This sequence of events, he thought, suggested progress, because it indicated a way that the COS and the settlements could more extensively complement each other's work and broaden each other's views. He argued, in effect, that the COS ought no longer to "restrict its activities to [a] narrow field"; rather, it should use its resources to investigate and publicize social conditions, and it should make its factual and organizational strengths a basis for political intervention by socially concerned groups.[71]

Inspired by the tenement work, as Hunter noted, was a successful tuberculosis committee and, by 1906, the new approach was well entrenched. According to its twenty-fifth annual report of that year, the COS leadership had decided not only to cooperate with settlement house workers but also to revise fundamentally its concept of its own mission. This it henceforth described as part of a broad tradition that included not only the journalism of Jacob Riis and Lincoln Steffens, but also the preventive social investigations carried out by settlement houses and by Booth and Rowntree. Armed with this new vision, the leadership concluded that

35

the result to the community in eliminating and diminishing some of the more important causes of pauperism is of infinitely greater value than could have been brought about by the same amount of effort and the same amount of money expended for the relief of individual suffering. [The society therefore] deliberately determined, without neglecting in any way its duty in the relief of individual cases of poverty, to lay emphasis on the field of removing or minimizing the causes of poverty, and to firmly establish and extend these forms of work by organizing them into a department for the permanent improvement of social conditions.

This department was directed by none other than Lawrence Veiller.[72]

In light of his later career as author of numerous housing and zoning codes, Veiller's COS and tenement work seem but a prelude to even more professional, if not necessarily altruistic, social interventions. His pioneering New York law of 1916 was the first zoning ordinance imposed on an entire metropolis; it restricted the height and bulk of buildings and regulated the uses of land and the density of population throughout the city. Its success led Veiller to national prominence in 1921 as an appointee to Commerce Secretary Hoover's Advisory Committee on Zoning, which provided "A Standard State Zoning Act" for state legislatures to implement in communities throughout the country.[73]

Like his progressive contemporaries, Veiller enlarged his vision to include municipal reform, engineering, architecture, and public health among his concerns as a "houser." His work stood at the intersection of the several "new professions" that aspired as the century turned to define and control not only problems long recognized as urban, but also the urbanizing and modernizing cultural and economic development of the nation as a whole. Redefining the situation that Riis had sought to rectify with a bridge "built of human hearts," this "planner in embryo" brought to it a sophisticated phalanx of techniques and a set of policies that addressed local problems as part of regional and national agendas.[74]

Unlike Veiller's zoning work, which was criticized (as were most zoning ordinances) as a way to maintain property values and preserve neighborhood characteristics rather than to deal with housing and congestion problems, the exhibition and its legislative proposals seem immediate and humanitarian. In contrast to the zoner's concern to establish "a rational land-use pattern of the metropolitan whole," the tenement project appears to be local and specific, revealing its genesis in Veiller's settlement work during the "panic year" of 1892–93.[75] Nevertheless, the exhibition was the work of a "professional technician of reform"; even as it represented the suffering of tens of thousands of tenement families as a fact no one could dispute, it sought to present the tenements and the poor as spaces and

subjects knowable in the same organized and rational way as Veiller's zoning ordinance later proposed that New York City could be known – based on "facts ... known in a strictly accurate and scientific way." Veiller's graphic procedures (including photographs) displayed the minute thoroughness of the committee's investigations and statistics, but he was also concerned to represent the very attitude of detached expertise with which the data had been analyzed and organized.[76]

Like his reform predecessors, Veiller emphasized the verisimilitude embodied by the exhibition, which he called his "happy idea of bringing the so-called slums to the people uptown, instead of trying to take the uptown people down to the slums." Within the museum-like arrangement of Sherry's five rooms, viewers could wander the "novel object lesson" in any pattern or direction, just as, ideally, they might wander the slums themselves. In addition to the "historical exhibit" documenting tenement development in New York, they might contemplate exhibits from other American cities with housing problems, inspect several hundred photographs of model homes in America and Europe donated by their builders, and examine the many photographs documenting the beneficial effects of recent reform efforts on behalf of parks, playgrounds, bathhouses, libraries, and lodging houses (see Figures 1.20 and 1.21).[77]

To the methods already familiar from settlement and commission reports, the exhibition added two other forms of graphic statistical interpretation, much remarked upon at the time. The first was six "ingenious and enlightening" papier maché models. Four of them represented blocks of model housing; one showed "a block as it will appear when solidly built up with houses such as are permitted by the present law"; and one an existing block of tenement houses (Figure 1.22). A plethora of statistics accompanies mention of this model block in Veiller's writings, and no doubt many of these data, documenting conditions "almost beyond belief," were made available to the public. A second innovation was a parallel series of forty-seven maps of New York tenement districts. "Disease maps" overlaid information on population and incidence of contagious disease onto detailed real estate maps of tenement neighborhoods, and "charity maps" displayed similar data regarding applications to the COS or the United Hebrew Charities (Figure 1.23). The parallel arrangement enabled viewers to compare instances of poverty and disease virtually building by building, and to see how frequently the conditions accompanied each other.[78]

Veiller carefully dissociated his "Social Exhibition [used] as a mechanism in civic and social work" from earlier "strictly commercial ones,"

Figure 1.20. Photographer unknown, *Model Tenements – New York*, n.d. Reproduced from De Forest and Veiller, eds., *The Tenement House Problem*, I, facing p. 108.

Figure 1.21. Photographer unknown, *Shower Baths of the Association for Improving the Condition of the Poor – New York*, n.d. Reproduced from De Forest and Veiller, eds., *The Tenement House Problem*, II, facing p. 46.

calling attention in his descriptions and publicity to the fact that exhibition photographs were amateur work, solicited by letter from volunteers in many cities. The photographs were presented anonymously and, it seems, almost casually.[79] Unlike Riis, Veiller emphasized the ease and pervasiveness of photographic production: "Where the photographer's tripod could

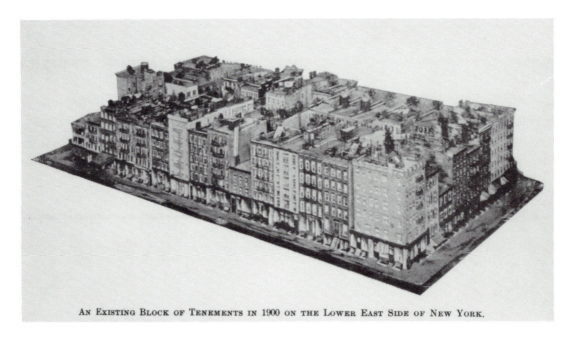

AN EXISTING BLOCK OF TENEMENTS IN 1900 ON THE LOWER EAST SIDE OF NEW YORK.

Figure 1.22. Photographer unknown, *An Existing Block of Tenements in 1900 on the Lower East Side of New York*, n.d. Reproduced from De Forest and Veiller, eds., *The Tenement House Problem*, I, facing p. 112.

not be placed, the kodak has done duty, and the result enlarged to the scale on which other photographs have been made," he recounted; and he stressed the camera's mechanical objectivity: "Buildings, courts, airshafts, closets, roofs, and fire-escapes all have been caught just as they are." As if to deemphasize the actual individual photograph, and its occasion, most pictures were presented in a uniform, 11-by-14-inch size. They were captioned with a handwritten card and, it can be conjectured, sometimes enhanced by nearby wall text, arranged as in Figure 1.24.[80]

Figure 1.25 shows a wall panel that was probably part of the exhibition's section on "shafts and inter-mural spaces."[81] As they did in other panels and in individually presented images, the title and also the repetition of compositional features – verticality, elimination of sky and street, the central placement of each airshaft – suggest the images are meant not only to represent these particular airshafts, but also to signify the multiplicity and quantity of airshafts with which the exhibition and the committee dealt. No contingent features individualize the images, and individual airshaft images have no captions; the general title, by insisting that we are

POVERTY MAP FROM TENEMENT HOUSE EXHIBITION.

Prepared by Lawrence Veiller.

Each dot represents 5 families who have applied for charity in 5 years, either to the Charity Organization Society or to the United Hebrew Charities.

Figure 1.23. Lawrence Veiller, *Poverty Map from Tenement House Exhibition*, n.d. Reproduced from De Forest and Veiller, eds., *The Tenement House Problem*, I, facing p. 114.

confronting only "some" of many airshafts, suggests that they be taken as representative, as a way of familiarizing ourselves with the many. In a similar way, we remember, Riis's less subtle comment on his photograph of "three different types of the station house lodger" stressed the value of that image to social control as a useful record of representative types.

Here, as in Figure 1.18, captions are choppy and telegraphic, as if discursive pleasure has been eschewed for some other purpose. Not merely

41

Figure 1.24. Photographer unknown, *Exhibit Prepared by the Hampton Institute Showing the Prevalence of Tuberculosis Among Negroes*, n.d. From Marshall Langton Price, M.D., "The American Tuberculosis Exhibition," *Charities and the Commons*, 15 (January 6, 1906), p. 453.

tersely efficient, such a style used in this context suggests that caption information may actually have originated as telegraphic transmission; like the pictures themselves, it thus suggests the extent of the factual information that the Charity Organization Society, as a national network, could collect from many cities.

The photograph of the coal-heaver and his family, the central image in Figure 1.25, was part of Riis's collection and had been published in *How the Other Half Lives*. There Riis described covering a murder which had brought him to "a ramshackle tenement on the tail-end of a lot over near the North River docks." He found the family, "honest" but "doomed by

Figure 1.25. Jacob A. Riis and unknown photographers, *Exhibition Board for Community Service Society Committee on Housing Exhibition on New York Tenements* (Wall Panel from the Tenement House Exhibition), n.d. Museum of the City of New York.

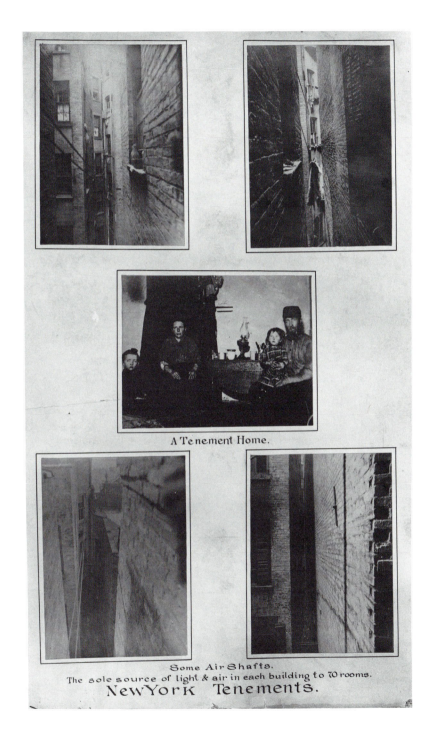

A Tenement Home.

Some Air Shafts.
The sole source of light & air in each building to 70 rooms.
New York Tenements.

poverty," living in wretched quarters, "uninterested witnesses" to the murder on the floor below. Like all of Riis's stories, this one serves to establish his master narrative over against other readings of the image. In its dramatic account of the instance of picture taking, it constructs a virtually separate, fictional character – the reporter/photographer "Riis" – who is endowed in the story not only with industry, curiosity, and moral righteousness, but also with humane concern and sympathy, qualities which are then inscribed in the photograph he presumably made and which we identify in ourselves insofar as we identify with him.[82]

Though Veiller was, we can assume, no less concerned than Riis to convey his own humanitarianism, if not necessarily to display it for our identification (lest he encourage "indiscriminate alms-giving"), he had no desire to privilege this or other photographs above other forms of data by narrating (or even noting) the method and circumstances of their making. (In this he did not depart from the norm in most investigative texts of the nineties, where data sources for maps and charts were specified, but photographs left unidentified as to maker and circumstance.) Although, like Riis, he needed to invoke the photograph's status both as humane instance and as surveillance, he eschewed the narrative with which Riis had mediated his documentary images. Stripped of the "personal" story in which Riis had embedded it, and hardly current in 1900, the *Coal Heaver*, like the exhibition's other photographs, appears not as the product of anyone in particular, or of any particular instance of photography. Riis's narrative underscored the irony of the family's conventional pose; but even without it, their careful arrangement around the bare table and functional lamp, one daughter perched on a bed of rags, is both ironic and pathetic in relation to the shocking caption, "the sole source of light & air in each building to 70 rooms." Though captioned no less minimally than other images, the *Coal Heaver* is set off, and thus implicitly further identified, by its horizontal composition and its human subjects frontally presented according to the iconic conventions of the family portrait. Since the curt caption does not elaborate that fact, however, nothing signals viewers to respond differently to this image than to the airshaft images that surround it.

However, Veiller's minimal captions are provocative, for they propose in effect that individual images are fully understandable only in the context of the entire exhibition. Encountering that totality, we find it gridlike rather than sequential, rational rather than narrative in structure. Fuller meanings for each image emerge not in the course of narrative enjoyment, but rather when, like the exhibition organizers themselves, the viewer

enters into an arduous process of cross reference, comparison, and analysis. The viewers' exhibition experience can represent, if not fully duplicate, that of the organizers who prepared it. As viewers thus become, however briefly, participants in COS "scientific" procedures, they can identify with and admire them, just as they identified with the adventures of the intrepid yet humane "Riis." And since the *Coal Heaver* represents, more directly than do airshafts and model homes, human consciousness and sentiment, and even refers, to an extent, to art and its conventions, Veiller's treatment of the image may be taken to imply that those things too, like facts or statistics, are also best named and understood by their place in a vast yet rational system of statistics, facts, and images-as-facts.[83]

Not only the processes of COS investigation but also the resulting bureaucracy were "profoundly appealing" to middle-class volunteer workers, Paul Boyer proposes, perhaps because "the sheer mass of dossiers offered deceptively tangible assurance that the complex and disturbing human reality they documented had somehow been subdued and rendered manageable." His comment evokes a certain poignance as we look back at an exhibition that used sophisticated graphics to create virtually a material representation of such dossiered information, and which sought stringently to circumscribe, even to diminish, the powers of the photographic medium it relied upon in order to ensure the potency of a single semantic feature – its supposed transparency and factual authority. Indeed, reformers' concern to display the expertise connected with both possession and efficient management of masses of information was evidently so great that reviewer Margaret Byington felt it necessary to caution against publishing "a picture of the record filing case in an office," which, she pointed out, might "seem to intensify the technical aspects of the work, and possibly to create misunderstanding." Needless to say, the Tenement House Exhibition avoided any such literal statement; its representation of "scientific" methodology was designed to cloak in dignity and benignity the reformers' social control ambitions. Nevertheless, to critical eyes today, Veiller's presentation seems as well to have shrouded from view the vivid human presence of his nominal subjects, the immigrant families of the Lower East Side.[84]

The COS in its new incarnation sought to fulfill Robert Hunter's charge to take the lead in "bring[ing] to the attention of all the people those social causes which are bringing the people to need" and "undertak[ing] to deal with the whole problem of poverty." The exhibition's legislative success and its material if not literal representation of professionalism were much noticed in reform circles. Powerful agencies including the Russell Sage Foundation and the National Child Labor Committee established depart-

ments of exhibits, thus certifying exhibition management among the "new professions," and the ensuing decade and a half saw a succession of increasingly sophisticated exhibitions that elaborated techniques initiated in 1900. The Exhibition on Population Congestion of 1908 included a life-size model of a tenement sweatshop, a twelve-by-twelve-foot area that was home and workplace for a family of seven. The Springfield, Illinois, Survey Exhibit of 1914 used moving devices and "lighting novelties" to attract interest in its maps and charts and stationed volunteer "explainers" along its predetermined ninety-minute route.[85] In 1918 the Russell Sage Foundation initiated a book series devoted to surveys and exhibits with *The ABC of Exhibit Planning*, written by its own exhibit experts, Evart and Mary Routzahn. Though acknowledging that "a standardized technique has not been fully worked out," the book dealt thoroughly with all aspects of exhibits and urged organizations to employ an exhibit specialist.[86] By 1923, the Routzahns had established a course on social reform publicity, the use of "lighting novelties" and films was commonplace, and composition and layout were generally done by commercial firms. Photographs, the Routzahns thought, needed to be used dramatically: when they were enlarged, "all irrelevant matter should be cut away so that the significant features of the picture stand out boldly"; exhibitors might turn to "familiar newspaper practice" for examples of "the possibilities of manipulating the details of photographs to obtain striking results." Indeed, photographs were not always the best means to bring out "the real points of the illustration," the Routzahns noted, recommending cartoons and sketches instead.[87]

Among the titles that the National Child Labor Committee gave photographer Lewis Hine was "Director of Exhibits";[88] though Hine was among those who learned to integrate the techniques of advertising and journalism into social work publicity, he never succumbed to technocracy or social engineering. Rather, in the years before the war, Hine struggled to create a social photography that not only confronted "disturbing human reality" in every instance but also remained true, in its published or exhibited form, to his self-imposed mandate to represent such confrontation. The photographic practice he achieved was ambitious and ambiguous.

Chapter Two

THE PITTSBURGH SURVEY: LEWIS HINE AND THE ESTABLISHMENT OF DOCUMENTARY STYLE

In his opening address to the Tenement House Exhibition, Governor Theodore Roosevelt of New York did not hesitate to state reformers' goals in moral terms:

if we succeed through this exhibition in upbuilding the material and moral side of the life which is fundamentally the real life of the greater New-York, we will have taken a longer stride than we can take in any other way. When you look on the disease and poverty charts downstairs you will notice that they include the most densely populated districts – where the greatest number of votes are cast. Then ask yourselves how in a popular government you can expect a stream to rise so very high when the source is so low. In order to make any uplifting permanent you have got to strive for the material betterment of the people.[1]

Two months later, in equally urgent tones, Roosevelt pressed the legislature to pass Veiller's measures, again citing the "striking features" of the exhibition, the charts "which showed the way in which disease, crime and pauperism increase almost in geometrical proportion as the conditions of tenement house life became worse." The tenement house, he went on,

in its worst shape is a festering sore on the civilization of our great cities. We cannot be excused if we fail to cut out this ulcer; and our fault will be terribly avenged, for by its presence it inevitably poisons the whole body politic and social.[2]

There is no room in Paul Kellogg's scheme of the Pittsburgh Survey (Figure 2.1) for the rhetoric of demoralization and uplift, disease and health, that Roosevelt had relied on only nine years earlier. Kellogg's schematization of social inquiry remains scientifically neutral right down to the question of results to be expected from his equation of social forces and social inquiry. In the few years since the Tenement House Exhibition, the urban reform movement had grown and changed with startling speed, and the Pittsburgh Survey, which used Lewis Hine as its principal staff photographer, was the great contribution of its pre-war, hopeful maturity.

47

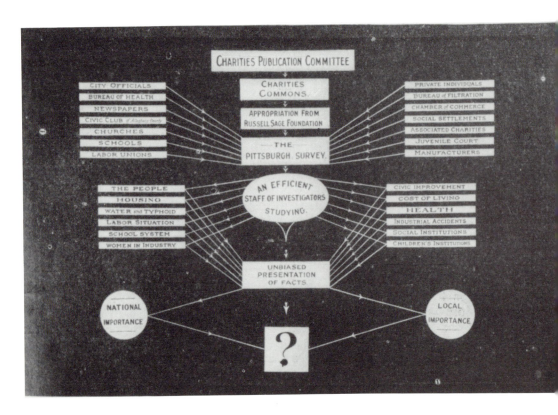

Figure 2.1. *Scheme of the Pittsburgh Survey.* From Paul U. Kellogg, "The Pittsburgh Survey," *Charities and the Commons*, 21 (January 2, 1909), p. 571.

Nevertheless, the optimism and scientism implicit in Kellogg's chart rested squarely on the rationality and bureaucratic expertise into which COS methods had channeled reformers' concern for urban moral order. Indeed, the chart suggests how successfully progressives had learned to publicize bureaucracy, eschewing photographs of office record filing cases in favor of a set of graphic symbols that handily conveyed the now-familiar principles of bureaucratic organization. However, as the terminology of sociology and economics replaced the rhetoric of moralism, the new language tended to detach reform investigations, and social control itself, not only from moralistic perspectives but also from surveillance and its connotations. As the title of the Pittsburgh project suggests, in the new century the progressive movement was concerned to project a new goal and purpose for investigation and for record keeping: the anonymously broad and impersonally preventive survey replaced the individually focused scrutiny

of surveillance. Lewis Hine and documentary photographers who followed him no longer needed to help reformers flaunt their access to and control of information. The survey method proposed not that they represent scientific methodology for mass audiences, but that reformers persuade them that such methodology itself represented truthfully and totally the interests and the realities of actual people.

Hine's achievement, and the Pittsburgh Survey as a whole, occurred at a moment of great hope, when it must have seemed that nearly thirty years of self-consciously organized urban reform work had at last begun to achieve coherence, consolidation, and a body of knowledge sufficient to ensure power. In fact, the question mark in Kellogg's chart is quite misleading, for the ambitions of the survey were never so uncertain as the chart suggests. The survey's precise and well-defined goals were set out by Kellogg, its director, who was also managing editor of the COS's *Charities and the Commons*, and by Edward Devine, general secretary of the COS and editor of that magazine, in which the survey findings were first published in 1908 and 1909. The survey was intended to connect the reformist purpose with all the newest methods of scientific inquiry, enlisting and coordinating a variety of methodologies and academic disciplines in the quest for the totality of the social fact. Its objective representation of industrial workers would, the surveyors hoped, substantially contribute to organizing and stabilizing the reform coalition's influence on corporate and government policy making.[3] Thus, as Edward Devine wrote with confidence of "Pittsburgh the Year of the Survey": "Since [Pittsburgh's hardships and misery] are due to haste in acquiring wealth, inequity in distribution, to the inadequacy of the mechanisms of municipal government, they can be overcome rapidly if a community so desires."[4]

"Why are we doing a Pittsburgh Survey?" Paul Kellogg asked in the March 1908 announcement of the survey, and he proceeded to give the first – and still the most lucid – explanation of the survey metaphor for social investigation:

The intersection point is the key to the work of a surveyor. In so far as typhoid fever is a prime measure of civic neglect, Pittsburgh is first; in so far as work accidents are the crudest exponents of industrial irresponsibility, Pittsburgh is first. Either one of these facts would give Pittsburgh a claim for consideration for the purposes of such a survey. Together they mark it off.

Calling "the term 'survey'...a new one in social investigation," Kellogg claimed that it stood "for a new method and for more than a new method." "Experimental" and "making repeated draughts on fresh sources of co-

operation," the work "[held] to a flexibility of front that has admitted of a full and effective following up of clues such as the investigation has itself uncovered and only could uncover," Kellogg wrote. Its perspectives allowed for "blocking out new ways of aligning the social facts which must be gauged and grappled with if what is ugly, wrong, and unhealthy and unjust in social conditions are to make way for the fuller life," he claimed.[5]

Not only was the survey perspective new, but so was the situation it studied. "We felt that Pittsburgh bore somewhat the same relation industrially to the nation at large that Washington did politically," Kellogg wrote.[6] Kellogg saw the Pittsburgh industrial community as exemplary of, and instructive to, the nation, and he claimed that the preeminent qualities that made it so were economic and industrial. It was because of its *corporate economic* organization that Pittsburgh needed to be investigated, but it was because of the consequent complexity and interdependence of its socioeconomic factors that Pittsburgh needed specialized, *expert* investigators and interpreters. The professional social investigator's role in the community and the nation, Kellogg wrote, was now comparable to the engineer's role in the steel corporation:

The [survey] undertaking is distinctive in that it is concerned with the structural relations of social problems. The engineer has to do with levers, eccentrics and axles, with chemical re-agents, and dynamos; but when it comes to making steel, it is with the organic whole of which these are but so many parts, and with the inter-play of those parts, that he has his real business. So with the factors which condition a working population. National and special investigations are going forward throughout the country as to child labor, women in industry, immigration, the prevention of tuberculosis and the like. Here the plan of work has the advantage of bringing various social problems to the touchstone of one community; of seeing them as a whole in their relations.[7]

Cold and impersonal as it may sound today, Kellogg's technocratic metaphor is nevertheless tentative and inchoate, as we shall see, in comparison to the post-World War I formulations of Thorstein Veblen, or of technocrats such as Howard Scott, or of Rexford Tugwell. Laying metaphorical claim to a social exactitude comparable to the measurements of the economist, surveyor, or engineer, Kellogg flaunted the authority of economics, the "hardest" social science, and of engineering in much the same way earlier reformers had used moralism and bureaucracy. In fact, Kellogg's hopeful view of social engineering may be said to reveal more about the pre-war reformers themselves than about the social problems they confronted. As Alan Trachtenberg has proposed, "The hopeful prognosis flew in the face of the evidence. The reformers uncovered and disclosed more

evidence than their assumptions, their view of their world, could accommodate."[8]

Nevertheless, Kellogg's comparison of the social investigator to the engineer radically expanded the function and status of the investigator to include the role of *explainer*. In the same way, Kellogg's work supported the practice of social documentary photography as publicity for corporate social engineering, and it encouraged the widespread, even conventional, identification of documentary style with institutionalized social welfare administration. Social revelation and reform in the twentieth century, Kellogg claimed, needed more than personal contact or "picturesque and graphic form." A community or nation needed an adequate "graphic representation" as a prerequisite for understanding and helping itself. Looking back on the survey in 1929, he defined such interpretive representation, describing the survey as "an adventure on the high seas" between the census and yellow journalism. "The effort was," he explained, "to make the town real to itself; not in goody-goody preachment of what it ought to be; not in sensational discolouration; not merely in a formidable array of rigid facts." That effort was the reason why, he wrote, "industrial biographies of roll hands and furnace tenders were collected by John A. Fitch," and "why the group picture of child life in a glass town" was included "alongside the analyses of labour legislation and compulsory education laws." And that was why, he continued, "in this city of engineers, maps, charts and diagrams were used as modern hieroglyphs to reinforce the text, why the camera was resorted to as a luminous and uncontrovertible transcript of life, why Lewis Hine's 'work-portraits' told their story of human wear and tear"And, he concluded, that was why "the 'piled up actualities' of the reports were visualized in a civic exhibit . . . where maps, charts, diagrams, pictures and placards were flanked by such challenging portrayals as a huge death calendar."[9]

Without such optimism and certainty of purpose behind it, Hine's work would be practically unimaginable. As art historian Elizabeth McCausland observed in the 1930s, "Hine had an extraordinary amount of success in his pioneering." Although, she explained, "the magazines and organizations which wanted his photographs for social propaganda could not pay large sums for his work, nevertheless they supplied channels of publication and support which many another man has not had."[10]

The Pittsburgh work culminated a transitional period in Hine's life and determined his career as a professional photographer. "Brought on" to New York from Chicago by his teacher and mentor Frank Manny of the Ethical Culture School (ECS), Hine taught nature study and geography

and was put in charge of photographic activities at the school. In 1904, encouraged and accompanied by Manny, Hine began to photograph immigrants at Ellis Island.[11] Some of these studies were published in *Charities and the Commons* in 1908, and Hine evidently continued the work through 1909.[12] Though Ellis Island was not a new subject for journalism and pictorial representation, Hine's approach and motivation may have been new. Hine mentions "news value" and "humanitarian interest" as factors contributing to his interest in the subject, but he must also have been influenced by Manny's determination that ECS students, many children of immigrants themselves, learn to view the new immigrants with the same respect and understanding accorded to the seventeenth-century Puritans.[13] Though Hine claimed an interest in "the most picturesque" aspects of the subject that "many of our friends were talking about,"[14] his photographs did not exploit the oddities (for Americans) of old world dress and demeanor. Rather, Hine photographed immigrants "in the act of experiencing Ellis Island," as Alan Trachtenberg has noted. Hine's photographs regularly included details that signified this most unexotic of settings, and he posed his subjects to allow for an expression of individual qualities that lifts the portraits to a realm beyond the mere depiction of immigrant "types" (see Figure 2.2). Employing a new style for the familiar immigrant topic, Hine made it virtually a new subject; undoubtedly, appreciation of Hine's Ellis Island work influenced Paul Kellogg's offer to him to photograph in Pittsburgh, where eighty percent of the labor force were immigrants.[15]

McCausland, who became Hine's friend and a conscientious publicist of his lifework during the thirties, claimed that Arthur Kellogg (Paul Kellogg's brother and also an editor at *Charities and the Commons*) suggested to Hine the step from teacher to professional photographer.[16] McCausland also recounted Arthur Kellogg's retort to critics who felt that Hine hadn't "the broad sociological background required": "Nonsense, . . . it's wonderful to find a photographer who has *any* sociological background."[17] Hine had in fact studied sociology at Columbia, and in 1905 he received a "master pedagogy degree."[18] As early as 1906, two years before he left the Ethical Culture School, Hine had asked Paul Kellogg to hire him as a photographer and writer for *Charities and the Commons*. In 1907 his freelance work was published in two National Child Labor Committee (NCLC) leaflets, and in the same year he contributed two articles to *Charities and the Commons*. By 1908 he had published at least seven articles on photography, teaching, and social work.[19] These and later accomplishments, however, never turned the head of this photographer from the Middle West, if we are to accept McCausland's stylishly populist description of Hine in the thirties:

Figure 2.2. Lewis Hine, *Young Russian Jewess at Ellis Island*, 1905. International Museum of Photography at George Eastman House.

Certainly, if ever a man spoke the American vernacular it is Lew Hine. He looks like a wheat farmer. Despite his Pd. M. from New York University in 1905, he talks like one. Try to get him to pose for a photograph. "Oh, gosh," he says, "what shall I do with my hurrah?"[20]

Undertaking the Pittsburgh work as a free-lance assignment for *Charities and the Commons* in the fall of 1907, Hine spent only three months there. In 1908 he was named staff photographer for the magazine and placed an advertisement for "social photography" on its back cover (Figure 2.3).[21] Hard upon publication of its three Pittsburgh Survey numbers, January – March 1909, *Charities and the Commons* changed its name to *Survey*, sig-

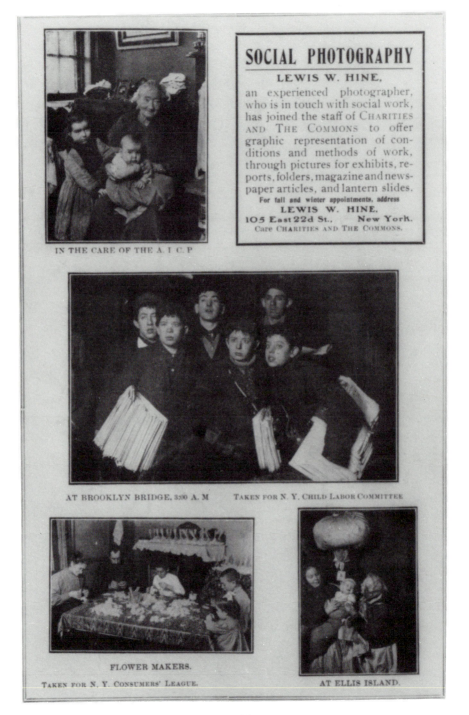

IN THE CARE OF THE A. I C. P

SOCIAL PHOTOGRAPHY

LEWIS W. HINE,

an experienced photographer, who is in touch with social work, has joined the staff of CHARITIES AND THE COMMONS to offer graphic representation of conditions and methods of work, through pictures for exhibits, reports, folders, magazine and newspaper articles, and lantern slides.

For fall and winter appointments, address
LEWIS W. HINE,
105 East 22d St., New York.
Care CHARITIES AND THE COMMONS.

AT BROOKLYN BRIDGE, 3:00 A. M. TAKEN FOR N. Y. CHILD LABOR COMMITTEE

FLOWER MAKERS.

TAKEN FOR N. Y. CONSUMERS' LEAGUE. AT ELLIS ISLAND.

nifying the success of the new methodology and approach. Unexpectedly for one who "created his own subject matter," yet utterly in keeping with the terms of his success on the survey job, Hine was to become America's exemplary documentarian, the figure whose career did most to associate documentary photography with vast and expert-studded sociological surveys.[22] Hine's mastery of a flexible yet identifiable documentary style helped to reify it: the style itself – rather than "scientific"-looking graphic representations, or the actual subject matter of the photographs – was to become the symbol not only of a concern to discover and disclose social reality, but also of liberal reformers' authority and ability to explain and ameliorate that reality.

Ambitious and self-consciously innovative, the survey offered Hine unique opportunities. Realizing the importance of Pittsburgh's industrial preeminence, Kellogg made the survey's central concern an American and twentieth-century working class with small regular earnings, in a community gathered and dominated by a master industry. Thus, for the first time in our social science literature, the industrial worker emerged as a distinct American figure presented without quibble or evasion, whose presence was to be acknowledged fully and reckoned with. The survey made "the ranks of wage-earners in the American steel district" its subject, and it studied the conditions of their lives because, and insofar as, they were affected by technocratically administered, internationally involved corporations.[23] The survey's clear and well-crafted prose avoided rhetorical abstractions and invidious discriminations such as pauperism, charity, and even poverty, replacing them with graphically detailed descriptions that always pointed to low wages, nonunion conditions, and corporate irresponsibility as the causes of suffering. Like New York in the 1890s, Pittsburgh was experiencing an enormous influx of immigrants. The survey presented four reports on immigrant ethnic groups and blacks and devoted many sections of reports on general topics to their relevance to immigrants.

The basis of the survey's innovation was its faith in the need for, and the persuasive power of, an industrial sociology. It claimed to inventory and analyze all the major social, political, and economic factors and their interdependence in an industrial community that was, in Kellogg's words, "the social expression of one of the few master industries of the country,"[24] and as such a portent of an increasingly industrialized future for other

Figure 2.3. Lewis Hine, *Advertisement for Social Photography*. Reproduced from *Charities and the Commons*, 20 (June 6, 1908), back cover.

American communities. Edward Devine summarized the social workers' view of Pittsburgh for the joint meeting of the American Sociological Society and the American Economic Association in 1908, charging: "Certainly no community before in America or Europe has ever had such a surplus and never before has a great community applied what it had so meagerly to the rational purpose of human life."[25] Devine's plain-dealing summary named eight major factors that determined the quality of life for Pittsburgh's workers in the year of the survey: overwork, low wages for men and even lower wages for women, an "absentee capitalism, with bad effects strikingly analogous to those of absentee landlordism," an influx of immigrants, the destruction of family life, and "archaic social institutions," among which he included aspects of city government and "the unregenerate charitable institution," both "still surviving after the conditions to which they were adapted have disappeared."[26] These factors, developed in the survey research, were the sociology shown in Hine's photographs.

Of the six survey volumes, John Fitch's *The Steel Workers* and Margaret Byington's *Homestead: The Households of a Mill Town* were central to the survey's subject and dealt with every major aspect of the iron and steel industries. In 1907, about 80,000 men, almost one-fifth of Pittsburgh's total population, worked in the iron and steel mills. Allegheny County produced nearly one-sixth of the world's iron and steel; the two biggest fortunes in history to that date – Andrew Carnegie's and J. P. Morgan's – had been made in Pittsburgh.[27] When the Homestead Strike failed in 1892, the Carnegie Steel Company successfully routed unionism from its mills, and especially after the steel companies – controlled by Carnegie – combined in 1901 to form the massive United States Steel Corporation, only a remnant of the once-dominant craft union, the Amalgamated Association of Iron and Steel Workers, remained in the iron mills.[28] The steel industry, never highly unionized, became totally nonunion. "Unionism is not entirely dead in the mill towns," John Fitch wrote, "at least the spirit of it is to be found among the men, though the form is absent." But management had systematically and successfully repressed any new efforts to organize. "A good many men in the mills are socialists at heart," Fitch continued, writing of the skilled men,

and though they still vote the republican [sic] ticket, they would vote with the socialists if that party were to manifest strength enough to give it a chance of carrying an election. A considerable number of others have gone the whole way and are active working socialists.[29]

Fitch found that in a typical steel mill nearly four-fifths of the men worked a twelve-hour day, six, seven, or eight shifts a week, and no overtime was paid. Hours had increased from ten to twelve and wages had fallen steadily since 1892.[30] The varying length of the work week was the result of the "long turn," the twenty-four hour shift which was part of the system by which day and night crews changed places in the continuous operation processes.

Overwork and falling wages were symptoms of a more fundamental change in the industry, one that was also expedited by the Homestead defeat. Fitch wrote:

Left free to manage their affairs as they saw fit, as outcome [sic] of the strikes of the nineties, the steel manufacturers carried to new lengths their internal policy of reducing cost by increasing output and lessening dependence upon human labor. Time was utilized as it never had been before in this industry, and every known mechanical device was introduced that would increase speed, cut down waste, or overcome halts in production. In the last eighteen years, machinery has transformed the industry, eliminating much hand labor and discounting human skill. ...No change has been overlooked that would put a machine at work in place of a man; thousands of men have been displaced in this way since 1892, and yet the industry has so grown that more men, in the aggregate, are employed than ever before.[31]

As the composition of the work force changed, and the percentage of unskilled workers climbed toward eighty percent, unskilled work came to be the exclusive province of recent immigrants from Eastern Europe – Slavs and "Huns," or "hunkies," as the native "whites" (so self-styled) called them. The many reasons for this immigration need not be examined, except to note that Fitch found it an "apparent fact that the steel companies have definitely sought this class of labor."[32] In the decade 1900–1910, the foreign-born population of Pittsburgh increased from 11,589 to 55,558, roughly one-fourth of the population. (Although the foreign-born population did expand greatly, some of that increase was also due to changes in measurement as a result of the annexation of neighboring towns to form Greater Pittsburgh in 1907.)[33]

The day wage of the unskilled man, $1.65, might have supported a single man in good health but, as Margaret Byington's household budget studies in Homestead showed, it was insufficient to support a family at the cost of living current in the Pittsburgh District in 1907. In Homestead, 50.5 percent of the Slavs employed in the mill were single, or at least apart from wives and children, living in boarding houses or as lodgers and ap-

parently able to save money themselves or to send it to their families in Europe, in many cases no doubt regarding their time in the steel mills as a temporary stay in America before returning home as richer men. The families of the other 49.5 percent of the Slavic day laborers, who earned the same wage, occasionally went out for housework or other casual employment (of which there was almost none for women in Homestead), but most commonly made ends meet by taking in the single men as lodgers, which created extreme overcrowding in the Pittsburgh tenements and Homestead "courts" – where Byington found that, of 239 immigrant families, "fifty-one families, including sometimes four or five people, lived in one-room tenements. One-half of the families used their kitchens as sleeping rooms. Only three houses had running water inside, and in at least three instances over 110 people were dependent on one yard hydrant for water."[34]

In her treatment of life in Homestead, Byington devoted three chapters to a separate analysis of the Slavs. The new immigrants were socially isolated from their native-born and older immigrant neighbors. Not only were their work and their language different, and their wages as a rule lower, but they also lived apart and socialized differently. Without benefit of unions to bring workers together, they established separate benefit societies, savings banks, churches, and parochial schools. On the subject of unionism, Byington's report echoed Fitch: "Common report has it that anyone who proposes trade unionism in the mill is promptly discharged, and experience has gone to prove this. One phrase current in the town is: 'If you want to talk in Homestead, you must talk to yourself.' "[35]

In *Women and the Trades*, Elizabeth Butler showed that of the 22,185 women workers she found in Pittsburgh in 1907–1908 (excluding agricultural and professional workers and domestic servants), over three-fifths earned less than $7.00 a week, one-fifth earned $7.00 to $8.00, and the rest earned $8.00 or more; and the number of women employed was growing, even in traditionally male-dominated industries. In general she found that "where skill and occupation are comparable, alike in skilled trade and unskilled occupation, the man's wage is double the woman's."[36] Her study of wages, health conditions, and working hours in trades employing women (cigar making, food processing, the garment industry, laundries, metal and printing trades and – the largest employer – mercantile trades) showed that despite their increasing numbers, women's "economic foothold" – the extent to which they could command an adequate wage – was far from secure.[37] (See Figure 2.4.)

Crystal Eastman's *Work-Accidents and the Law* investigated the cases of

Figure 2.4. Lewis Hine, *Bottling Olives with a Grooved Stick*, 1907/08. Reprinted from *Women and the Trades: Pittsburgh, 1907–1908*, by Elizabeth Beardsley Butler, by permission of the University of Pittsburgh Press. Copyright 1984 by the University of Pittsburgh Press.

the 526 men who were killed in industrial accidents during the year July 1, 1906, through June 30, 1907, and the cases of 509 men treated in hospitals for on-the-job injuries (see Figure 2.5).[38] She studied the factors involved in such accidents, which ranged from personal carelessness to gross company negligence; considered the problems of disabled workmen, methods

59

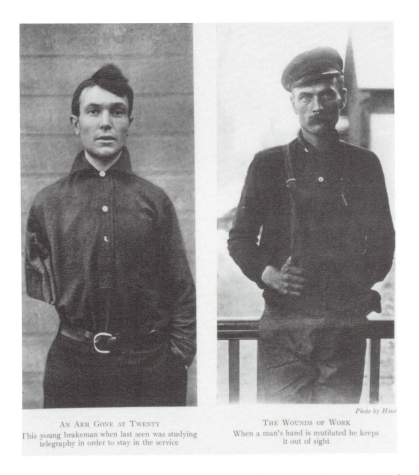

Photo by Hine

AN ARM GONE AT TWENTY
This young brakeman when last seen was studying telegraphy in order to stay in the service

THE WOUNDS OF WORK
When a man's hand is mutilated he keeps it out of sight

Figure 2.5. Lewis Hine, *Work Accidents*, 1907/08. Reproduced from Crystal Eastman, *Work-Accidents and the Law* (New York: Russell Sage Foundation, 1910), facing p. 144.

of accident prevention, and the policies and safety provisions of various companies; and discussed at length the inadequacy of the application of the common law of master and servant to such workmen's disability cases. She found:

(1) that the workmen injured were in only a small proportion of the cases personally responsible for the accidents which caused their injury, and (2) that their wages were not adjusted to cover their risk. We can assert, therefore, without qualification, that the distribution of the economic loss from industrial accidents revealed by this study, – which leaves the injured man and his dependents to bear

the entire burden in over half the cases and relieves them only in rare instances of an appreciable share of it, – is on the face of it unjust.[39]

During the years that the survey volumes were being published, a number of municipal reforms were initiated in Pittsburgh as the result of local elections and state legislative measures. The first of these was the election in 1906 of a Democratic reform mayor, George Guthrie, who "made thorough application of the principles of civil service reform and stood out for business methods in awarding all contracts, including the banking of the city's funds."[40] Mayor Guthrie could not succeed himself, and his administration yielded in 1909 to that of Republican William McGee, nephew of Chris McGee, the boss described by Lincoln Steffens in 1904 in *The Shame of the Cities*. But the fact that a Democratic election had occurred at all in "this steel ribbed Republican stronghold"[41] was taken by the Pittsburgh surveyors as an indicator of new trends in city politics and of a growth in "civic forces" of which they heartily approved. The articles collected in the two final volumes of the Pittsburgh Survey – *The Civic Frontage* and *Wage-Earning Pittsburgh* – are chiefly devoted to chronicling these changes and to proposing more of the regulatory legislation, rationalization of municipal government and social services, and provision of cultural opportunities deemed necessary to promote the "unified organic development" of Greater Pittsburgh, the new administrative unit of a half-million people formed by the annexation in 1907 of neighboring Allegheny. In 1908 Mayor Guthrie, as one of his last official acts, appointed a "representative Civic Commission" chaired by W. D. English, the head of the Chamber of Commerce – which itself, following the trend toward consolidation, had combined the previous year with its rival, the Merchants and Manufacturers Association. The Civic Commission formed "committees on public hygiene, housing problems, rapid transit, municipal efficiency, industrial casualties and overstrain, education, police courts, charitable institutions, neighborhood and district improvement agencies, and city planning."[42]

The Civic Commission evidently had some effect, for in 1911 the Pennsylvania legislature, under pressure from lobbying civic groups, passed several bills intended to reform Pittsburgh's municipal government. The legislature ended the ward system of school control, which had divided the city into sixty-one ward school districts, each responsible for financing and administering its own schools, and "substitute[d] a single district embracing the whole city, organized on modern business and educational lines" with a central school board elected at large.[43] Although the legislature was not able to abolish the notorious "aldermanic courts," where

aldermen settled both civil and criminal cases for a fee, it also passed a new city charter, which in Robert Woods's words displaced "the unwieldy and graft-smirched councils [of ward aldermen] by a compact legislature of nine councilmen at large." The 1911 legislature also passed tax legislation that consolidated school and city taxes.[44]

The twenty-two articles in these two final volumes were intended to propagandize the desirability of progressive reform measures. Full of new rhetoric – "organic development," "municipal efficiency," "city planning," "industrial relations" – they were written by men and women who were rising to national prominence in what truly appeared to be a nationwide reform coalition. Here we find Paul Kellogg, Edward Devine, and Robert Woods (a native Pittsburgher and head of South End House in Boston since 1896) interpreting Pittsburgh's growth and current administrative situation; Florence Kelley, general secretary of the National Consumers' League, calling for adequate factory inspection; and John R. Commons, professor of political economy at the University of Wisconsin, analyzing the labor force. Allen T. Burns, secretary of the Pittsburgh Civic Commission, wrote on the accomplishments of the "coalition of civic forces"; and Shelby M. Harrison, soon to be director of the Russell Sage Foundation's Department of Surveys and Exhibits, explained the necessity of ending disproportionate taxation.

Although addressed to various subjects and not at first appearing to form a whole, these articles in fact provide the ideological skeleton that holds together in their particular relations the separate parts of the survey, including the photographs, and gives them their ultimate meaning and value in its scheme. The measures proposed and praised in these volumes answer the question posed in Kellogg's chart (Figure 2.1). They are the "results" of the survey: they link the reformist impulse to social scientific investigation; they coordinate disciplines and methods for a greater achievement; and most important, they present an authoritative body of apparently objective fact addressed directly to the makers of corporate and government policy.

The articles in the final survey volumes also justified the larger scope and new direction of reform ambition. Robert Woods, for example, noted the passing of "the old type of dominating, watchful, industrial and financial leader," without whom "the large industrial interests have now been in the main turned into bureaucracies whose plans in detail are decided in New York, and whose local officials must guide their public actions so as to serve the corporations' interests."[45] However, the "coalition of civic forces," consisting of national reformers joined with local reformers such

as Mayor Guthrie, might take the place of and speak with authority equal to that of Carnegie, F. F. Jones, and others of the old guard. To this ambitious end the national reform movement sought to contribute its analytical and factual power, as local reform administration fostered the "urban coherence" and "strong sense of corporate individuality [that] comes to any community challenged by great tasks."[46]

This emerging national and corporate ambition suggests a new purpose in the reform movement's keen appreciation and ready deployment of graphic representation and reproducible images. Even as Hine went about recording the complex circumstances of working-class life in Pittsburgh, his photographs were increasingly regarded and used as *publicity* – as manifest emotional and intellectual symbols of a powerful, nationally coherent reform coalition, rather than as the graphic records of people in a particular time and place.

Indeed, from one point of view, the Pittsburgh Survey as a whole was simply a chance by-product – encouraged by the timely founding of the Russell Sage Foundation – of a transitional period during which the COS sought to extend awareness of its activities among the reform-minded, professionalizing middle class. By 1905 the COS's *Charities* had merged with *The Commons*, "the national organ of the settlement movement," and it had absorbed *Jewish Charity*, the official newspaper of the United Hebrew Charities of New York.[47] The merged publications program was placed under the authority of the Charities Publication Committee (CPC), a directing group of well-known philanthropists from many cities who mapped out an extensive set of plans. They intended not only to publicize but actually to undertake "important pieces of social investigation not provided for by any existing organization," and they meant to encourage the development of a national reform network by "the extension of organized philanthropy to smaller cities and the rekindling of existing agencies to more progressive ways," and by cooperation with "national bodies" in order "to give general application to reforms wrought painfully in one locality." Their publications would feature "popular issues, live news, and readable articles, that will make practical philanthropy a part of the everyday interest of the general reader."[48] "The impulse that actually set the Pittsburgh Survey underway," wrote Kellogg, "came through Frank Tucker, a member of the committee, who, as a former journalist, visualized the possibilities of Pittsburgh in public opinion."[49]

The Pittsburgh investigation began in the fall of 1907 with $1,000 from the CPC and several small contributions from Pittsburghers. The major contribution, without which the survey would never have become the in-

fluential standard that it is, came from the newly founded Russell Sage Foundation. Mrs. Russell Sage had inherited about $65,000,000 from her husband, a New York financier and associate of Jay Gould who died in 1906. In March 1907 she established the Russell Sage Foundation with a gift of $10,000,000. The purpose of the foundation, according to articles of incorporation written by Robert DeForest (Mrs. Sage's lawyer, as well as president of the New York COS), was to "apply the income [of the fund] to the improvement of social and living conditions in the United States of America." The specific applications were left very much to the discretion of the trustees.[50]

The establishment of the Russell Sage Foundation concentrated power and money in the hands of a small group. At their third meeting in May 1907 the trustees voted to give $20,000 to the CPC for *Charities and the Commons* to increase its "circulation and educational influence and in return for its acting as press bureau and performing ... other services in the line of publication" for the foundation. At the same meeting the trustees voted an additional $7,000 to the CPC for the Pittsburgh Survey, with a proviso that the foundation might publish the findings if the trustees so desired.[51]

It took only "a few weeks in the field," according to John Glenn's history of the Russell Sage Foundation, before the trustees saw that the Pittsburgh Survey needed more money. They added two more grants in the fall and winter, to bring the total Pittsburgh Survey appropriation to $27,000, which paid salaries of investigators for a full year of field work.[52]

By March 1908, Kellogg was able to publish an announcement of the survey and two "preliminary articles" – on housing and accident liability – in *Charities and the Commons*. It was his purpose, as he wrote later, "to make the Survey not merely a criticism or an inventory, but a means for establishing relations which would project its work into the future."[53] Thus, in his 1914 report on field work, Kellogg claimed that "the Survey as a whole paved the way for the Pittsburgh Civic Commission," and he praised the Chamber of Commerce housing campaign of 1908, which had used some survey data.[54]

Such confidence in the powers of publicity and photography extended to reformers and activists of many persuasions. Hine's Pittsburgh photographs were used by the *International Socialist Review*,[55] and the survey itself attracted the attention of William D. Haywood of the Industrial Workers of the World. Asked to comment on the establishment of the Industrial Relations Commission (formed in 1913 in response to the bombing of the Los Angeles *Times* in 1911), Haywood called the commission itself "a tragic joke, perpetrated by legislative jugglers," but went on to say:

If, however, the work of the commission could be confined to publicity along the lines of the Pittsburgh Survey, there is unlimited material for such effort. The silk industry and conditions of the silk workers suggest a starting point.[56]

The passionate enthusiasm for the graphic and the real, the "modern hieroglyph" and the "luminous and uncontrovertible transcript of life," as Paul Kellogg called Hine's Pittsburgh photographs, fostered Hine and fueled his vision of photography as a "human document" that could provide "intelligent interpretation of the world's workers."[57] But it is not surprising that this same idea of publicity, of "graphic interpretation" used to promote grandly scaled social engineering, ultimately diminished the social and political presence of the very working people who were its subjects, encouraging their treatment as unimportant details in schemes administered by established business, commercial, and political interests. Historian Robert Wiebe has described the progressives' truncated view: on the one hand, the people were assumed to exist and to give the nation its "mystic coherence," but on the other hand, "day by day administrators would deal with them in rational subdivisions." In Pittsburgh, far from organizing local forces to make a stand against "absentee capitalism," reformers' interventions actually held open the way for corporations to do as they pleased with that city and with other communities. Historian Samuel Hayes has suggested that by taking the model of the efficient business enterprise as their "positive inspiration," reformers helped to bring about "a gradual shift upward in the location of decision-making and the geographical extension of the scope of the area affected by the decisions." "While [reformers] expressed an ideology of restoring a previous order, they in fact helped to bring forth a system drastically new."[58]

Such an analysis suggests the crux of a contradiction in progressive ideology and style, a problem accentuated by the very power of the survey's investigative and interpretive technology. Embedded in survey ideology was a pro-corporate orientation that ensured that the project would only display, and never help to resolve, the tensions it discovered between working people and the business system, between local civic strength and national policy, between political democracy and technocratic social engineering, between particular realities and abstract symbols. For it was ultimately, of course, just this orientation that enabled and supported the project's investigative precision.

Within this pattern of contradiction, writ large in the survey as a whole, Hine's photographs offer a series of specific and various, brilliant and many-faceted explications of reform. Astute and self-conscious as he was,

Hine never forgot that reform ideology gave his photographs their audience and their authority. Yet, for modern eyes, the essential meaning and importance of his achievement may be in the clarification of reform ideology and process it offers because it partly denies and opposes them even in the act of confirming and publicizing them.

At a 1929 exhibition of "illustration in social work publicity," Hine was the guest of honor. His twelve-year career with the NCLC was summed up by director Owen Lovejoy's description of him as "the first person to focus the camera intelligently, sympathetically and effectively on social work problems," which before Hine's work were "intellectually but not emotionally recognized."[59] Lovejoy later wrote to Hine, "In my judgment the work you did under my direction for the National Child Labor Committee was more responsible than any or all other efforts to bring the facts and conditions of child employment to public attention."[60]

As the terms of Lovejoy's praise suggest, the "philanthropic trust"[61] appreciated the polysemy of photography, the very variety of appeal that Veiller had sought to circumscribe. Hine himself, deeply aware of photographs as representations, proposed that a photograph "is often more effective than the reality would have been," because "in the picture, the nonessential and conflicting interests have been eliminated."[62] Nevertheless, as Hine was also aware, the "added realism" that enhances the medium derives from the photograph's status as *index* – that is, as a symbol fulfilling its representative function "by virtue of a character which it could not have if its object did not exist," to quote a standard semiotic definition.[63] Art historian Rosalind Krauss, elaborating on the definition, described the photograph as an index or *trace*, "a signifying mark that bears a connection to the thing it represents by having been caused, physically, by its referent." Photography, Krauss writes,

is an imprint or transfer off the real; it is a photochemically processed trace causally connected to that thing in the world to which it refers in a manner parallel to that of fingerprints or footprints or the rings of water that cold glasses leave on tables. The photograph is thus generically distinct from painting or sculpture or drawing. On the family tree of images it is closer to palm prints, death masks, the Shroud of Turin, or the tracks of gulls on beaches...technically and semiologically speaking, drawings and paintings are icons, while photographs are indexes.

In this, Krauss continues, consists photography's "special status with regard to the real."[64]

Because photography's mechanical and chemical means of producing

an image are different from those of drawing or painting, the claim to, or proof of, having photographed something is equally – and uniquely – a claim to have been in its presence; for without the proximity of photographer and subject no image could have been made. Thus, as Hine suggests, implied in the photographic claim is a further claim that *that exact subject has actually existed*. However, as Hine also acknowledged in an address to the National Conference of Charities and Corrections, in 1909, the advances in printing technology and newspaper and magazine distribution that were disseminating photography to ever-wider audiences had already made photography an element of mass communications. In these circumstances, not only did the necessity to establish the photographer's integrity as authentic social witness and spokesperson become more important to the reform movement – intent on using photography to "educate and direct public opinion," as Hine wrote – but also such special integrity became much more difficult to convey to photography's new, larger audience.[65] As Hine foresaw, the ingenious conception itself of the *documentary* use of photography posed for reformers a never-ending series of decisions to be made about the appropriate means to authenticate the documentary photograph and to authorize its meaning with written text, captions, and identification of the agency presenting the image.

Hine's photographs appear primarily in the early volumes of the survey. Margaret Byington's *Homestead* has thirty-eight of them, by far the largest number; each of the other volumes contains roughly a dozen Hine photographs, except for *The Pittsburgh District: Civic Frontage*, which has none at all. Hine spent only three months in Pittsburgh, perhaps because the work he had begun almost simultaneously for the NCLC called him away before he could accomplish more. In all, Hine took about eighty of the photographs; about twenty drawings were made by Joseph Stella, who spent half his time on the project as an Italian interpreter and half sketching the city and its workers.[66] The rest of the photographs came from the steel, railroad, or food processing companies under discussion, or from picture agencies or amateur photographers, including social workers with photography experience. In article form and in final volume form, the Pittsburgh Survey made extensive use of illustrations; the six volumes include 525 photographs and drawings and numerous charts and tables.

As McCausland observed, "Hine worked closely with his editors and writers. He understood that photographs should be buttressed by material which cannot be presented visually."[67] Evidence for Hine's participation in selection, captioning, and layout of his pictures emerges in recent research. Hine collaborated with Paul Kellogg on "selecting, sizing, cropping

and arranging photographs for reproduction" in the Pittsburgh Survey, according to photographic historian Daile Kaplan, and by 1909 Hine had "assumed control of the . . . design and layout of his photographs and captions" in *Survey* and was also preparing slides, pamphlets, posters, and exhibits for the NCLC.[68]

The textual content of NCLC articles that included his own photographs did in fact depend largely on Hine. Of the various positions he held with the committee, including "Staff Photographer" and "Director of Exhibitions" (which he assumed in 1914), "Special Agent" seems the most suggestive of the real and usually single-handed social detective work required of him. McCausland wrote:

For example, the age of a child working illegally in a cotton mill is susceptible to pictorial presentation only by inference, if the child is photographed beside some object of familiar reference, as a window sill, or beside a full-grown man whose maturity is signified by costume, mustache, etc. Hine talked to children in the mills and made surreptitious notes, writing with his hand concealed in his coat pocket. Later he managed to photograph the entries of their birth in family Bibles, on the pretext of gathering data for child life insurance. . . . Wages, hours of work, etc., also can only be visualized by indirection. Data on these points was obtained by superior detective work on the photographer's part.[69]

The articles published under Hine's name in the *Child Labor Bulletin* during the period 1913–15 are not numerous, but they are telling and well written. They are presented without photographs (they may have originated as the texts of lantern slide shows), but the information and brief histories of child workers they present were repeated in other forms, with photographs, in exhibitions, in other issues of the *Child Labor Bulletin*, or as articles or "Time Exposures" in *Survey*. For example, Hine's article, "The High Cost of Child Labor," which introduces the concept of a "human junk pile" as the ultimate product of child labor, is reshaped and enlarged in the handbook for the NCLC exhibition at the Panama Exposition in San Francisco in 1915. The title of the handbook repeats the article's title, and the concepts of "high cost" and "human junk" are visually elaborated in two montage posters (Figures 2.6, 2.7).

The link between Hine's articles and his original field notations can also be discerned clearly. For example, the notation written on the back of a print of the photograph reproduced here as Figure 2.8 (now in the Hine collection of the International Museum of Photography) reads:

View of Gulf Coast cannery at 7:00 AM. Many tiny workers here, some of whom began to arrive at the factory as early as 5 o'clock, an hour before daylight on a

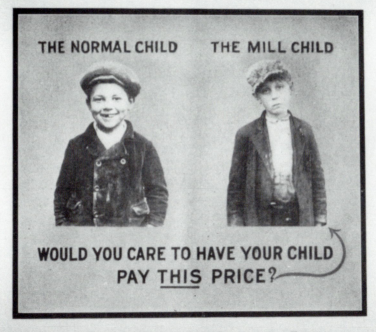

Figure 2.6. Lewis Hine, montage poster: *The High Cost of Child Labor*. Reproduced from *Child Labor Bulletin*, 3 (1914–1915), p. 25.

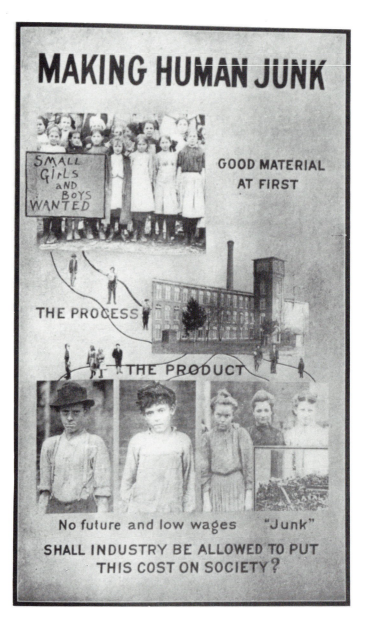

Figure 2.7. Lewis Hine, montage poster: *Making Human Junk*. Reproduced from *Child Labor Bulletin*, 3 (1914–1915), p. 35.

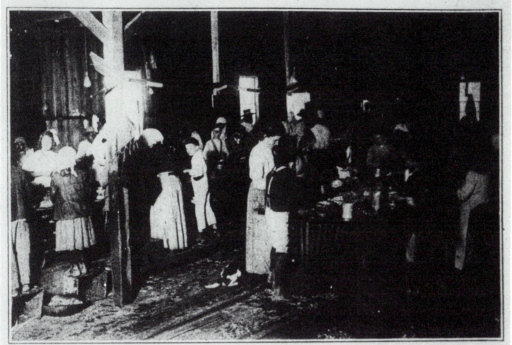

TIME EXPOSURES *by* HINE

Three bits of testimony for the consumers of shrimp and oysters

I. The Photographer

Extract from a report on the canneries at Pass Christian, Miss., by Lewis W. Hine of the National Child Labor Committee, February, 1911.

Come out to one of these canneries at 3 o'clock some morning. Here is the crude shed-like building, with a long dock, at which the oyster boats unload. It is cold, damp, dark. The whistle blew some time ago, and the weary workers slipped into their meager garments, snatched a bite to eat (there is no time for breakfast now) and hurried to the shucking shed. The padrone told me: "Ef day don't git up, I go and git 'em up."

See those little ones over there stumbling through the dark over the shell piles, munching a piece of bread, and rubbing their heavy eyes. Children 6, 7 and 8 years take their places with the adults, and are at work all day.

II. The New York *Sun*

Extract from a dispatch in the New York *Sun* on the day spent by President Woodrow Wilson at Pass Christian, Miss., January 2, 1914.

Of course, the moving-picture men made a quick reverse of their instruments. They caught the President coming on the pier; they caught him viewing the progress of the power boat.

While the President was on the pier he was observed with great interest by the throng of oyster shuckers busily toiling in the draughty shed of the packing company. He saw children 7 to 8 years old, working their ten-hour shift in steam and blustering wind, their little hands sore and bleeding from the action of the acrid juices and the brine. The President started to take a walk through the oyster packing plant, but a whiff of the noisome steam struck him and he retired to the motor car.

III. The Investigator

Extract from report on violations of the law in canneries at Pass Christian and vicinity, by H. H. Jones, National Child Labor Committee, January, 1914.

The law sets an age limit of 12 years for boys and 14 for girls. Boys under 16 and girls under 18 may not begin work before 6 a. m. or continue later than 7 p. m., nor work more than eight hours in one day or 48 hours in one week.

I found 50 violations of the law as to ages and 45 as to hours in the canneries at Pass Christian and vicinity. I found no affidavits of age on file. One superintendent promised faithfully that he would immediately see that the children under age were sent out of his factory. He said that his company, at its Louisiana cannery, conformed to the child labor law of that state, and that it was not detrimental to their business.

Figure 2.8. Lewis Hine, *Time Exposure by Hine*. Reproduced from *Survey*, 31 (February 28, 1914), p. 663.

damp foggy day. The whistle had blown and they stood around merely to hold their places. When the "catch" had been good, they begin work early, but today it was not good so they were waiting for daylight.[70]

Hine's NCLC article on the canneries, paraphrased in the *Survey*, presents the scene in paragraphs that begin:

Come out with me to one of these canneries at 3 o'clock some morning. Here is the crude, shed-like building, with a long dock at which the oyster boats unload their cargoes. Near the dock is the ever-present shell pile, a monument of mute testimony to the patient toil of little fingers. It is cold, dark, damp. The whistle blew some time ago, and the weary workers dressed themselves, slipped into their meagre garments, snatched a bite to eat (there is no time for breakfast now), and hurried to the shed....[71]

Another example of a field notation incorporated into a written text is from the Pittsburgh Survey. The notation on the back of a print in the Hine collection of the International Museum of Photography (reproduced here as Figure 2.9) reads: "Steel worker, Homestead, PA. Said he was a 'Genuine American', 1908." The caption for that print in Eastman's *Work-Accidents* reads: "Steel Worker – A Genuine American." As we see, Hine preserved the worker's description of himself so that it could accompany his portrait; and by making it the caption, Hine granted the self-designation preeminence over other terms that might have been used to anchor the image. Though unaware of the choice that had been made, viewers might still have responded to a tone that departed from the survey's usual neutrality.

It was in 1909, probably soon after his work in Pittsburgh was completed, that Hine spoke before the National Conference of Charities and Corrections on the use of the camera in "social uplift":

This is the era of the specialist. Curtis, Burton Holmes, Stoddard and others have done much along special lines of social photography. The greatest advance in social work is to be made by the popularizing of camera work, so these records may be made by those who are in the thick of the battle. It is not a difficult proposition. In every group of workers there is sure to be one at least who is interested in the camera. If you can decide that photography would be a good thing for you, get a camera, set aside a small appropriation and some definite time for the staff photographer, go after the matter with a sympathetic enthusiasm (for camera work without enthusiasm is like a picnic in the rain). The local photographer (unless he is a rare one) cannot do much for you. Fight it out for yourself, for better little technique and much sympathy than the reverse....

Apart from charitable or pathological phases of social work, what a field for photographic art lies untouched in the industrial world.

Photo by Hine

STEEL WORKER—A GENUINE AMERICAN

Figure 2.9. Lewis Hine, *Steel-Worker – A Genuine American*, 1907/08. Reproduced from Crystal Eastman,
Work-Accidents and the Law (New York: Russell Sage Foundation, 1910), facing p. 100.

There is urgent need for the intelligent interpretation of the world's workers, not only for the people of today, but for future ages.[72]

This description of the camera as the tool of the "specialist" who can make an "intelligent interpretation" of his subject seems to echo Kellogg's rhetoric, and in fact it describes a kind of camera work that Hine did

provide for the survey. The majority of *Homestead* photographs are of this kind; they work in a simple and straightforward way with the text, illustrating its various sections. They show types of housing, interiors that illustrate how families have used their housing space; they show shopping, eating, and "other budget expenditures" such as nickelodeons, saloons, amusement parks, and pianos in the parlor. They show cultural opportunities such as the Carnegie Library, and they show children. The photographs in the chapters on the Slavic households are equally straightforward, except that care is taken to show overcrowded housing and to emphasize the hardships of "life at $1.65 a day" (see Figures 2.10–2.13).

The photographs that work in this straightforward, clearly comprehensible way serve to confirm the analogy between camera practice and expert sociological observation: the image made by the photograph – the "light writer" – establishes more firmly the facts presented by Byington's figures on wages, work hours, rent, and food costs. The photograph–text relationship links our understanding of the anonymous, statistical analysis of the expert to a seeming individuality, putting before us the reality of overcrowded house, sordid saloon, or grubby child in their affecting specificity.

There is, however, a second kind of Pittsburgh Survey photographic practice in which the anchoring function of caption and text is made more complex by an oppositional, even dialectical relationship among the elements of the documentary mode. Although each instance is differently constituted, they all undercut the assumed realism and transparency of documentary and allow us to see it as the construction it is. Such an intention seems in keeping with Hine's attitudes and convictions. "In touch with social work," and among "regular contributors of articles" to *Survey*, Hine had claimed for himself the role of *social photographer*. Yet, even as his special status and expertise were acknowledged and honored, Hine wrote to Frank Manny, describing his NCLC work: "I have to sit down, every so often and give myself a spiritual antiseptic, – as the surgeon before and after an operation. Sometimes I still have grave doubts about it all. There is a need for this kind of detective work and it is a good cause, but it is not always easy to be sure that it is all necessary."[73]

These lines can be read as suggesting that Hine aspired to present a social fact undetermined by the requirement that it be, above all, uncontrovertible; and the Pittsburgh photographs propose a definition of documentary that allows photography and text to extend their collaboration beyond either narrative construction like Riis's or Veilleresque factitious "information." The relations set up between image and text in the Pitts-

Figure 2.10. Lewis Hine, *A Nickelodeon in Homestead*, 1907/08. Reprinted from *Homestead: The Households of a Mill Town*, by Margaret F. Byington, by permission of the University of Pittsburgh Press. Copyright 1974 by University Center for International Studies, University of Pittsburgh.

Figure 2.11. Lewis Hine, *Into America Through the Second Ward of Homestead*, 1907/08. Reprinted from *Homestead: The Households of a Mill Town*, by Margaret F. Byington, by permission of the University of Pittsburgh Press. Copyright 1974 by University Center for International Studies, University of Pittsburgh.

burgh volumes in some sense deconstruct the documentary mode, and it can be argued that in so doing, they succeed in using it to bring viewers closer to confronting both the multiple meanings of reform and the actual processes of social change. Though we may never know the extent to which these documentary instances may reliably be read as inscriptions of Hine's ambivalent and complex understanding of his own practices and commitments, they nevertheless invite us to confront our own.

One example is from the *Homestead* volume. The image (Figure 2.14) is candid and picturesque, with the seeming romanticism of an Ash Can painter like John Sloan; it is simply captioned "The Street Market," and the overtones of this title reinforce the warm nostalgia summoned up by the mother's smile, her daughter's antics, and the picturesque barefoot boys. The photograph is placed, naturally enough, in the chapter called "Table and Dinner Pail." The text preceding and following the image does

Figure 2.12. Lewis Hine, *Out of Work, Homestead Court, Spring of 1908*. Reprinted from *Homestead: The Households of a Mill Town*, by Margaret F. Byington, by permission of the University of Pittsburgh Press. Copyright 1974 by University Center for International Studies, University of Pittsburgh.

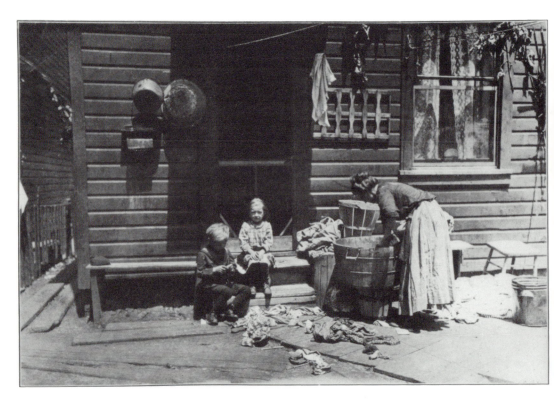

Figure 2.13. Lewis Hine, *Wash-Day in a Homestead Court*, 1907/08. Reprinted from *Homestead: The Households of a Mill Town*, by Margaret F. Byington, by permission of the University of Pittsburgh Press. Copyright 1974 by University Center for International Studies, University of Pittsburgh, facing p. 141.

not concern street markets particularly, but more generally the housewife's problems in buying food. The immediately preceding text concerns the fact that twenty-one out of the ninety families Byington studied in Homestead could not spend twenty-two cents per day per man for food – the figure household budget studies in 1907 had established as "the minimum for which an adequate supply of food could be procured." And the following text examines the various exigencies that forced housewives in Homestead to cut down on food expenditures.[74]

Thus the surrounding text directly contradicts any estheticism or sentimentality that the photograph and its caption might have signified. Although the photograph can be and still is experienced as a charming moment from a bygone age, the text identifies "the street market" as but

Figure 2.14. Lewis Hine, *The Street Market*, 1907/08. Reprinted from *Homestead: The Household of a Mill Town*, by Margaret F. Byington, by permission of the University of Pittsburgh Press. Copyright 1974 by University Center for International Studies, University of Pittsburgh.

one of many places of work, and it identifies the woman in the photograph as a housewife at the never-ending task of making ends meet in a place where, Byington had found, "the ordinary staple articles were more expensive ... than in any other city of similar size in the country."[75]

Another example of a text that contradicts an image occurs in John Fitch's chapter on "Health and Accidents in Steel Making." Of the numerous "hard conditions which the working force must face," Fitch emphasized heat. He wrote: "It is difficult to convey to the understanding of one who has never visited a mill, or who has visited one only in winter, the intensity of the heat in certain departments during the summer months," and he listed a number of measures that might be taken – but were not – to relieve the heat and its ill effects (which he also described).[76] Opposite this text are two portraits of steel workers by Hine, captioned

79

Figure 2.15. Lewis Hine, *Ready for a Hot Job* and *Between Spells*, 1907/08. Reproduced from John A. Fitch, *The Steel Workers* (New York: Russell Sage Foundation, 1910), facing p. 59.

"Ready for a Hot Job" and "Between Spells" (Figure 2.15). They are calmly posing in their work clothes, which consist of as little as possible: shirts with torn-off sleeves unbuttoned to the waist, and for one a towel to wipe off the sweat "between spells." In this instance the contradiction is doubly powerful. We learn from the text that the men's clothing, which at first appears irrational, peculiar, and even antisocial, is in fact intelligent and functional, an emblem of the demanding work they do and, as such, one source of the pride that shows in their faces. But we also realize that the very pride Hine's photograph inscribes in their faces and their poses utterly denies the pitiable condition that Fitch's text ascribes to these workers. Fitch's prose, detailing workplace oppression and its effects extending throughout workers' lives, is undercut by Hine's images displaying the workers' personal self-assurance and pride. To make sense of the documentary instance offered here requires that we bring to bear a mode of perception that, placing the text and image in dialectical relation, allows

them meaning and significance not only in themselves, but also in and from the very process of opposing each other.

What such meaning might be is elaborated in a third example. In *Women and the Trades*, a photograph (Figure 2.16) shows a woman who is "Head of the Checkroom," according to the caption. Her pleasant expression, her workmanlike concentration, and her fresh clothes and neat hair suggest she has achieved some pinnacle of modest success; she seems to be a well-rewarded, even complacent forelady. But this illusion is shattered when we read on the page facing this portrait that

Here [in the laundry checkroom] men and women are competing for work which requires no physical strength but which does require a common school education, intelligence, accuracy and speed. Nine years ago the work was exclusively in the hands of men. The one plant which had the prestige of a chain of laundries in several cities, began to employ women checkers, and women have now wholly displaced men in fifteen out of twenty-six laundries, and partially displaced men in five others. The reason for this is not, as we have seen, that women have proved quicker or more accurate. The reason is financial: women are cheap. From the South Side to the East End you hear it said that "you can get two women where you got one man; get twice as much work done, and done just as well."[77]

The head of the checkroom is, in fact, as exploited as any newly immigrated day laborer or office cleaning woman, and this despite her brave show, her title, and her generous attention to her work. In this instance, by presenting her exact job title, the *caption* exemplifies the progressive idea of social publicity, connoting the technical and social expertise and special sociological knowledge by whose authority social facts are discovered, captured by the camera, and brought into legitimate public existence. However, the third element of the documentary mode, the *text* – announcing the bad news of apparently unrestrainable female exploitation – contradicts both the *photograph* and the *caption*. Having read this text, we can read neither image nor caption in the way we did before. Showing us not only the reformers' technology and technique, but also the unpredictable strengths and qualities of the human subject of exploitation – and object of reform – this instance prods us to think more deeply about the social relations that reformers assumed, represented, and even perhaps enforced. Arranging the four elements of the documentary mode so that their contradictions disrupt its monolithic "truthfulness," the work here seems to suggest that such "truth" may be not only based upon, but achieved by, the confirmation of fixed assumptions about the nature of working people and, consequently, about the unitary, secure, and remote position of their middle-class viewers. It does not go too far to say that

Figure 2.16. Lewis Hine, *The Head of the Checkroom*, 1907/08. Reprinted from *Women and the Trades: Pittsburgh, 1907–1908*, by Elizabeth Beardsley Butler, by permission of the University of Pittsburgh Press. Copyright 1984 by the University of Pittsburgh Press.

both Riis's narrative and Veiller's information had established such assumptions – and security – virtually as documentary tradition. Proposing, in its "life-like" irresolution, bafflement and lack of closure, that viewers no less than workers are "subjects-in-process" never quite to be comprehended, Hine's documentary offers itself neither as narrative entertainment nor as a map of reform ideology; rather, it proposes a means to connect with, to imagine and respond to, the actual processes of social change.

In a fourth example, the relationship between two photographs of the same subject is important. In the *Homestead* volume appears the well-known photograph of Slavic laborers (Figure 2.17) that we recognize as a symbol of the strength, cooperation, and fraternity we have come to value as positive qualities of the immigrant experience. This photograph faces a contradictory text, in which Byington presents her wage data:

The first and most important fact revealed by [the data] is that the pay of over half the men in the Homestead mills in 1907 was that of common laborers. Eighty-five per cent of the Slavs, 23.4 per cent of the native whites, 32.7 per cent of the English-speaking Europeans and 56.2 per cent of the colored were classed as unskilled, receiving less than $12 a week. This will reveal the situation as it actually is to those who have heard only that wages in the steel industry are high.[78]

The workers' stalwart front is slightly diminished when we learn these facts about their oppression, but their fraternal solidarity is enhanced because their oppression is shared by many of their non-Slavic Homestead neighbors.

In *The Steel Workers* there is another photograph of Slavic laborers, captioned "Immigrant Day Laborers on the Way Home from Work" (Figure 2.18), to which we are compelled to have a much less positive reaction. This is an alien and slightly dangerous looking group, and it is not typical of Hine's portraits of immigrants. There is a reason for this portrayal, and I believe it can be found in the accompanying text, in which Fitch asks "why the Slav came to monopolize the unskilled positions, when there were still American boys and some of English and Irish immigrants already on the ground who might conceivably be looking for work." One of the reasons, Fitch wrote, was racism:

Today the young American who starts in the lowest position with the intention of working up is rare. The Slavic peasant, accustomed to subservience to authority, and taught it by all the force of tradition, is distrusted and disliked by his more independent American neighbor. Stolid and willing, living amid unsanitary surroundings, hoarding his earnings and spending only for immediate necessities, he

Figure 2.17. Lewis Hine, *Slavic Laborers*, 1907/08. Reprinted from *Homestead: The Households of a Mill Town*, by Margaret F. Byington, by permission of the University of Pittsburgh Press. Copyright 1974 by University Center for International Studies, University of Pittsburgh.

is misunderstood and despised by the more liberal, wide-awake Anglo-Saxon, until "Hunky" has come to be a convenient designation and a term of opprobrium as well. Many American boys fancy that they degrade themselves by entering into competition with a Slav for a job.[79]

Certainly this group portrait represents the fearful image of the "distrusted and disliked Hunky" conjured in Fitch's text, a fantasy which might well have dominated the imaginations of the "native American" boys. They knew little about the new immigrants, had no reason to be tolerant, and could easily have found fuel for their fears on the way home from work any day – where they were, in fact, greatly outnumbered by such groups of day laborers who made up the majority of the work force.

The implications of this final example seem to propose for documentary

Figure 2.18. Lewis Hine, *Immigrant Day Laborers on the Way Home from Work*, 1907/08. Reproduced from John A. Fitch, *The Steel Workers* (New York: Russell Sage Foundation, 1910), facing p. 145.

the possibility of an insistent and salutary self-interrogation: the questions raised by the images concern the relations of the photographs to each other, to their captions, and to their texts. The captions are neutral, legitimizing identifications; they tell us we are looking at the same "thing" in each photograph. The images cancel each other's visual integrity: had we wanted to accept either one as being "correct" about immigrant workers, we could not do so without ignoring the other. Nor can either photograph function satisfactorily as a representation of "quintessential" Slavic workers, for the enviable fraternity of one is at war with the mean sullenness of the other. Each photograph calls the other into question and shows it up for what it is – a moment of reality that exists only as an image, a *trace* of what it denotes. The text serves both to fix and to unfix meaning: "In Hine's work, the text confirms the *social* existence of what the image denotes" [my italics], Alan Trachtenberg has written, and this limited yet

vitally important confirmation – essential to documentary – occurs even though the "social existences" confirmed are in contradiction.[80] In proposing that history includes not only these specific workers (some "good" men, some "bad"), but also various and paradoxical situations that have encompassed both fraternity and subservience, both interracial solidarity and racist fear, Hine asks that we acknowledge a more demanding and complex "social fact" than we may be prepared for. In return, he has left us a documentary practice that begins to show the grand dimensions of the "untouched field for photographic art" that he envisioned and sought to record in the industrial world.[81]

Hine must have felt, at least in 1909, that the contradiction between the inevitably polysemic communication offered by photographic realism and the insistent, explicitly ideological structure that presented the documentary mode could and should be put to the service of truths both moral and esthetic. Hine told the National Conference of Charities and Corrections:

The photograph has an added realism of its own; it has an inherent attraction not found in other forms of illustration. For this reason the average person believes implicitly that the photograph cannot falsify. Of course, you and I know that this unbounded faith in the integrity of the photograph is often rudely shaken, for, while photographs may not lie, liars may photograph. It becomes necessary, then, in our revelation of the truth, to see to it that the camera we depend upon contracts no bad habits.[82]

This self-critical evaluation assigns to the photograph–text relationship a role and status equal to that of the art work, and it connects even history – and documentary evidence itself – to a realm of volatile and resonant expression that notes and firmly disregards the limitations of mere objectivity in favor of the more truthful revelation of ambiguity, and acknowledgement of dialectic, that work together at the heart of our self-knowledge and discovery.

Hine's masterful and controlled camera practice presented a concatenation of social and human meaning – a content specific to the working class – that was, and remains, rich and complex. Hine's work, like the other particularities that set forth workers' humanity, politics, and autonomy from reform apparatus, was ultimately denied in favor of the ideal of a neutral reform community of business leaders and experts, excluding workers. Hine's belief in the authority of exact information about people was, inevitably, fragile. It verged on the subversive, and it was overridden by the powerful ambitions implicit in survey ideology. The survey linked

the documentary photographic style to the ever-increasing cultural authority of social expertise, and it collaborated with corporate capitalism by providing a theory of benign social engineering that helped to mask the facts of class exploitation.

Chapter Three

"SYMBOLS OF IDEAL LIFE": TUGWELL, STRYKER, AND THE FSA PHOTOGRAPHY PROJECT

Although the Farm Security Administration photography project, like the New Deal as a whole, responded to the crisis of the Great Depression, the ideological assumptions that made possible the virtual redefinition of the documentary mode that the project accomplished were actually developed in the "New Era" prosperity of the postwar decade. The experience during the First World War of successful cooperation among business, the academy, and the military had greatly reinforced pre-war tendencies toward nationally centralized, high-level decision making. In the postwar years, corporate business expansion, rising productivity, and higher living standards made the United States the world's first mass consumption economy, and industries and professions sprang up to develop and direct the advertising techniques and communications networks necessary to manipulate public opinion and to sustain the national rate of consumption.[1] As we have seen, Paul Kellogg and other reformers who studied America's great industries before the war had hoped that the testimony of social scientific fact, interpreted authoritatively to high-level management, might stimulate needed reform. The emergence during the 1920s of a self-conscious, even reformist, "scientific management" mandated, in the famous words of the movement's founder, Frederick Winslow Taylor, "the deliberate gathering in on the part of those on management's side of all of the great mass of traditional knowledge, which in the past has been in the head of the workman, and in the physical skill and knack of the workman, which he has acquired through years of experience," and which, Taylor acknowledged, "is his most valuable possession." In addition, the development of social engineering into ever more refined sociological specialties such as industrial psychology, personnel management, and even "consumption engineering" reinforced reformers' crucially "realistic" insight that the most powerful levers for social change were now located within the management structures of large corporations.[2]

89

In the 1920s, reform was no longer publicized with the hopeful idea that information about people might interpret, mediate, and manage class relations; rather, the goal of social publicity was the apparent elimination of class manifestations altogether and the portrayal of social and economic management as a matter of smooth, humane bureaucratic administration. The scientific management movement was "the articulate and self-conscious vanguard of the businessman's reform effort" in the early 1920s, as historian David Montgomery has pointed out; and Rexford Tugwell, the economist turned New Deal administrator who fostered the FSA photography project was, as he said of himself, a "Wharton School ... Taylor Society ... Van Hise" kind of progressive.[3]

The existence at all of a photographic project in the Resettlement Administration (RA) and in its successor agency the FSA was the culmination of a collaboration that began in the early 1920s at Columbia University between Tugwell and Roy Stryker, then Tugwell's teaching assistant. There is no evidence that Stryker did not agree with Tugwell, who was his teacher and mentor. Although Tugwell was not notable as a theorist, it was his significant contribution to combine and synthesize the ideas of more original social thinkers – not only Taylor, but also the economists Simon Patten (Tugwell's mentor at the Wharton School) and Thorstein Veblen, and the philosopher John Dewey – and to use his various public appointments during and after the New Deal to experiment with practical applications of their ideas. The economics textbook *American Economic Life and the Means of Its Improvement*, which Tugwell published with Thomas Munro in 1924 and for which he engaged Roy Stryker as illustrations editor, made its "acknowledgement of deepest debt" to Simon Patten and John Dewey.[4] Intended as reformist, as its title suggests, the book described the three "levels of living in America" – poverty, comfort, and riches – and "it went on to suggest ways those who now lived in poverty might move – or be moved – upward: by increased productivity, by more equitable sharing, and by more reflective use of goods and services," as Tugwell wrote in his memoirs. Perhaps because Tugwell incorporated into his book a protest directed to his colleagues and students against the continued teaching of classical economic theory – which he characterized as "a hardened logical system ..., dangerously close to a speciously attractive, highly elaborated abstraction, relevant to nothing in the real world" – *American Economic Life* was not used in Columbia's introductory Contemporary Civilization course, for which Tugwell had intended it as an "attempted text."[5] It was, however, this attempt to introduce a more realistic view of current economic and social life to beginning students that particularly encouraged

Tugwell's and Stryker's interest in "new means of communication" developed since the war. A part-time settlement house worker during his first year at Columbia, and long familiar with progressive social and educational thought, Stryker had developed a "laboratory section" of the Contemporary Civilization course that featured instruction based on field trips to observe New York life and labor and that used photographs and other visual materials, in whose use and production Stryker had developed a distinctive expertise. Though the authors of *American Economic Life* commissioned no photographs, Stryker captioned and edited over 300 illustrations including photographs, charts, and graphs assembled from many sources. Lewis Hine's photographs of rural and industrial work and workers formed Stryker's most important resource, and he used some seventy of Hine's photographs in *American Economic Life*.[6]

Hine had taken on a number of advertising and industrial commissions throughout the 1920s, and in 1924 he won the New York Art Directors' Club medal for photography. As this award suggests, and as Hine's own description of his shift toward "positive documentation" confirms, Hine was interested in adapting to his own subject matter some of the "innumerable methods of reaching this great public" that advertising had suggested to him as early as 1909.[7] Urging reformers to forego "the old steps of doubt and conviction" about the value and uses of advertising publicity, Hine encouraged them even then to turn it to their own ends.[8]

Hine must have been, at least initially, keenly interested in the textbook project, and he may have seen Tugwell's and Stryker's concerns to "present relevant data from industrial experience" to their students and to foster among them "the understanding, the control, and the improvement of the uses of industrial forces," as they wrote in the preface to *American Economic Life*, as goals comparable to those of his own current projects.[9] At the start of his own career twenty-five years earlier, at the progressive Ethical Culture School, Hine had used methods like those Stryker would adopt, but with greater pedagogical imagination, for Stryker stopped short of using the actual practice of photography as a teaching method. Hine's articles during the teens articulated not only a "social photography," but also what we might today call "visual literacy." As he exhorted social workers in 1909, Hine's earlier publications in educational and photographic journals asked progressive educators to consider "whether we are taking advantage of the many opportunities which the pictorial art offers to increase our efficiency by appealing to the visual sense and recording for mutual benefit, the school work." Pointing out that "the modern newspaper and magazine" have come to rely on photography's "wealth of ma-

91

terial and realistic illustrations" as "indispensable" ways of "reinforcing and varying the written explanation," Hine noted that the student camera could function as recorder and organizer of salient features of classwork and field trips at the same time that it taught the basics of a skill that might later become a livelihood. As an alternative to traditional shop work, Hine argued, training in photography offered progressive educators "one more channel in accord with the bent of the individual pupil." But the highest value of practical camera work, Hine wrote, was the chance it offered students to learn how to bring out "the beautiful and the picturesque in the commonplace," and to "sharpen the vision to a better appreciation of the beauties about one" – a combination of practical and esthetic training that Hine considered "the best fruits of the whole work," and a pedagogical innovation that might stimulate a "life interest in art" for those to whom "the brush and the pencil had made no appeal."[10]

However, Stryker seems to have regarded Hine as something of a has-been, and Hine never challenged Tugwell's role as Stryker's mentor. For several years during the 1930s, Hine, increasingly ill and poor, sought Stryker's help in getting steady work with the FSA or some other New Deal agency. Although dissembling his actions in his correspondence with Tugwell – "it was my hope that we could have him on the staff, but unfortunately, it was impossible to make the type of arrangements which would be satisfactory to him" – Stryker adamantly refused Hine work, becoming his open admirer only in 1938 when such support was clearly, as Stryker told Tugwell, "one of the last things we can do for him." In connection with his request for Tugwell's endorsement of a Hine retrospective in New York, Stryker wrote that "look[ing] back now [at *American Economic Life*], [I] realize that his photography made much more impression upon me than I had suspected at the time," and added that a recent "opportunity to look over a great deal of his work" had led Stryker finally to conclude that Hine "had been doing the type of work which we [at the FSA] are now doing, back in 1908 and 1912."[11]

Perhaps it was inevitable that tension developed between Stryker and Hine during work on *American Economic Life*. Hine wanted to show "the meaning of the worker's task, its effects upon him, and the character of his relation to the industry by which he earns a living," he told an interviewer in 1920, and he saw his workplace photography as "a new development in the movement to study the human problem of men and women in modern industry." But in all his work, and especially in the photographs he published in 1932 in *Men At Work: Photographic Studies of Men and Machines*, which documented the construction of the Empire State Build-

ing, Hine emphasized workers' traditional skills and responsibilities; and as his early articles show, he saw camera work itself not as a newly developed mode with its own professional strictures, but rather as another arena for traditional craftsman's skill. Hine thought that the postwar industrial worker was "as underprivileged as the kid in the mill that he had photographed in the Teens," and unlike Tugwell and Stryker, he showed no interest in portraying the benefits of the new management sciences.[12] As the textbook shows, Stryker drew upon the carefully wrought form that Hine had used before the war, but Stryker did nothing to further its development. Although he appreciated the craft and clarity of Hine's work, in virtually no instance do Hine's photographs appear in *American Economic Life* with the full complement of text and caption necessary to communicate their meaning.

Figure 3.1, from the textbook's section on rural poverty, "contrasts," the caption tells us, a mother and child of "the comfort group" with a "widow and her nine children," in order that we may readily comprehend how "poverty [is] self-perpetuating." Although the photographic contrast was a technique that Hine and others had used to good effect, here it fails to provide the ready comprehension of "poverty self-perpetuating" that its caption promises. Apparently we are meant to see that, while the large families favored by poor people perpetuate their poverty, the middle-class "comfort group" – its eyes on the finer things of life, as its name suggests – is at once more socially scientific and less sexually self-indulgent. But since a crucial piece of information is missing – that is, the actual number of children in the "comfort group" family – the root causes of "self-perpetuating poverty" remain unclear.

In his accompanying text, however, Tugwell provides, if not more facts, at least a more developed perspective on rural poverty. In an earlier section of the chapter, Tugwell, praising the "imaginative enlightenment" he found in realist literature such as Hamlin Garland's, had quoted at length from *Son of the Middle Border*, Garland's autobiographical account of the drudgery of boyhood farm life. Garland showed, Tugwell wrote sympathetically, not only "the hardships of farm life," but also the "impotence" of people "in the grip of the natural forces with which farmers have to contend."[13] But here, speaking more harshly about rural life, he considers not natural forces but human nature, and he contrasts the rural present with a past at once idyllic and entrepreneurial:

The self-made prosperous farmer of today ... probably came from a fresh pioneer family whose vitality had not yet been sapped by years of privation and disease;

Poverty self-perpetuating. It can more readily be comprehended when one contrasts these two pictures. Left.—Mother and child of the comfort group. Right.—Widow and her nine children. (Photos Hine.)

Figure 3.1. Lewis Hine, *Poverty Self-Perpetuating*, n.d. Reproduced from Rexford Guy Tugwell, Thomas Munro, and Roy E. Stryker, *American Economic Life and the Means of Its Improvement* (New York: Harcourt, Brace), 3rd ed., p. 94.

he worked to the top in a region and at a time when fertile land was waiting in plenty for the first plow.

Today the rise to agricultural prosperity is often an infinitely harder one. Those whose families have been for years on the land, yet remain poor, have grown up in an atmosphere of discouragement, in a social system already somewhat crystallized and less responsive to individual efforts. Many of them, unlike the old pioneers, begin life with the handicap of poor health, mental and physical, the culmination of three or four generations of sickness and malnutrition. Diseased or feeble-minded strains have for years intermarried, in remote and secluded districts or among the outcast poor; the result is a generation of children doomed from the start to misery.[14]

Harsh and unsparing, Tugwell's impassioned investigation penetrates the "remote and secluded districts," and it illuminates even the previously undisturbed "outcast poor." Enhanced by Tugwell's prose, the contrast

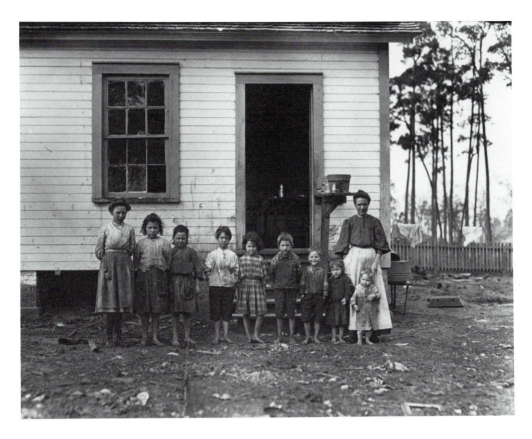

Figure 3.2. Lewis Hine, *Doffer Family, Tifton, Georgia, January, 1909*. International Museum of Photography at George Eastman House.

intended by Stryker's illustration is now sharpened. We see that, although both families appear fatherless, the comfortable mother and child, posed Madonna-like and linked by a gaze that does not include the viewer, appear confident and protected. The self-contained indifference conveyed by the familiar pose, an icon whose connotations include perfect security, points up the vulnerability of the widow and her family who, with unsentimental frontality, their fatherlessness emphasized by the widow's protective arms on her two youngests' shoulders, are lined up as if for investigation or display. Characterized by its poverty and vulnerability, the family seems "the object of information" rather than "a subject of communication," as Michel Foucault has described the subjects of modern "human sciences." The family members' exclusively frontal visibility seems to legitimize their

own inspection and to confirm its necessity.[15] The illustration complements Tugwell's ruthless charge against the tradition-bound rural poor: wayward human "strains," they are, left to their own devices, incapable even of reproducing themselves efficiently. Without trained intervention, the separate, special, and endemic poverty of such farm families will reappear, stubbornly thwarting progress, with every new generation.

Hine's photograph of the fatherless family was taken in 1909 for the NCLC; his field notation identifies the woman as Mrs. A. J. Young, five of whose children worked with her in a Tifton, Georgia, cotton mill.[16] Figure 3.2 shows a fuller version of Hine's print. Hine, too, believed in self-perpetuating poverty, for that is what he meant by "human junk," and that is the "vicious circle" he described in the *Child Labor Bulletin* ("Child labor, illiteracy, industrial inefficiency, low wages, long hours, low standards of living, bad housing, poor food, unemployment, intemperance, disease, poverty, child labor . . . ").[17] But he did not blame the "diseased" and "feeble-minded" themselves who irresponsibly married in secluded districts and among the outcast poor for this circle. Rather, he blamed the employer of children. "Not only the child, but the parent, the humane employer and society in general pay tribute to the child employer," he wrote. "He injures all of us because by forcing down wages he ruins the health and souls of future generations, and thus he weakens the nation."[18]

In the light of Hine's vigorous prose, we can see the Youngs differently: we see how they have been allowed to arrange and to present themselves so that their frank self-consciousness before the camera provides poignant confirmation of the reformers' assertion that here is represented unjust and undeserved damage done to an unlucky family by a criminally irresponsible industrial system. With Hine's text and caption restored, we can realize the intersection of industry and family life that the image actually represents. The image gains, if not the absent father, at least a social consciousness restored and shared; the Youngs' composure, and their smiles, signify a kind of imaginative participation in the image-making – which participation, even as it is represented inside the photographic frame, reveals the workings of Hine's photographic art. Partaking *themselves* of the authorial task of "imaginative enlightenment" (in Tugwell's phrase) in their enacted consent to Hine's photography, the Youngs *as subjects* illuminate *Hine's* subjectivity, and they show the social purpose of his camera work. The photograph records the momentary transaction that occurred one day in 1909 between a "social photographer" visiting Tifton, Georgia, and his subjects; and the family's composure comments not only on Hine, but also on a wasteful and unfortunate human connection

enforced upon "all of us," a nation weakened by the practices of the child employer.

Although Hine was available to tell him what the picture showed, Stryker miscaptioned it anyway. Perhaps the implicit sexual information that the photograph conveyed, so complementary to Tugwell's textual characterization of the isolated rural poor and so evocative of the "generation doomed to misery from the start," was too tempting to pass up. Or perhaps the large, fatherless family struck a chord from Stryker's own rural childhood as one of seven children dependent on a vigorous father.[19] Somewhat disturbing, however, and thus perhaps the determining factor, must have been the fact that Hine's photograph actually showed the effects of modernization, a process whose more positive aspects Tugwell was in fact greatly concerned to publicize. For it was encroaching capitalism that, disrupting the rural economy and disturbing the "agricultural ladder," had created "a social system already somewhat crystallized and less responsive to individual efforts," as Tugwell wrote; and it was the Youngs' ill-paid participation in that system, rather than their adherence to folkways, that had perpetuated their poverty.

As the vehemence of his expression here suggests, Tugwell had come to consider agriculture the particular site of the struggle for planning and coordination of production under the leadership and control of government-sanctioned experts. "Since graduate school I had had more sympathy for farmers than for industrial workers," Tugwell wrote in his memoirs, and he went on to explain his sentiment. Agriculture, although "the most individualistic of all industries," was nevertheless the most promising one on which to experiment with centralized planning and national management. A long history of government support for and cooperation with farmers had constructed a far-flung system of agricultural colleges and extension services, county agents, and a centralized Bureau of Agricultural Economics in Washington; the result of their extensive data gathering was that "more was actually known about agriculture, collectively, than about any other widespread activity carried on in America."[20]

Farmers for the most part did not participate in postwar prosperity; the resumption of European agricultural production after the war eliminated their foreign markets, and neither expanding domestic markets nor the too slowly declining farm population compensated for this loss. Although per capita farm income remained lower than it had been in 1919, and in 1929 the average income per person on farms was less than half that of nonfarmers, no dominant organization or coherent leadership had emerged with consistent and detailed proposals for reform.[21] The situation was

particularly acute for those at the bottom of the agricultural ladder – the tenants and "sharecroppers" soon to be the particular object of New Deal publicity. Whether they joined the industrial labor force, like the family in Hine's photograph, or stayed in rural areas as day laborers, they were increasingly proletarianized and socially immobilized by whatever advances in technology and capital-intensive methods did occur, but too isolated and powerless to organize along class lines.

However, the same economic and social disruption and geographical isolation prevented large growers, owners, and middlemen from consolidating the types of associations, national networks, and public relations campaigns that business used to such advantage in the 1920s.[22] Not from the realm of vociferous but divided agriculture, but from the business world and the irresponsible financial interests that dominated it, came the "proliferating propaganda for free enterprise and against collectivism" that Tugwell saw "permeat[ing] the press and the radio, the principal means of mass communication" in the 1920s. For Tugwell, eager to intervene – to make farmers "give the expert his chance" to actualize the social experiments advocated by his mentors – agriculture seemed a field for technological and social reform almost unhampered by existing institutions. The leadership of trained experts was already sanctioned and supported by the extension and county agent system, and a reorganized and centrally administered agriculture could serve as a model for the combination of productive efficiency and constructive social relations to be achieved everywhere in the new corporate state. Agriculture was thus most constructively viewed as a current base for future reorganization of the more capitalized and more resistant industries.[23]

Needless to say, the industrial system to which Tugwell welcomed former farmers had little to tempt those who came from a rural life at once "individualistic" and traditional. But, as Arthur Schlesinger has written, "in the work of ... Taylor, the father of scientific management, Tugwell found the techniques by which society might achieve the ends proposed by Patten, Veblen, and Dewey," and Tugwell felt no need to mince words in describing the situation of the modern industrial worker. Since, as Tugwell bluntly wrote in 1927, "the industrial revolution has completely denuded the worker of responsibility, just as it has stolen away his skills," not only industrial efficiency, but also the social contribution resulting from that efficiency, were now "the responsibility of managers, not workers."[24]

To compensate for these losses, however, workers were offered the chance for greater consumer participation than ever before in the new "economy of abundance" promised by high production. Following his mentor Simon

Patten, who had proclaimed as early as 1905 that "the economic revolution is here, but the intellectual revolution that will rouse men to its stupendous meaning has not done its work,"[25] Tugwell elaborated in *American Economic Life* an ideal "symphonic consumption" – a "use of the goods of life" that was "at once various and harmonious," and "rounded into a perfected whole unlike any of its elements, yet dependent upon each of them for its perfection."[26] Those who had not yet learned to revere the "new ideals of human behavior appropriate to an economy of abundance" must be led to abandon their "ancient social emotions" by, as Tugwell wrote, a "program of constructive mass education in the ways of better living."[27]

Like Patten before him, Tugwell saw the agencies of this "constructive education" as virtually identical to the functions and processes that promoted rationalized, efficient production. The new types of specialized managerial expertise then developing, which included Americanization plans and corporate welfare programs offered as alternatives to unionization, might promote a "friendly cooperation with workers" to be substituted for "the suspicious driving of the system inherited from entrepreneurial industrial organization." But more than this, "better education and raised standards of living have tended to reduce craft or even class consciousness," Tugwell wrote, and ever-increasing absentee ownership promoted "a feeling of identity of interests between [managers] and their workers rather than between [managers] and their owners."[28] An important public relations task for academic social scientists, for educators, and for the government was to ensure that the emergent class of engineer–managers – "the technicians of industry" – were hindered by neither capital nor labor from "promoting continuous operation and smooth functioning at any cost, even that of the sacrifice of dividends."[29] But in addition, the public should learn to identify its interests with those of engineers newly entering management positions after the war, because (as Veblen had argued) their training in scientific method and their commitment to a craftsman's ethos could strengthen corporations and enlarge their social role. No longer merely an economic instrument, the corporation's size and influence mandated the new role of responsible social institution.[30]

In their preface, the authors of *American Economic Life* acknowledge Patten and Dewey for their "questing minds ... [which] have ranged over all the data of human experience," and for their "thought ... [which] penetrates [the text's] very fabric."[31] Dewey, Tugwell's colleague at Columbia, was the best-known spokesman for a liberal ideology "rising to its highest level of publication and popularity" in the 1920s, as philosopher Morton

White has claimed; the New Deal would be "its apogee."[32] In his memoirs, Tugwell spells out his debt to the philosopher whose thought provided "a comprehensive justification for much of my own work," as he wrote.[33] Since first articulating his "revolt against formalism" and "challenge to education" in the 1890s, Dewey had elaborated the view that education itself, at all levels, must become a "process of living," a social process continuous with and responsive to community needs and to social change.[34] Not content merely to socialize education, Dewey had, in his *Pedagogic Creed* of 1897, named education "the fundamental method of social progress and reform," contrasting its "evolutionary" nature to "all reforms which rest simply upon the enactment of law, or the threatening of certain penalties, or upon changes in mechanical or outward arrangements," which, he declared, were hopelessly "transitory and futile."[35]

This elaboration and expansion of educational functions and experiences, as well as his various implicit and explicit calls for a "socialized intelligence" and a national "intellectual trust," were heady stuff for intellectuals such as Tugwell.[36] Equally crucial, as Tugwell makes clear, was Dewey's fundamental concept of intelligence as *instrumental*, a word Dewey used virtually interchangeably with the terms "experimental" and "pragmatic." Dewey's concept of the mind or intelligence as instrumental rested on his particular conception of experience as "what it is because of a transaction taking place between an individual and what, at the time, constitutes his environment."[37] This transaction "includes an active and a passive element peculiarly combined," for even as intelligence undergoes experience, it attempts to act upon it in order to modify it for its own future ends – which naturally include a more satisfying range of future experiences. "The very fact of experience thus includes the process by which it directs itself in its own betterment," as Dewey wrote. Instrumentalism describes the particular, future-oriented perceptions and operations carried out by intelligence within experience so conceived, so that, as Dewey wrote, "experience in its vital form is experimental, an effort to change the given; it is characterized by projection, by reaching forward into the unknown; connection with the future is its salient trait."[38] Calling instrumentalism "the method of most importance for reassessment [of industrial society]," Tugwell wrote that Dewey "encouraged my turn away from classicism in economics and politics and my admission of the future as the chief influence on the present." Dewey's instrumentalism "meant that the future could be brought into focus, judged in advance as a working hypothesis, and altered before it was reached. This was and is the essence of planning."[39]

As Tugwell's visual metaphor suggests, Dewey's pragmatism, intended to liberate and socialize the forces of "intelligence," privileged as "realistic" a vision grounded in the knowledge and power of modernizing planners and managers. Such a politics of vision – and of knowledge itself – came perilously close to sanctioning a virtually authoritarian "administration of experience," as Dewey himself seems occasionally to have acknowledged. "Although, as has been so often repeated, this self-creation and self-regulation of experience is still largely technological rather than truly artistic or human," Dewey wrote in *Reconstruction in Philosophy*, "yet what has been achieved contains the guaranty of the possibility of an intelligent administering of experience. The limits are moral and intellectual, due to defects in our good will and knowledge."[40] Meant to replace and discredit the deadening distortions of formalist terminology and to allow the "positive evolution of intelligence as an organizing factor within experience," the future-oriented instrumentalism Dewey advocated nevertheless constructed representations, at once "scientifically" transparent and socially opaque, that created their own kinds of distortions.[41]

The discussion of collective bargaining in *American Economic Life*, which describes the "influences at work to strengthen industrial unionism and to undermine ... craft unionism," was illustrated by Figure 3.3, actually a full-page argument for "influences" that divide and weaken the newly emergent industrial unions.[42] The figure employs, perhaps somewhat ironically, a familiar journalistic technique for presenting close-up portraits as a way of identifying figures associated in a common enterprise or business venture; and the textbook's presentation is an unexceptionably sober-sided view of its ethnic subjects. Stryker cropped severely ten of Hine's photographs from the Pittsburgh Survey and set them off from each other; captions identify the workers by nationality, or more properly, by ethnicity. Here again, as in Stryker's treatment of "poverty self-perpetuating," breezy speculation substitutes for facts. The caption suggests that failures to organize unions for collective bargaining may be attributed to the insuperable obstacle created by the differing ethnic backgrounds of industrial workers. Nevertheless, the layout of Stryker's montage is arranged to communicate visually the overriding significance of exactly such differences: the stark presentation removes all traces of social life and intercourse, of the common values and aspirations that may unite workers across craft and ethnic lines (as John Fitch of the Pittsburgh Survey had found, for instance, in McKees Rocks, Pennsylvania, in 1909).[43] In *American Economic Life*, the Russian appears without the fraternal hand that grasps his shoulder in Hine's original photograph, and the black strap hanging over the

101

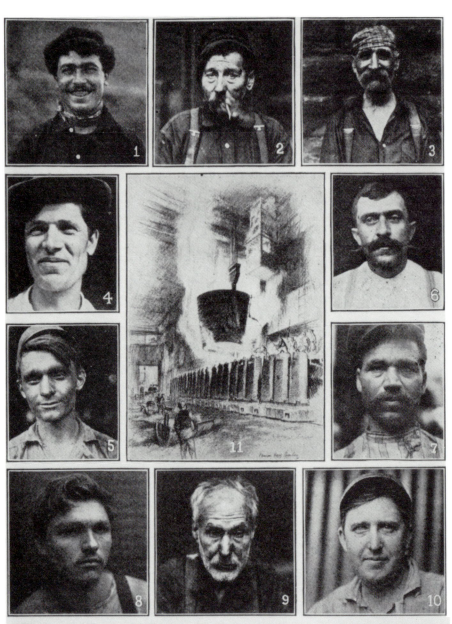

Workers in the steel industry: (1) Italian; (2) Irish; (3) German; (4) Lithuanian; (5) Polish; (6) Serbian; (7) Russian; (8) Slovak; (9) English; (10) American. (11) Interior of a steel mill. The difficulty of organizing large groups of men for collective bargaining is apparent when the different nationalities involved are considered. (Photos by Hine. Drawing by Vernon Howe Bailey. Courtesy Interstate Steel Company.)

Slovak's left shoulder is meaningless when we cannot see the accordion it holds in his lap (see Figure 2.12). Although their social life is denied, the antisocial – that is, the actions that deserve such a severe, mugshot-like record – is not specified beyond the general "difficulties" that ethnicity, as here typified, supposedly makes "apparent."

Stryker's careful numbering system, in the bottom right-hand corner of each photograph, emphasizes the importance of the photograph–caption relationship, but his message is further enhanced by the compositional relation between the circumscribing, emblematic frieze of photographs and the central, iconic imagery. The assertive composition insists on organizing stylistically incompatible images as if they were equivalent iconographic elements, so that, in its editorializing insistence, the composition becomes a kind of ideograph: it is an intellectualization that naturalizes the oddity of its layout with the *political* justification that ethnicity in any American context is not only odd but objectionable, and that justifies this political sentiment by invoking *esthetic judgment* – the photograph, evidence of the camera's realistic eye, shows how alien ethnic workers actually do look.

In the central sketch, we find not a person but a process of production and, in *its* center, a massive suspended ladle, full of molten steel, which, overhanging the ranked cast-iron molds, dwarfs the tiny figures in the left foreground as well as those on the right whose ropes or chains guide it. Those who actually control the ladle are hidden in the windowed crane tower behind and to the right. The smoking cauldron, implying the load of molten steel that will cool and be built into the infrastructure of American industry and commerce, refers as well, of course, to the melting pot metaphor. Used to describe the Americanization process, the metaphor compares American society to a fiery purification which separates, as it were, dross from metal, and which transforms ethnics into Americans to ensure a "100% American" working class.[44]

Nor would it be overreading, I think, to suggest that Tugwell and Stryker may have been drawn to that other icon shown in the sketch – the watchtowerlike crane shaft, which might stand here as symbol of the planned future. As historian Samuel Haber has noted, in Taylor's factory scheme it was the planning department, "repository of the science of work" and hence of management power, which was "the new center of the factory." As in Tugwell's design for agriculture, so central was the planners' role in

Figure 3.3. Photos by Lewis Hine, drawing by Vernon Howe Bailey, *Workers in the Steel Industry.* Reproduced from Tugwell, Munro, and Stryker, *American Economic Life*, 3rd ed., p. 650.

industry that, as Taylor himself wrote, "in theory at least, the works could run smoothly even if the manager, superintendent, and their assistants outside the planning room were all to be away for a month at a time." Although Stryker's cropping and layout shears away horizontal conjunctions among workers, it replaces them with an important *vertical* relation which is like the relationships implied not only in Taylor's but also in Dewey's prose. The central windowed tower oversees men and machines, recording and controlling their operations. This implicit vertical gaze, to which workmen and steel-filled ladle both aspire, organizes Stryker's montage, just as the planners' higher, "evolved intelligence" organizes and "administers" experience.[45]

The tension between styles in Stryker's ideographic image helps to make these social and political points. Although documentary and realist in style, the photographs are no longer current: they are so formalized and set off by the graphic variety of the total image that their means of production is obscured. Halfway between a montage and a photo-essay, the illustration uses iconologic tension itself as an organizing principle – the *directed reading* of iconography, not yet a narrative technique as it would become in the picture magazines' photo-essays, is at least an editorial strategy, making it difficult to think how these "ethnics" exist at all independent of the ideology that so blatantly constructs them here to its own measure and proportion.

In the Pittsburgh Survey, Hine's work portraits served as "graphic interpretation" significant not only of reformers' concern to discover and explain social actuality but also of their special authority to ameliorate it. By contrast, here in Stryker's illustration, the photographs – at once close-ups and almost ciphers – seem meant to hold open the way for some more real and more important message, which is in fact articulated in the caption and emphasized in the compositional structure. Embracing an ideology that located the intellectual and cultural authority of science in the operations of a more "reasoned" and "prospective" intelligence, Tugwell and Stryker no longer felt the earlier progressives' need to confirm and publicize their inquiries with a factual and particularizing style. As Stryker's tentative and somewhat clumsy efforts in *American Economic Life* suggest, he intended to use the documentary photograph to represent more than social reality and reformers' expert relation to it. The iconologically engaging photograph might become an "intellectual instrumentality," in John Dewey's telling phrase. It could be a vehicle of a seemingly transparent message, whose content could represent for a mass public not specificity but rather ideals and ideality – "symbols of ideal

life" that were appropriate for the machine age, as Dewey wrote in *The Public and Its Problems*. For, Dewey pointed out, "symbols control sentiment and thought," and "the new age has no symbols consonant with its activities."[46]

In *American Economic Life*, Stryker was learning to construct a documentary image that might succeed because in it realistic forms of visual expression could control the appearance of seeming social fact in order to express what was currently appropriate and even attractive about the new ideology. To show the inevitably modernizing American, but in a style credibly humanitarian and artfully individualizing, would be Stryker's task at the FSA. It was, of course, a task made easier because the New Deal government was both the agent of change and the sponsor of representation.

Rexford Tugwell became a member of Roosevelt's brain trust in 1932 and an important contributor to the early New Deal legislation that became the Agricultural Adjustment Act. He left Columbia to become assistant secretary of agriculture in 1933, and he hired Roy Stryker to work temporarily in the Information Division of the Agricultural Adjustment Administration in the summer of 1934. In May, 1935, when Tugwell became administrator of the Resettlement Administration (RA), which, *sans* Tugwell, became the FSA in 1937, he called Stryker back to direct the Historical Section – Photographic of the RA's Information Division.

Created by executive order and funded under the Emergency Relief Act of 1935, the RA was an independent coordinating agency that inherited rural relief and land use administration from the Department of the Interior, the Federal Emergency Relief Act, and the Agricultural Adjustment Administration. Many of the projects that we now associate with the RA and the FSA – cooperative rural resettlement communities, rehabilitation loans and grants to small farmers, farm debt adjustment, migrant camps, and erosion and flood control – had already been initiated by those agencies. Tugwell's contribution included, of course, the coordination of these various programs, and also the theory that what was needed was a reorganization and reform of agriculture along industrial lines, to be accomplished, according to his "own novel suggestion," by the "rehabilitation of poor people and poor land together in one federal agency."[47] This nationwide, centrally controlled Land Use Program "concerns itself with taking some 10,000,000 acres of submarginal or substandard land out of crop production and converting it to its proper uses," Tugwell wrote in the *First Annual Report*. He hoped that the federal government would be able "directly [to] hold and administer...all areas which cannot at the time be effectively

operated under private ownership" and also to "control the private use of the areas held by individuals to whatever extent is found necessary for maintaining continuous productivity."[48]

Two other aspects of the RA, resettlement and rehabilitation of people who lived on unproductive land, Tugwell saw as necessary components of his overall scheme to control land use. "The object of the resettlement program," he wrote, "is to provide adequate homes and good farm land for those who now toil on substandard land which the Resettlement Administration is purchasing, and for those families who have proved their worth under the Administration's loan program and are eligible for resettlement on better farms. In this way, rural resettlement helps to carry out the program for better land use." Rehabilitation, which included making small loans to farmers, granting funds in emergencies for subsistence needs, and voluntary arbitration of farm debt cases, "represents," Tugwell continued, "the immediate or emergency aspect of [our] work."[49]

The fourth RA task, suburban resettlement, which produced the famous Greenbelt towns, was closest to Tugwell's heart and to the industrial system. "The continuous increase in output per worker both on farms and in factories," Tugwell wrote in 1934, "and the fact that the per capita consumption of many farm products is not very flexible, while the demand for most industrial products seems to be almost indefinitely elastic," made it "practically inevitable" that the farm population would continue to decrease, "once a functioning industry is reestablished to absorb the excess workers." Believing that only "exceptional persons" would want to exist permanently as subsistence homesteaders, Tugwell conceived the Greenbelt towns as suburban centers offering an intermediate lifestyle and culture that could help to absorb both worthy city dwellers and erstwhile farmers into "our general industrial and urban life," which he called "the more active and vigorous mainstream of a highly complex civilization."[50]

Widely and popularly known, the FSA photography project appeals because of its seemingly uncommercial values and procedures – so different from those that characterize the opportunities usually offered to young photographers – and because of the urgently humanitarian rhetoric of its images. The FSA is generally seen as the exemplar of documentary photography, rather than the inheritor and culminating phase of a tradition, and energetic attention of various kinds continues to be paid to it.

Part of an Information Division responsible for all publicity pertaining to the RA and later to the FSA, the photography file, which continued

under Stryker's direction until 1943 and which grew to include some 270,000 prints and negatives (of which 170,000 are now stored at the Library of Congress), was intended to publicize not only the long-standing rural distress which had necessitated such unprecedented federal intervention but also the ameliorative effects and the unique long-range goals of agency programs.

Centralized in Washington, where printing, filing, and distribution of images took place, but employing a core staff of thirteen photographers traveling through the country under project chief Stryker's direction and soliciting useful images from other sources when appropriate, the FSA practiced an apparently modern, if not always in fact well rationalized, division of documentary labor. Although its size, scope, and talented photographers entitle the FSA project to attention, it is not those qualities alone that have ensured its preeminence. "Artists have always been the real purveyors of news," Dewey proclaimed in 1927, aptly describing the coming age of photojournalism, "for it is not the outward happening in itself which is new, but the kindling of it by emotion, perception and appreciation."[51] In the 1930s, the newly founded mass circulation picture magazines worked successfully to establish a public view of corporate photojournalism as a mode of mass communication not only reliable and professional but also "artistic" in Dewey's sense. Not inconsequentially, the camera, with its image both realistic and mass reproducible, rose to become the "central instrument of the age," as James Agee was to write in the 1930s, and the photograph became the central symbol of modern communication. Successful mass communication itself, as Dewey's assertion suggests, bestowed legitimacy upon and thus enhanced the authority of any message; the ability to gather an audience of millions demonstrated a professional skill that wedded art and science and implied the cultural perspicacity to appeal to a common culture and to invoke a shared appreciation.[52] To deploy "the art of full and moving communication," apparently irrespective of what was communicated, was, Dewey seems to suggest, an affirmation of social responsibility. If mass communication was to be an instrument furthering the broad sweep of progressive education, then art might legitimize such an undertaking, demonstrating the cultural authority and professional competence of its principals.[53]

Thus, for example, as former executive editor Wilson Hicks maintained, an issue of *Life* magazine was more than mere entertainment or distraction. Produced by a large and specialized staff working at the highest levels of technical support and visual sophistication, its editorial pages were not only "a design which reflects the world's week in sight and echoes it in

sound," Hicks wrote, but also "a week of life seen from the critical view-point of a free press."[54] At the FSA, as in his later corporate public relations work for the Standard Oil Company, Roy Stryker, proving himself the right man for the times, perceived that by annexing the emergent prestige and authority of professional photojournalism to the already established "scientific" reliability of social scientific experts, he could popularize and glamorize the public images of social science and social work – including, of course, the government's.

As project chief, Stryker managed a growing file of substantial, socially concerned photographs which were supplied free to editors and publishers. If Stryker could ensure photographs that were compatible with corporate photojournalism's modes of production, and if they were also useful in constructing the already established multipage picture story and photo-essay – which quickly became the picture magazines' "formalized" and staple form of presenting current information – then, lending legitimacy to modern style by grounding it in socially current content, FSA photographs might offer to publishers a significant way to deflect any public perception that photojournalistic ventures were socially or professionally irresponsible. It does not go too far, I think, to suggest that Stryker, concerned to advance professional photojournalism, was already, at the FSA, working in corporate public relations. He provided editorial guidance for a team of roughly a dozen talented photographers; but equal achievements were the establishment of a file of useful and authoritative photographs and the construction of an extensive network among publishers and editors to ensure that the photographs were widely used.[55]

Walker Evans, Arthur Rothstein, and Carl Mydans began the FSA's work in the spring and summer of 1935; next hired were Ben Shahn and Dorothea Lange. Russell Lee replaced Mydans in the summer of 1936, and other photographers, including Jack Delano, John Vachon, Marion Post Wolcott, and John Collier, were hired as the project continued. FSA records show that in 1935 Stryker distributed a total of only 965 pictures for publication during a five-month period – an average of 193 a month. The first RA photographs to appear outside a government publication were published in the January and March 1936 issues of *Survey Graphic* (see Figures 3.4 and 3.5), where they illustrated, in both cases, articles that dealt with the dire straits of southern sharecroppers and tenant farmers. Figures 3.6 and 3.7 are examples of the types of images used in the RA annual reports of 1935 and 1936 and in government pamphlets distributed to RA clients. By the end of 1936, Stryker had placed photographs in *Time*, *Fortune*, *Today*, *Nation's Business*, and *Literary Digest*, and he had prepared twenty-three

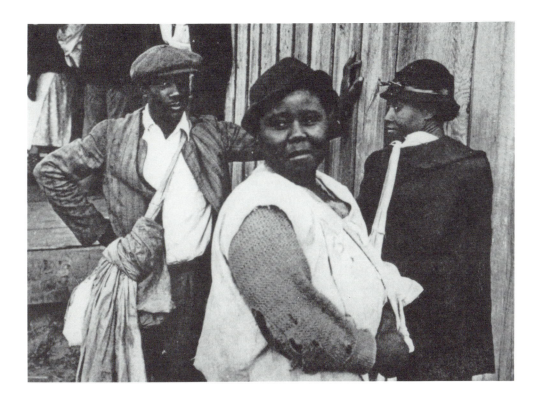

Figure 3.4. Ben Shahn, *Negro Sharecroppers*, n.d. Reproduced from Edwin R. Embree, "Southern Farm Tenancy: The Way Out of Its Evils," *Survey Graphic* (March, 1936), p. 150.

exhibits, including one at the Museum of Modern Art and another at the Democratic National Convention of 1936. (Figure 3.8 shows an FSA exhibit in Dallas.) *U.S. Camera* used four RA photographs in its salon of 1936, and the newly founded *Look* published an RA spread in 1937.[56] By 1938, the year of real flowering for Historical Section photography, neither Evans nor Shahn remained on the payroll, and Dorothea Lange, working on a per diem basis, was on her way out. But in that year, Willard Morgan's Grand Central Exposition of Photography gave the FSA an entire – and hugely popular – section, which the Museum of Modern Art later toured as a separate traveling exhibition.[57] The newspapers and magazines that used FSA photographs included not only *Look, Life*, and the *New York Times*, but also *Junior Scholastic*, the Lubbock (Texas) *Morning Avalanche* and the *Birth Control Review*. Edwin Rosskam was hired in 1938 solely to design

109

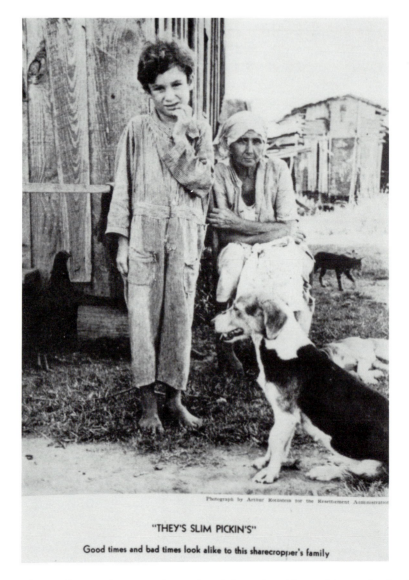

Figure 3.5. Arthur Rothstein, *Sharecropper's Family*, n.d. Reproduced from Lilian Perrine Davis, "Relief and the Sharecropper," *Survey Graphic* (January, 1936), p. 20.

Figure 3.6. Uncredited FSA photographer, *Rural Rehabilitation in the South*, n.d. Reproduced from Resettlement Administration, *Interim Report* (Washington, D.C.: Government Printing Office, April, 1936), p. 8.

exhibits and to promote and supervise the use of FSA photographs in books, and that year also saw publication of Walker Evans's *American Photographs*, Archibald MacLeish's *Land of the Free*, and Herman Nixon's *Forty Acres and Steel Mules*.

In 1940, the Historical Section could claim an average picture distribution of 1,406 images per month, and by 1942 the number of published books illustrated with FSA photographs approached a dozen, including Dorothea Lange and Paul Taylor's *American Exodus: A Record of Human Erosion*, James Agee and Walker Evans's *Let Us Now Praise Famous Men*, Sherwood Anderson's *Home Town*, Richard Wright and Edwin Rosskam's *12 Million Black Voices*, and Arthur Raper and Ira Reid's *Sharecroppers All*.[58]

Figure 3.7. Uncredited FSA photographer, *Rural Rehabilitation in Indiana*, n.d. Reproduced from Resettlement Administration, *First Annual Report* (Washington, D.C.: Government Printing Office, November, 1936), p. 8.

Although its operation was of course much smaller than that of a picture magazine, nevertheless a formidable bureaucracy, laboratory, and clerical staff were necessary merely to maintain the FSA file. To caption, record, and distribute an average of seventy prints a day (as indicated by the 1940 figures) required the kind of time-consuming and labor-intensive information processing and visual record keeping that is theoretically, if not always practically, done today by computers, video, and even newer technologies. Despite some opposition, the operations of such "ponderous ma-

Figure 3.8. Photographer unknown, *Resettlement Administration Exhibit at the Texas Centennial Exposition, Dallas*, n.d. Reproduced from Resettlement Administration, *First Annual Report* (Washington, D.C.: Government Printing Office, November, 1936), p. 99.

chinery," as Edwin Rosskam called the office procedures, affected the content and the interpretation of images in the picture file.[59]

The FSA program divided the United States into eleven administrative regions. As correspondence shows, photographers in the field depended on local FSA officials and other knowledgeable and concerned people such as health officials, social workers, journalists, and farmers themselves to guide them to their subject matter. However, all FSA negatives, no matter where they were made, were sent to Washington for editorial selection, printing, and captioning based on the photographers' field notations, and all distribution was centralized in Washington. Unwieldy at best, this arrangement became a source of friction when regional needs for local and topical photographs conflicted with Stryker's emerging policy that promoted national publication over all other picture uses. "The [Dorothea] Lange negatives which you mentioned in your letter . . . have arrived and are now being catalogued in the files," wrote executive assistant Grace Falke in 1936 to Jonathan Garst, FSA regional director for California and the West, adding that, "it will be a few days before we will be able to send any of this material on to you." But there was, she continued, "one additional fact" that Garst needed to consider:

The Information Division has found it very desirable to offer such magazines as LIFE and MID-WEEK PICTORIAL and the large metropolitan dailies the exclusive

use of certain sets of pictures, provided they are published within a certain length of time. Some of the material in Miss Lange's set seems most desirable to be used in this manner.

In view of this policy, she continued, Garst would not be able to receive for "local circulation" all of the photographs he wanted until after "they have been used by these magazines with national circulation."[60]

As her biographers have shown, difficulties with Roy Stryker arising from Dorothea Lange's determination to control her negatives and to use her photographs to publicize regional current events led eventually to her dismissal from the FSA in 1939.[61] Correspondence and interviews make clear that similar issues contributed to Walker Evans's dismissal in 1937 and to Ben Shahn's resignation in 1938.

By 1935, Evans and Shahn, friends who had shared a Manhattan studio, had labored for some time to establish themselves, trying their hands at various kinds of art. Having exhibited in group shows in New York and elsewhere since 1930, Evans was given a one-man exhibition, "Photographs of Nineteenth Century Houses," at the Museum of Modern Art in 1933. He undertook several commissions to photograph works of art, collaborated with the poet Hart Crane on illustrations for two editions of Crane's *The Bridge*, and in 1932 traveled to Cuba on a book illustration commission. Beginning in 1930, Evans published photographs in various magazines, and in 1934 he sold his first set of photographs, on the subject of the Communist party, to *Fortune*.[62]

Shahn's three one-man shows at the Downtown Gallery during the years 1930–33, of which the most important and successful was *The Passion of Sacco and Vanzetti* in 1932, established him as a painter and muralist. In 1932, he worked with Diego Rivera on the Rockefeller Center mural project, and he participated in the group exhibition of murals and photographs at the Museum of Modern Art in that year. Joining the New Deal's Public Works of Art Project in 1934, he worked on a projected but unrealized series of murals for the Central Park Casino.[63]

Although, in 1935, Shahn and Evans still struggled to earn a living, each had become sufficiently confirmed in his ambition to have defined a style and subject uniquely his own. "Here was something to paint!" Shahn concluded his long contemplation of the "crucifixion"-like Sacco–Vanzetti case. "From then on, I knew what I wanted to do, and I've been doing it ever since."[64] Speaking with an interviewer in 1971, Evans remembered how it felt to be an "inventor," which, as he pointed out, "a stylist is": "I was doing some things that I thought were too plain to be works of art.

...I knew I *wanted* to be an artist, but I wondered if I really *was* an artist. I was doing such ordinary things that *I* could feel the difference, but I didn't have any support."[65] Such doubts about style and subject seem to be belied, however, by an authoritative statement that Evans wrote in 1935 or 1936 as an unpublished author's note for *American Photographs*:

These anonymous people who come and go in the cities and who move on the land; it is on what they look like, now; what is in their faces and in the windows and the streets beside and around them; what they are wearing and what they are riding in, and how they are gesturing, that we need to concentrate, consciously, with the camera.[66]

Like Lange and other FSA photographers, Shahn and Evans took seriously their opportunity for government work, and it seems beyond doubt that each was concerned to contribute his talents to the fullest. Speaking to an interviewer in the 1960s, Shahn praised as "very beautiful" the "esprit de corps" he found at the FSA; noting the agency's "strange harmony with the time," he made it clear that he set great value on the FSA's function, feeling "a real, total commitment" to his work both as a Special Skills designer and artist and as an Historical Section photographer.[67] Evans as well, in a 1935 letter to John Carter, then head of the Information Division, proclaimed himself "exceedingly interested in the [FSA] undertaking, which seems to me to have enormous possibilities, of precisely the sort that interest me." Just as they had come to understand the difficulties they faced in realizing their high ambitions, however, Evans and Shahn must also have learned the costs to an artist of confusing or compromising his or her purpose. Naturally, both artists sought to assert the kind of control over their work that, experience taught, was crucial to its success; and their process of constant clarification and redefinition of artistic identity and esthetic purpose led them inevitably into conflict with the FSA. Thinking over his permanent appointment to the Historical Section, Evans was concerned with the possible encroachment of "politics" or "propaganda." He intended "never [to] make photographic statements for the government or do photographic chores for gov or anyone in gov [sic]," because he believed, as he wrote in a memo intended perhaps only for himself that "The value and, if you like, even the propaganda value for the government lies in the record itself which in the long run will prove an intelligent and farsighted thing to have done."[68]

In his early letter to Carter, Evans also mentioned his determination, based on "a certain craftsman's concern," to "allow [himself] time to make all the necessary prints [from his FSA negatives]." Hoping to persuade

Carter "to agree with [him] that the only really satisfactory prints of a careful photographer's negative must be made by the original photographer," Evans makes all too manifest a "craftsman's" determination that must have seemed to Roy Stryker as inadmissably stubborn as Dorothea Lange's somewhat differently motivated efforts to control her own work. Evans continued to make prints from FSA negatives for his own use throughout his tenure, and this practice, combined with his well-known inaccessibility and low output, added up, for Stryker, to grounds for dismissal after two years on the payroll.[69]

Describing his own reasons for resigning from the photography project in 1938, Shahn took into account the agency's treatment of Evans. Though Shahn was on the RA and FSA payrolls from 1935 to 1938 and worked later for the Office of War Information as well, his direct employment by the Historical Section was brief. Assigned to travel for three months to learn about depression conditions in preparation for his Special Skills work, Shahn took a camera along because he "felt there wouldn't be enough time to draw," and he presented the Historical Section with his negatives from that trip as a gift. In 1938, he covered the harvest in Ohio for a month and a half as a photographer for the Historical Section.[70] To an interviewer in the 1960s Shahn described his FSA photographs as documents for himself – "a lot of paintings came out of it over the years" – and, calling photography "a mind and an eye, but not an art," he firmly refused to privilege, or even to distinguish, photographic communication in relation to other visual mediums: "To me images are images. I don't care whether they're made with pen, pencil, brush, they're images, and they can be moving or not." His FSA photography "was not my livelihood nor my career," Shahn said – "to everybody's amazement I resigned [after the Ohio trip]. I had a big mural to do and photography ceased to interest me suddenly....I felt I would only be repeating myself and stopped it dead."[71] Despite this firm detachment, Shahn's recollections hint at some aspects of the project that would have disappointed him had he intended to make FSA photography an integral part of his career. Although Shahn believed that the FSA project "would not have gone on under anyone else" except Stryker, he nevertheless blamed him for changes that occurred in the agency. In the beginning "there were no instructions," but later on the FSA became "a little bureaucratic," and assignments for work "became a little more specific." He "personally didn't like the idea of the dictation that went with it." Evans, Shahn said, had reasons in addition to print quality not to "get along too well with Stryker," and Shahn makes clear that had he needed a further reason to leave the section, Stryker's dismissal of Evans, "the

best photographer we had there," would have provided it: "Walker Evans, who had the least number [of photographs] because he is such a perfectionist, was the one who was dropped . . . and I thought that was insane."[72]

For Evans, Shahn, and Lange, photographers and artists who had each achieved a mature style and defined an individual project by the 1930s, bureaucratic impositions, and the mentality they implied, were inevitably deeply provoking. But even in the work of younger and less established photographers who welcomed their project work as a springboard to a journalistic career, there is an implicit contradiction between the social photographer's role as creator of graphic records of people in a particular time and place and the agency's need to use photography as photojournalism and as publicity symbolic of a national reform program.

According to Paul Vanderbilt, the photographic archivist responsible for the current organization of FSA files in the Library of Congress,

[a] change in the point of view came about gradually, partly as photographers themselves began to turn in pictures not strictly in line with their program assignments, and partly as the program assignments themselves began to be based upon possibilities for publication.

"It was doubtless a publisher's demand," Vanderbilt claimed, "which caused the concept of the survey to go beyond its limitation to rural America and depressed conditions and [to include] the urban areas and [more] sophisticated activities."[73] Despite Vanderbilt's claim, however, the caption material actually submitted with their photographs suggests that most FSA photographers, little concerned with "possibilities for publication," took their documentary function seriously. Garnering details that celebrated their opportunities, as social photographers, to respond to what Hine had called "the beautiful and the picturesque in the commonplace," they referred in their captions and field reports to what had been powerful and engaging about the actualities they confronted in their work.[74]

Figure 3.9 shows captions probably written by Sheldon Dick, a filmmaker and short-term FSA employee, which record in much more detail than would ever see print the circumstances of an FSA client borrower. Dick reports not only the name of the client's FSA supervisor, the amount of his FSA loans, the size of the farm he works as a tenant and the nature of his crops, but also his sons' aspirations, his reading materials – *Grit, The Pennsylvania Farmer*, and *Capper's Weekly* – and his leisure-time music making and lesson giving on the violin, piano, guitar, and mandolin.

Figure 3.10, a draft of captions written by Ben Shahn in 1938 for a set

117

4.

71M5: **Farm Supply Co.** Ephrata, Lancaster Co. Pa.

Thomas G. Evans, R.D.2, Barto, Berkshire County, Pa. Rehab-
ilitated FSA client, under Carl Ifverson, FSA supervisor, Reading.

Evans is 44, and his wife Helen M., 40. He has two sons.
Joseph 18, who works on the farm, and wants to go to Penn. State, to study
agriculture-- a 4 months course. A second son, Dick 19, is majoring in
English at Ursines College on a scholarship. He is a junior this year,
and he wants to teach.

The farm consists of 65 acres which he works on shares.
Evans gets 2/3 shares, and the landlord 1/3.

Evans bought with his FSA loan, 2 horses, a corn planter,
a binder, a feed grinder, and 3 3/4 tons of fertilizer. He had cows from
a prior resettlement loan. His loans have been:
1. Feb. 1936...$250.00
2. Oct. 1936... 50.00
3. Apr. 1938.. 458.00
His loans are due in 1939 and 1943, and he is up to date
in his payments.

He has 11 acres in wheat, 15 acres in corn, 9 acres in oats,
11 acres in hay, 2 acres in potatos, 1 acre of home garden, and 7 acres
of pasture. His farm is valued at between $2500.00 and $3000.00. He
works a 4 year crop rotation, corn, oats, wheat, and hay. He reads
' Grit', "The Pennsylvania Farmer", and "Capper's Weekly". He plays
violin, piano, guitar, and mandolin, and he teaches music to the neigh-
boring farmers' boys for fun.

His gross income from the farm is $792.00 plus $360.00 which
he receives for boarding Mrs. Evans' grandmother, Mrs. Springer. Therefor
his total gross income is $1152.00. Farm expenses are $493.00, and
living expenses are $251.00 per annum.

These pictures were shot in August, 1938

72M3: Evans farm, Berks. Co. Corn crib
72M4: " " " " Joseph Evans
74M1: Country fair, sponsored by the American Legion. Lancaster Co.
74M3: " " etc. Scene painter
74M4: " "
75M1: Sign of town of Lititz, Lancaster Co. Pa.
75M3: Sign board (near) Lititz,
75M4: Barn near Lancaster, advertising the country fair.
75M5: Country fair etc. Gypsies.
76M2: Letter box of Minnich farm, Lititz, Lancaster Co. Pa.
77M1: Thomas G. Evans farm, Berks. Co. Mrs. Springer, Mrs. Evans' grand-
 mother.

77M3: " " " " " " Threshing
79M2: " " " " " " Thomas G. Evans.
79M4: " " " " " " Mrs. Springer, Mrs. Evans' grandmother
80M1: " " " " " " The pump.

Figure 3.9. Photograph captions written by Sheldon Dick. Library of Congress.

Figure 3.10. Photograph captions written by Ben Shahn. Library of Congress.

of photographs of Plain City, Ohio, includes with straightforward captions a dry recitation of a relevant tale heard locally:

Hard-pressed farmer came to banker for loan. Farmer not a "good risk." Banker refused coldly. Farmer pleaded. Banker, moved by the plea, makes a sporting offer – "one of my eyes is glass. It is considered a perfect match for the other. Guess which eye is glass, and I'll let you have the loan." Farmer gazed intently at both eyes. Finally pointed at left eye, saying, "This is the glass one." Banker, amazed: "How did you guess?" Farmer: "It looked kinder."

In Figure 3.11, we see the original caption that Dorothea Lange provided for her photographs of Nettie Featherston, the "Woman of the High Plains" shown in Figure 3.12 in a reproduction from *An American Exodus*. Poor captioning was not one of the faults that Roy Stryker found with Lange's work; on the contrary, he held her up as exemplary to other photographers. As this caption suggests, she often tried to reproduce verbatim what her picture subjects had said to her. We see from the full caption that its last lines – "If you die, you're dead – that's all," which are used in the book – mean something different from what the book implies. Nettie Featherston is talking about her hard life as a migratory worker in Childress County, Texas – "a hard county," where "you can't get no relief...until you've lived here a year," and where "they won't help bury you" – and about her thwarted desire to leave it. The bleak assessment – "if you die, you're dead" – is not Mrs. Featherston's view, as the book implies. Rather, showing a kind of spiritual strength comparable to that of Hine's *Head of the Checkroom* (Figure 2.16), Mrs. Featherston, controlling her outrage with dry irony, uses the phrase to characterize the callousness of arrogant county relief authorities who might be expected to justify their refusal of a pauper's grave to the poor simply by denying that there was any possibility of afterlife for them.[75]

In its shorter and more bluntly dramatic form, the caption is an esthetic enhancement of the image; its unlikely, irreligious denial of any hope augments the sense of isolation conveyed by the monumental figure silhouetted against an almost featureless sky. But this sense, of course, traduces the ironic social comment expressed by the phrase in its fuller context – and which seems, once we know it, further expressed by Mrs. Featherston's pose, which combines bitter amusement with a gesture of frustration. But despite such occasional straining after dramatic effect at the expense of complex and vigorous meaning, there is implicit in Mrs. Featherston's dissatisfaction, and explicit in the comments of other farmers

Figure 3.11. Photograph captions written by Dorothea Lange. Library of Congress.

18283 C Migratory laborer's wife with 3 children.
Near Childress, Texas.
"We made good money a pullin' bolls, when we
could pull. But we've had no work since March
When we miss, we set and eat jest the same.
The worstthing we did waswhen we sold the
car, but we had to sell it to eat, and now we
cant get away from here. We'd like to starve if
it hadn't been for what my sister in Enid sent
me. When it snowed last April we had to burn
beans to keep warm. You cant get no relief here
until you've lived here a year. This county's a
hard county. They wont help bury youhere. If
you die, you're dead, thats all."

18284 C Campaign posters in garge window, just before
the primary. Waco, Texas.

18285 C J.R. Butler, president of the Southern Tenant
Farmer's Union, Memphis, Tennessee.

18286 C Mechanization in the Arkansas Bottoms was
beginning to expel farm people by 1937, adding
to the refugees to the West coast. There are many
vacant cabins. Near England, Arkansas.

18287 C Fruit jars being sterilized on Old Lady Graham's
back fence in berry season. Near Conway, Ark.
"We just gather and can --peas, beans, berries,,
and sausage when we butcher a hog in the winter.
We put up 75 quarts of berries, 60 qts of beans,
60 qts of kraut, 30 qts of grapes, and 20 qts
of peaches. I swapped 2 bushels of grapes and got
2 bushels of peaches, --and I swapped one bushel
of grapes for one bushel of apples."

18288 C Colored field hands hoe cotton from 7 A.M. To
6 P.M. for 60¢ a day. Near Menipee, Arkansas.

18289 C An"Arkansas Hoosier" , born in 1855.
Conway, Arkansas.
"My father was a Confederate soldier. He give his age
a year older than it was to get into the army. After the war
he bought 280 acres from the railroad and cleared it. We
never had a mortgage on it. In 1920 that land was sold,
and the money divided. Now none of my children own their
land.
"It's all done gone, but it raised my family"
"I've done my duty --Ifeel like I have. I've raised 12
children, 6 dead and 6 alive-- and 2 orphans.
"Then all owned their farms. The land was good and there
was free range. We made all we ate and wore. We had a loom
and a wheel. The old settlers had the cream. Now this hill
land has washed, and we dont get anything for what we sell.
We had two teams when this depression hit us. We sold one,
we had to to get by, and we sold 4 cows.
"In 1935 we got only 50 and60¢ a hundred pounds for
picking and in 1936 only 60 and 75¢, and we hoe for 75¢ a day.
"Then the govt reduced the acreage, and where there was
enough for 2 families now there's just one. Some of the land
owners would rather work the cotton land themselves and get
all the govt. money. So they cut down to what they can work,
and the farming people, they go to town on relief. The
sharecroppers are just cut out.
"Then the lord took a hand init, and by the time he'd
taken a swipe there was drouth and army worm. I dont know
for sure whose work it was, the lord's or the devil's, but
in 3 days everything wilted.
"Folks from this part has left for Calif. the last yr. Two
My 2 grandsons went to Calif tohunt work. It was a case of "haf to".
When you see 'em out there tell 'em you were talkingto OldLady

GRAHAM, IN ARKANSAS

121

"If You Die, You're Dead—That's All"

and migrants recorded in the book, an important subject that was in fact the major thrust of *American Exodus*. The book traced the effects of machinery on agriculture throughout American history and, as its full title – *A Record of Human Erosion* – suggests, it exposed with poignance the current human costs of progress. Farmers' foreclosures and forced migrations during the 1930s resulted not only from drought and soil erosion, but also from the introduction of mechanized methods that required less labor and encouraged large-scale operations at the expense of small farmers. In addition, government incentives for acreage reduction further decreased the demand for labor. "Farms are growing bigger and fewer.... Landlords clash with their tenants over the crop reduction check, not openly or in organized fashion," Paul Taylor wrote from Childress to government researchers in June 1937. "But the landlords force tenants off the place, they use the government checks and their own livestock as payments on tractors, so more and more tenants 'can't get a farm.'"[76]

The displacement and proletarianization of farmers caused by mechanization, which Taylor reported from Childress (as did others elsewhere in the country), was of course an aspect of modernization anticipated by Tugwell. What concerned Taylor as an agricultural economist, however, was the contradiction he perceived between the government's unheralded commitment to the technological and economic processes of rural modernization and its vociferous and well-publicized proclamations of "greater obligation to poorer farm families," and "successful rehabilitation through better farm and home practices." This less than forthright management of information about the larger consequences of governmental agricultural policies was, as Taylor pointed out, especially exemplified by the failure of the widely read report of the 1936 Committee on Farm Tenancy to analyze mechanization as a major reason for the collapse of the farm tenant system. As both Taylor and Lange had perceived, the FSA had no stake in upholding farming traditions or in preserving the economic bases of local cultures and attachments if they stood in the way of economic efficiency or technological progress. It was certainly the force of this perception that gave political animus to Lange's disputes with Stryker over matters that seem, on the surface, merely technical or bureaucratic.[77]

Not long before his death, Roy Stryker called the image shown in Figure 3.13 an eloquent statement of the notion, "These are the hands of Labor," thus adding his praise to a chorus of humanitarian interpretations which

Figure 3.12. Dorothea Lange, *"If You Die, You're Dead – That's All." Texas Panhandle, 1938.* Reproduced from Dorothea Lange and Paul Schuster Taylor, *An American Exodus: A Record of Human Erosion* (New York: Reynal & Hitchcock, 1939), p. 101.

Figure 3.13. Russell Lee, *Wife of a Homesteader. Woodbury County, Iowa, December 1936*. Library of Congress.

had begun with the first publication of the photograph in 1937. In 1939, Elizabeth McCausland, an influential leftist art critic and collaborator with the photographer Berenice Abbott on the *Changing New York* series sponsored by the Fine Arts Project, described Russell Lee's photograph as "a human and social document of great moment and moving quality." She went on to say: "In the erosion of these deformed fingers is to be seen the symbol of social distortion and deformation: waste is to be read here, as it is read in lands washed down to the sea by floods, in duststorms and in drouth [*sic*] bowls." McCausland was writing in *Photonotes*, the publication of the Photo League, a New York-based organization of young photographers including Paul Strand, Aaron Siskind, and Jerome Liebling that was connected in various ways with the Communist party. In her article, titled "Documentary Photography," Lee's photograph is used to support the argument that "the best sponsor of knowledge" about "social themes,"

124

Figure 3.14. Russell Lee, *Mr. and Mrs. Andrew Ostermeyer, Homesteaders. They have lost their farm to a loan company. Woodbury County, Iowa, December, 1936.* Library of Congress.

as well as about "soil erosion and flood control, highway engineering, agricultural experiment stations and numerous other important technical activities," has been "the government."[78]

The most obvious quality in Lee's photograph is, of course, its subject's lack of a head. In the further absence of any original caption that refers to that lack, the immediate meaning of the image seems to reside in its important departure from the portrait convention to which it partially subscribes in its frontality, single subject, and detailed rendering of dress. Exactly this bafflement, or deflection, of the partially engaged convention makes this image quintessential "documentary art" – as McCausland and

Stryker, two reliable ideologues, certainly thought – rather than a "work portrait" like Hine's, or a personal record portrait bought and paid for. The photograph excludes any reference to the circumstances of its making, to the human interaction that occurred between the woman who was subject and the man who was photographer at the moment of the picture's making. Specifically, we cannot know or even imagine from this image whether the woman was posing for a portrait – unaware, of course, of how the image was actually being framed – or whether she was caught in conversation, perhaps with Lee, perhaps with someone else. No documentary caption or text makes the missing human connection, nor (as it would in a commissioned portrait) does requisite attention to the particularities of pose, costume, and setting register implicitly the economic transaction between the sitter and the photographer that brought the image into being. Although the unusual framing seems to direct our notice, as it were, to the lack of anything in the picture's content suggesting the economic or other motive that sparked the picture making, the documentary style thus signified nevertheless manifests its own intention and purpose. As a rural person, this woman stood in some relation to the FSA. Like the ruined and wasted rural land with which she was equated, she was – or soon would be, or at least ought to be – an FSA client, under FSA management. In fact, Mrs. Andrew Ostermeyer, seventy-six years old, and her husband, eighty-one, as the Library of Congress file captions tell us, had been among Iowa's original homesteaders. Since having lost their farm to a loan company, however, they have worked and lived on their son's farm in an area of exhausted Iowa farmland hard hit by drought, one that did include numerous rehabilitation loan clients and applicants. The picture that became so popular, as well as several other images of the Ostermeyers such as the one shown in Figure 3.14, were taken on Lee's first major trip for the FSA. In two letters to Roy Stryker sent from the field in December 1936 and January 1937, Lee described the conditions he found in Woodbury and Crawford counties – the "worst hit district of the [Iowa] drought counties." "Today I have talked with township chairmen of drought committees and they have shown me several places," Lee wrote. He had seen "several destitute families" and learned that there was "practically no feed for the hogs, cattle, and horses, and what there is is supplied through the [FSA] which is flooded with applications for loans and grants. In the opinion of these local men," Lee continued,

there is danger of an uprising unless immediate aid is forthcoming. . . . In Crawford county as well as Woodbury county, I have heard some threats of uprising. That

is one of the strongholds of the Farmers Holiday Association and there is quite a bit of agitation in these two counties. In Crawford county a Farmer-Labor paper is published. I am sending you 2 copies of it together with a statement of conditions one farmer who showed me around voluntarily prepared and presented to me.[79]

Comparing the two Ostermeyer images, we can see why one and not the other became popular. Far from noble, seeming both agitated and disoriented, the aged couple, standing near the headboard of a brass bed, piques our curiosity and cries out for explanation. Lacking artful composition, the photograph seems more connected to real life, and the questions it provokes draw us directly into the Ostermeyers' social world. We wonder if they speak English, if they are healthy and well cared for, and what exactly they had been doing (and if they had consented) when Lee decided to photograph them. Ironically, the hands of both Ostermeyers seem even larger and more gnarled when seen in proportion in the double portrait than do Mrs. Ostermeyer's hands in the image composed to show off precisely those qualities. In the same way, reflection makes clear, it is by our informed reading of the details of the larger world of actual social and political reality attendant upon the portrait – rather than by our necessarily limited response to the more stylized statement – that we appreciate the heroic, if vulnerable, qualities that Lee evidently sought to convey. The image of Mrs. Ostermeyer's hands seems to state, with its iconologically important frame, a too-transparent intention to be somehow significant by itself, in an idealized realm apart from topical and current events. It encourages categorial, rather than particularizing, interpretations, and the actual circumstances of the social and political reality that Lee experienced in his camera work are exactly what the image represses and conceals. Unlike the double portrait, the "hands" image does not engage current and painful contradictions between such rural aspirations and traditions as were embodied in this woman and her family and neighbors, and – not only drought and erosion on submarginal land – but also what was in fact, as Dewey had written, humanly "harsh and narrow" in the social and technological change for which the FSA was agent.[80] Because representation of these crucial social facts is missing, the popular photograph seems, to the informed and critical eye, to diminish its subject and to encourage irresponsible interpretation. But it is exactly the absence of complex social reference – combined with telling graphic appeal – that makes the image attractive and meaningful to a wide audience, ensuring its success as a popular symbol of humanitarian sentiment. Such humanitarianism as we acknowledge in the "hands" photograph is inscribed in the careful framing that eliminates Mrs. Ostermeyer's particularity and

127

presents her suffering abstracted, so that Lee's reportage offers the possibility of esthetic and even sentimental appreciation.

Certainly McCausland could not have interpreted the Ostermeyers' double portrait in the same way as she did the hands; and it is of course unlikely that, knowing the facts, she would have read that photograph as she did. It seems doubtful that she would so assuredly have described as "waste" the Ostermeyers' life of homesteading, which after all constituted the original, courageous (and government-sponsored) importation of agriculture and its way of life to Iowa. Nor do the printing and distribution of a militant farmer–labor newspaper in two isolated Iowa counties, the formation of drought committees, and the preparation of a statement of conditions to the government seem like examples of "social deformation."Responding to the photograph as it was presented to her and to its mass audience, however, McCausland gave it an "artistic" reading that goes well beyond Lange's and Taylor's equation of human and social distortion and deformation with geological erosion and waste. The crux of McCausland's reading rests on a technocratic assumption that underlies and makes possible her metaphor: just as soil erosion and waste can be controlled by efficient land management, so the putative *social* deformation and waste shown in the photograph can be controlled by social and cultural management. McCausland's reading not only captions but also captures Lee's image, annexing its very realism to a set of assumptions that could hardly be more detached from, indeed antithetical to, the social reality of this woman homesteader.

By 1937, Ben Shahn told an interviewer in the 1960s, children he met in the field had become "very sophisticated" – enough to be sure that the documentary photographer's presence among them was commercially motivated and that his interest in their lives meant that he "work[ed] for *Life* magazine."[81] In the next year FSA Information Division director John Fischer sent a memo to all regional information advisers explaining a "reorganization of the ... photographic program" undertaken in the wake of budget cuts because "the Washington photographic staff has never been able to provide entirely satisfactory service for the regions." Fischer asked regional advisers – many of whom, according to his memo, were "already competent photographers" – to do all their own photographic work of a "special regional character," while "the Washington photographic staff will continue to handle most material of national interest, or which covers a number of regions," taking whenever possible not "single, isolated shots," but rather picture sequences, a practice which, as Fischer wrote, "the best picture editors everywhere are developing."[82]

128

The "unsatisfactory service" so clearly at issue for Dorothea Lange and for regional officials in California is further illustrated in correspondence from the South and Southwest. Although the agency's most popular traveling exhibit, the exhibit on migrants, was requested over eighty times in a three-year period, none of those requests came from Oklahoma, Arkansas, or Texas; and, equally telling, the southern states did not make a single request for the next most popular exhibit, on sharecroppers.[83]

It was in these same years that James Agee, composing the text for *Let Us Now Praise Famous Men*, made his claim for the camera's preeminent status and went on to proclaim his "rage" at a "misuse" of photography, which had, he wrote, "spread so nearly universal a corruption of sight that I know of less than a dozen alive whose eyes I can trust even so much as my own." Foremost among those whom Agee trusted was, of course, Walker Evans, his friend and collaborator on *Famous Men*, and the photographer of whose work Paul Vanderbilt was to write in the early 1940s that it "was never quite divorced from an instinctive cynicism or even the hatreds inherent in his personal philosophy" and was thus of little use to FSA "programs."[84] As Agee perceived, the reportorial camera was readily dedicated to the cultural modernization for which Patten had called some thirty years before; indeed, the terms of its instrumentality seem to be specified in a particularly prophetic diary entry that Rexford Tugwell made in 1935. Because "there is very little public sympathy" for "the poorest agricultural folk" whom the FSA intended to "help out," Tugwell wrote, "it must be one of our first considerations to try always to conciliate public opinion so that we may go ahead in the effort to lift the levels of living of these people."[85] Where Hine would "educate," Tugwell wanted to "conciliate" public opinion, and the new purpose is significant. Tugwell did not stress the interaction between photographer and subject that previously had grounded the currency and authority of the documentary image and provided the photographer's documentary impetus. Rather, his subtle redefinition of social publicity assumes both the persuasion exerted and the artifactual and cultural consumption offered by the purveyor of images to his middle-class audience. That such an audience, or market, could be gathered only through the commercial mediation of corporate mass communications was no cause for concern.

As we have seen, the subjects of FSA photographs were presented to their mass audience shorn of social and cultural vigor and interest, not only by framing and composition but also by text, caption, and graphic arrangements that made of local particularities, collectivities, and attachments simultaneously examples of outmoded "social emotions" and nostalgic

129

evocations of a receding popular life. They seem indeed "the most friend-
less, hopeless people in the whole country, [whom] nobody wanted to see,"
as Tugwell said of them.[86] But it was exactly their hopeless maneuvera-
bility, their enforced lack of attachment, that made such rural people the
ideal "symbols of ideal life" that it was finally the purpose of FSA pho-
tography to create. Having nothing to lose, they were unthreatened by
change – they were an exemplary constituency for reform.

It comes as no surprise that Elizabeth McCausland, the Photo League,
and many others proclaimed that the loss of particularity and the more
formalized and editorialized representation that they saw in FSA photo-
graphs signified a new, transcendent, "social art which cannot be silenced,"
with "the integrity of a style," and with a special "Americanness" – a
quality that linked FSA work to "the continuity of American life and tra-
dition" that, they claimed, the photography preserved and continued, just
as the economic aid and expertise of the FSA program as a whole claimed
to preserve and continue rural productivity.[87] FSA photography exploited
the conventions of documentary style – such as black-and-white prints and
uncontrolled lighting – that signified topicality, social concern, and social
truth, but in actuality these critics celebrated the development of a new
graphic rhetoric. They rightly perceived that the individual, but no longer
particular, subjects of FSA photographs connoted less the project's iconog-
raphy than its iconology: the conventional documentary realism that
such content signified helps to direct our reading of a mode of visual
communication which, giving symbolic form to communications technol-
ogy itself, imaged an American instrumentalism that eased accommoda-
tion to perpetual change and gave grounds for popular approval of
engineered "progress." FSA photography offered to its urbanizing and sub-
urbanizing audience a mode of "art" and communication that conven-
tionalized both currency and nostalgia; its documentary style evoked a set
of "humanitarian" responses that masked the loss of once-valued respon-
sibilities, perceptions, and attachments.

The FSA photographs quickly achieved the status, as Tugwell told an
interviewer in 1965, of "an art form," a judgment that his mentor John
Dewey would probably have approved. The project's deployment of doc-
umentary realism legitimized reform in ways that pre-war activists could
only dream about; yet today as in the 1930s the project's mass of images
provides neither the resolution of art nor the particularity of documentary.
Like many other artifacts of New Deal culture, the FSA collection offers
instead an instrumentalist's utopia, where the pain of change is not only
rewarded but also vindicated by ever-immanent progress.[88] The project

130

stands today as a compelling and enduring monument to the cultural prestige of liberal reformers; but the acclaim it is granted reveals the extent to which central institutions and communications modes have diminished the authority of artistic and political perceptions and installed in their place the devalued currency of instrumental discourse.

Chapter Four

IN CONCLUSION: STRYKER, STEICHEN, AND THE SEARCH FOR "A GOOD, HONEST PHOTOGRAPH"

In the waning days of the New Deal, as World War II approached, the need for a yet more ideological and abstract image became more pressing and constraining on the FSA. In a famous memo, Roy Stryker called in 1942 for photographs of "people with a little spirit," particularly "young men and women who work in our factories, [and] the young men who build our bridges, roads, dams and large factories." As the Historical Section–Photographic was transferred from the FSA to the Office of War Information (OWI), and the FSA itself fought to survive in the face of congressional attacks, the possibilities for complex representation grew slimmer. Stryker wanted "pictures of men, women and children who appear as if they really believed in the U.S.," and he urged photographers to concentrate on "shipyards, steel mills, aircraft plants, oil refineries, and always the happy American worker." Their images came to look, according to photographer John Vachon, discouragingly "like those from the Soviet Union" (see Figure 4.1).[1]

Finding that his position had changed from "editorial director to ... administrative operator," and that under the OWI the section had become – as he wrote to Dorothea Lange – "a service organization ... maintaining the files, running the laboratory, and hunting pictures from other Government Agencies," Stryker resigned in 1943 and went to work in corporate public relations for the Standard Oil Company of New Jersey (SONJ). The new job, Stryker claimed, would help him "find out how the other half of America lives."[2]

Two decades later, in 1962, photography department head Edward Steichen mounted "The Bitter Years, 1935–1941" at the Museum of Modern Art (MOMA). The revival exhibition, dedicated to Roy Stryker, introduced not just the Depression but also the work of the FSA photographers "into the consciousness of a new generation," Steichen claimed, and it revealed "the endurance and fortitude that made the emergence from the Great

133

Figure 4.1. Arthur Rothstein, *Exhibit at Grand Central Station. New York City, New York. 1943.* Library of Congress.

Depression one of America's victorious hours."[3] The show featured brief, thematic captions as well as overblown prose. Lee's "Wife of a Homesteader," for example, was identified only by the photographer's name and the caption "Old Age"; and such methods sealed the fate of FSA photography as, in Rexford Tugwell's phrase, "an art form." Seven years earlier, in 1955, Steichen had mounted his phenomenally successful "The Family of Man," which used universalizing, apolitical themes to organize 503 photographs from sixty-eight countries; the choice of images and editorial methods used in "The Bitter Years" drew on the approach made familiar worldwide by the earlier show.

The possibility that social documentary photography might continue as the vigorous and variously realized representational form traced in this

study certainly ended in 1943, when the FSA was transferred to the OWI. And, when television usurped photography's pride of place as the most immediate of representational media, the significance of photographic practice as a whole was radically and permanently changed. Nevertheless, it is worthwhile to delineate, if only briefly, the particular chain of events which in effect re-produced documentary as an institutionalized, "museum-ified" artifact during and after the war. The story deserves telling not least because of the extent to which exhibitions such as Steichen's have obscured it. Its events involve key cultural institutions, and they show photography used to unite government, corporations, and cultural institutions in ways that even today ensure those agencies' cultural hegemony. Unsurprisingly, Roy Stryker remains a centrally implicated figure.

One "administrative" project Stryker had undertaken in the year before he left Washington was assistance to Steichen on "Road to Victory," which could not have been mounted without "the invaluable cooperation from you and your entire staff" for which MOMA board member David McAlpin thanked Stryker two days after the show's opening. A "vivid demonstration of what photography can do to tell a sincere, direct and convincing story," according to McAlpin's letter, "Road" found one-third of its 134 images in the FSA files; the rest came from other government agencies (no doubt via the FSA) or, by solicitation, from industry and individual photographers. As it had done for earlier war-related shows at MOMA, the FSA handled the extensive laboratory and darkroom work involved in enlargements and printing of all the government agency photographs.[4]

Developing in the 1940s into a "minor war contractor," as art historian Eva Cockcroft has written, the museum provided "cultural materials" for the Library of Congress, Office of War Information, and for Nelson Rockefeller's Office of Inter-American Affairs. During and after the war it co-operated closely with government efforts to promote and use American art and photography as propaganda.[5] Steichen, first associated with MOMA's photography department in 1942 and appointed department head in 1947, understood photography's "chief natural functions of documentation and human interest recording," as a colleague wrote. Indeed, "to prise photographs from their original contexts, to discard or alter their captions, to recrop their borders in the enforcement of a unitary meaning, to reprint them for dramatic impact, to redistribute them in new narrative chains consistent with a predetermined thesis," wrote photographic historian Christopher Phillips in 1982, was standard procedure for the series of thematic exhibitions that Steichen produced for MOMA beginning with "Road" in 1942 and culminating in 1955 with "The Family of Man."[6]

Phillips's animus is directed at the use of such overbearing editorial techniques at a major art museum, which might be expected to privilege "the photographer as autonomous artist [and] the original print as personal expression." In contrast, as Phillips makes clear, Steichen's techniques strikingly recall not only exhibition techniques of the Progressive Era, but also Riis's protocinematic narratives of the 1890s and the photojournalistic forms established as standard in the 1930s. Like those precedents, Steichen's "narrative chains" installed documentary photography yet more firmly in the realm of popular entertainment and mass culture. As Phillips has pointed out, a major reason that MOMA hired Steichen to replace Beaumont Newhall was that Newhall's connoisseur-like curatorial policies distanced the museum from the ever-increasing number of amateur photographers – as well as from other viewers whose esthetics and expectations were shaped by the mass magazines – so that the museum was called "snobbish" and "esoteric" in the popular photography journals, and the market for photography remained sluggish despite booms in modern painting and sculpture. Steichen, who later admitted that by the 1940s he didn't "give a hoot in hell about [promoting photography as one of the fine arts]," was hired to correct this situation and was particularly welcomed not only for his ties to fashion and the media but also because, as MOMA board president Nelson Rockefeller said, he had "the endorsement and support of the photographic industry."[7]

"Road to Victory," wrote one celebratory critic in the MOMA *Bulletin*, was "a portrait of a nation, heroic in stature. And as such, needless to say, it is art."[8] The first of Steichen's elaborate installations at MOMA, the exhibition was designed by Herbert Bayer to present images as free-standing or free-hanging murals, some as large as ten by forty feet, which filled the museum's entire second floor. Through these the viewer walked on a predetermined route that presented a narrative "photographic procession" (see Figure 4.2). Not only did the viewer's progress enhance the metaphor in the exhibition's title, but also the layout persuaded that "Each room is a chapter, each photograph a sentence," as the museum's *Bulletin* proclaimed. With captions and poetic commentary by Carl Sandburg, the exhibition moved "from the landscape of the primeval continent through the folkways of simple Americans, the extraordinary mechanisms of peace and war, to the cavalcade of men flying and sailing and motoring and marching to the defense of that continent," the *Bulletin* explained. Emphasizing the "faces of the men and women who constitute the basic strength of the country," "Road" did not "give us hell," as one critical viewer complained in a letter to the New York *Herald Tribune*; its intention, rather, was to

Figure 4.2. Scale model showing viewers' predetermined route in "Road to Victory" exhibition at the Museum of Modern Art, 1942. Collection, The Museum of Modern Art, New York.

make viewers identify easily with its subjects and feel "part of the power of America."[9]

Though "The Family of Man" exhibition was larger and more elaborately installed, "Road" introduced crucial innovations that were amplified in the later show. At the exhibition's "critical juncture" was an alcove that constituted a specially dramatic point (see Figure 4.3). It juxtaposed a typically monumental Dorothea Lange photograph made in 1938 of an American migrant farmer (echoing a similar type seen in Figure 4.1, this figure became the theme image for "The Bitter Years") against an equal-sized enlargement of an American destroyer exploding at Pearl Harbor. To this a smaller image of two laughing Japanese men – the ambassador Nomura and the peace envoy Kurusu, originally photographed for *Life* – had been appended, with the caption "Two Faces." "War," read the American's caption; "they asked for it – now, by the living God, they'll get it."[10]

137

Figure 4.3. Installation shot, "Road to Victory" exhibition at the Museum of Modern Art, showing photo-mural with caption "War – they asked for it – now, by the living God, they'll get it," 1942. Collection, The Museum of Modern Art, New York.

A rationale for such radical manipulation was offered by designer Bayer, who wrote that a modern exhibition, intended to "explain, demonstrate, and even persuade" a viewer to "a planned and direct reaction," should necessarily be designed in a way "parallel with the psychology of advertising." Like the erstwhile adman Riis, Bayer valued narrative for its associations in viewers' minds with other media and their fictive pleasures, key elements of effective persuasion. Not only did the viewers' route proceed narratively through "Road" in a more efficient and "filmic" version of their page-turning progress through the photo-essay, but also the exhibition itself was, from the beginning, "conceived not as a single presentation, but as a set of multiple 'editions' of varying physical dimensions

intended to circulate – in the manner of motion pictures or magazines – throughout the United States and the world."[11]

Attendance figures show 80,000 visitors to "Road" at MOMA during the summer of 1942, and the exhibition traveled to Chicago, St. Louis, Portland, and Rochester. Never intended only for domestic consumption, it was also shipped in smaller versions to Latin America, Britain, and the Pacific. Not only the large attendance and the extensive tours, but also the very terms of critical praise underscore the dimensions of MOMA's bid to establish photography as an art form that was simultaneously popular culture. Choosing among reviews apparently unanimously positive, the MOMA *Bulletin* reprinted comments that stressed the exhibition's appeal to "everyone with two eyes and a heart," as *PM* magazine put it, and that invoked the soon to be widely shared appreciation that would "keep the Museum of Modern Art packed for months to come." Though it did not identify and implicate the viewer so thoroughly as would "The Family of Man" installation – in which he or she at one point faced a mirror strategically placed in the midst of nine identically sized portrait photographs (see Figure 4.4) – "Road" enacted Bayer's injunction not to "retain its distance from the spectator." Like the movies, it was meant to be viewed in a crowd. And, like advertising, it not only commodified and quantified the esthetic experience it offered, but also flattered its viewers' passive spectatorship: its ceaseless self-congratulation proposed that mass participation in appreciation was actually, like artistic creativity, an activity that confirmed and strengthened individual identity.[12]

During the war Rockefeller's Office of Inter-American Affairs, which circulated "Road" in Latin America, also toured nineteen exhibits of contemporary American painting as part of MOMA's international programs. And like Rockefeller himself, who was president of MOMA from 1939 to 1940 and again in 1946, staff members from Inter-American Affairs moved into international leadership positions at the museum during and after the war. Similarly, a personal connection linked the museum in the 1950s to the Central Intelligence Agency (CIA), whose notorious supervisor of cultural activities, Thomas W. Braden, left a position as executive secretary of the museum to join the agency in 1950.[13]

The reasons for the museum's key participation in quasi-official international cultural exchanges have been made abundantly clear in recent scholarship. "Handcuffed," as Cockcroft has written, "by the noisy and virulent speeches of right-wing congressmen like Representative George A. Dondero (Michigan) who regularly denounced from the House floor abstract art and 'brainwashed artists in the uniform of the

Figure 4.4. Ezra Stoller, installation shot, showing mirror among photographs, "The Family of Man" exhibition at the Museum of Modern Art, 1955. © ESTO Photographs.

Red art brigade'," official government agencies could not openly sponsor the avant-garde art that might establish the United States internationally as a genuine contender in the "cultural war" with the Soviet Union. Supported by the Rockefeller family, the museum "in effect carried out government functions" in the cultural arena. By the 1950s, for example, at a time when the Soviet cultural program in France alone was estimated at $150 million a year – more than the entire United States expenditure – the museum's explicitly political purpose, according to its historian Russell Lynes, was "to let it be known especially in Europe that America was not the cultural backwater that the Russians ...were trying to demonstrate that it was."[14]

In addition to the geopolitical imperative to use art internationally to demonstrate that "cultural advancement and political freedom were interdependent," as the CIA's Braden put it, there were other reasons for both government and private capital to promote artistic activity on the domestic front.[15] Artists developed and sustained by New Deal projects needed new buyers and patrons in the 1940s. During the war years, which had ended unemployment but provided few consumer goods, Americans had amassed huge savings they were now ready to spend. The postwar purpose of museums, dealers, and artists themselves was to reorganize and open up the American art market to include American artists, traditional and avant-garde alike. Beginning with "Buy American Art" weeks held in 1940 and 1941, and attaining a "picture boom" in 1944, the art world and the media found new ways to publicize, advertise, and sell American art to record numbers of buyers. Although, as art historian Serge Guilbaut contends, "art became a commodity" and the "gallery a supermarket" for the masses rushing to consume, an art purchase "still made it possible for the harried buyer to gain in status by being seen as a 'cultivated man.'" Jackson Pollock – his "exuberance, independence, and native sensibility" domesticated, despite his aspirations, into a "perfect commodity" – became "the perfect symbol of the modern painter" in this newly arranged and more populous art world.[16]

"The ideological preparation for America's [postwar imperialism] came with the New Deal," *Monthly Review* editor Harry Magdoff recently told an interviewer. On Magdoff's view, Roy Stryker's move to Standard Oil might merely confirm an established trajectory. Stryker, however, seems to have made the actual move to the corporate world with more than one kind of ambivalence. The curiously backward look implicit in his invocation of Riis's title to describe his own job suggests, at the least, an unreadiness to face the implications of this new moment in the cultural history of the arts – a moment which, as a prominent and enthusiastic figure, he had done much to bring about.[17]

Conceived in wartime, SONJ's program was intended to repair the damage done to the company's public image by the revelation that a 1929 cartel agreement it had made with Germany's I.G. Farbenindustrie had delayed American development of synthetic rubber and had thus, however inadvertently, actually "enhance[d] Nazi military strength while penalizing American [war efforts]."[18] Discovering, via an Elmer Roper poll, that a majority of Americans had feelings that were "not so friendly toward Standard Oil Company of New Jersey," the company established its first public relations department in early 1943 with the help of Earl Newsom

141

and Company public relations agency. Edward Stanley, a Newsom executive who had come to know and admire FSA work as executive photography editor for the Associated Press during the late 1930s, and who had worked in 1943 with Roy Stryker in the Domestic Services Branch of the OWI, borrowed unabashedly both the scope and the operating procedures of various New Deal agencies. The department's several divisions included press relations, internal and external liaison, a reference division, and an operations division which had charge of "editorial and art work, writing, photography, newsreels, motion pictures, and periodic and special publications." Choosing for his staff a number of photographers who had been with him at the FSA and the OWI, Stryker planned for a file of at least 25,000 photographs documenting every conceivable aspect of the production and consumption of oil. In 1949, when the project began to be phased out in favor of other types of publicity, its archives included some 68,000 photographs, including 1,000 color transparencies and 15,000 images documenting SONJ operations abroad.[19]

"Well-to-do, happy, free whores" at SONJ, as photographers Edwin and Louise Rosskam told an interviewer in the 1970s, they had "very little respect for the project [because] the underlying thing in it ... was so corrupt." Though it offered more freedom to Stryker and to photographers than was possible under the prescriptive subject matter requirements of the OWI, the project did not avow the principles of democratized art and communication that had been fundamental to the New Deal projects. Rather, in accord with public relations theory and then-current views of art, it developed a kind of cultural propaganda – like that later sponsored or funded by the CIA and USIA – intended to be effective for a specific audience. The project meant to influence important but problematic "thought leaders" – educated and sophisticated individuals "more conscious of art than the public as a whole," who were also found to be the most critical of Standard Oil Company. Estimated at about 20,000, these sophisticates were considered by the public relations department to be "the ones you really want to get to."[20]

Part of a larger program consciously to use art to influence public opinion, the photography project was ultimately unsuccessful on its own terms. Nevertheless, it represented a considerable step forward in the exploitation of the visual arts as a corporate funded "servicing agency for mass culture."[21] While retaining what was useful from New Deal precedent, SONJ developed new ways to offer the prestige of art and cultivated entertainment in exchange for positive public opinion. The company tried to distinguish itself by an emphasis on creating a documentary record, as Steven

Plattner has pointed out, and its graphics and visuals were intended to evoke "a certain quality of boldness,...integrity or honesty," as Edward Stanley has described them. However, the consolidation of these purposes into documentary photography and film was not automatic. In 1944, SONJ commissioned a number of painters to record the oil industry's role during wartime, a project that Stanley saw as one component of a sophisticated "artistic orientation" that could be beneficial at a time when even abstract art was featured in popular magazines as well as New York journals. However, the company evidently soon perceived painting as too great a risk: "Take that communist crap away from here and bring me a good, honest photograph," one member of the board of directors is supposed to have said when he realized that some of the paintings were abstract rather than strictly representational. For the rest of the decade, the company confined itself to documentary photography and to the well-known documentary film *Louisiana Story*, by Robert Flaherty, commissioned in 1944 and released in 1949.[22]

Indeed, as a sympathetic *Fortune* writer emphasized in 1948, "Jersey officials hope that the visual record of the industry's operations will help create a more favorable impression, here and abroad, of free enterprise, the capitalist system, and democracy." Pointing out that "the majority of the pictures are quite directly related to oil," the writer went on to note as "significant" the fact that "*any* industrial enterprise provides the opportunity of recording as much of the American scene as these photographs have done." Unduly modest perhaps, the observation is nevertheless perspicacious, for it points out the particular success of the SONJ project: its photographs represented, with the force of documentary authority, what was in fact the crucial significance and real subject of the project itself – that is, the apparently applauded and unresisted corporate penetration of virtually all areas of American life (see Figures 4.5 and 4.6). The photographs were, in their diversity, "far more representative of technological and consumer-oriented America...than their [FSA] predecessors," as Edwin Rosskam wrote – and the structure of their sponsorship as well bears out his point.[23]

However, to "tell the story of oil from the jog on a seismographer's chart to the car, home, or business of the user," as Stryker wrote, and to show from a pro-corporate point of view that "people and not the machines they work with are what is important in our industrial civilization," required deployment of all the graphic appeal and sentimental "progressive humanism" (in Roland Barthes' phrase) that documentarians had developed throughout the 1930s.[24] The logic of the project's

Figure 4.5. Harold Corsini, *Well in the Center of an Oil Camp. Illinois. 1944.* The Standard Oil Company (New Jersey) Collection, University of Louisville Photographic Archives.

history suggests that its artfully "revelatory" presentation of its message came actually to constitute a kind of self-defeat, even as it displayed the project's key significance. Despite exhortations to photographers to think "in terms of stories," and despite efforts to "get more and more of the pictures into *Life* magazine and the other big magazines," Stryker found himself unable to compete with the work of independent professional photojournalists. The SONJ photographs found many outside uses, appearing in *Fortune, Time, Life, Vogue,* and the *Saturday Evening Post*; however, finding that their credibility rested upon the maintenance of an apparently balanced, "objective," or pluralist point of view, mass circulation magazines usually preferred to

144

Figure 4.6. Edwin Rosskam, *Oil Train. Montana. 1944.* The Standard Oil Company (New Jersey) Collection, University of Louisville Photographic Archives.

assign or to buy work directly from photographers – or they printed SONJ photographs without credit lines. In 1948, when SONJ found that its public image had improved only slightly since 1942, and also that it had no way to measure the public relations impact of the photography project, the company began gradually to eliminate it. In 1950, Stryker left the company to become director of the Pittsburgh Photographic Library.[25]

The somewhat different tack the company took in its sponsorship of Flaherty's film, apparently with Stryker's encouragement, was more successful. Though the film publicized the often fruitless work involved in the early stages of oil exploration, and thus presented oil companies as willing

risk-takers on the public's behalf, it carried no acknowledgment of SONJ sponsorship. Rather, the company's free-handed commission of a great filmmaker, who happened to be "the symbol of the creative American, untouched by commercialism or big business" in the eyes of postwar Europeans, along with the heavily symbolic art – or artiness – of the film's narrative "reconciliation of industrial progress with the natural order" were relied upon to generate word-of-mouth goodwill. Sidestepping problems of dissemination and of credit assignment that plagued the photography project, SONJ found in documentary film a medium by which to purvey art among a large, yet self-selected, audience, similar to the one that television would gather in the 1950s. Indeed, as the international success of *Louisiana Story* had helped the company to realize, by 1950 television was a better way to reach the "thought leaders" on whom good public relations depended.[26]

The photography project's failure to be eminently exploitable as mass culture may have resulted, ironically, from the same stylistic features that forestalled its success as art. Stryker had perceived the necessity for perceptible, even individual, style in mass culture offerings; he had emphasized, in Willard Morgan's 1942 *Encyclopedia*, documentary photographers' "love for life" and "combination of the emotional and the sensory."[27] However, he seems not to have realized the currency of a stylistically signified "objectivity" as an important criterion for visual expression throughout an increasingly image-saturated postwar culture. Objectivity had become an ideal, sociologist Michael Schudson has noted, "precisely when the impossibility of overcoming subjectivity in presenting the news was widely accepted and . . . precisely *because* subjectivity had come to be regarded as inevitable." Although the term "objectivity" was "common parlance," Schudson writes, it was not much-vaunted objectivity, but in fact "the social heritage, the 'professional reflexes,' the individual temperament and the economic status of reporters" that had assumed "fundamental significance" as early as the 1930s.[28]

In other words, even for photojournalistic professionals, success was associated less and less with the content or substance of their work; rather, success came to measure above all the ability to generate and control esthetic response, a stylistic accomplishment that signified, in journalism, versatility, flexibility, and professional detachment from subject or content. In such an atmosphere, it was not difficult for critics in the realm of art and culture to suggest that personal or political commitment, and realism itself, were somehow impediments to first-rate accomplishment – and, as did even Alfred Barr of MOMA in an article for the *New York Times* in 1952,

146

to equate non-abstract art with the "reactionary dogma" of both right and left "totalitarianism."[29]

The ease with which Stryker was able to adapt his work to corporate sponsorship may have disguised for him the role his project played in sustaining a "free world" imperialism intimately linked to the repressive aspects of cold war politics from which, it can be said, he himself ultimately suffered. Efforts such as Barr's to associate any and all art forms with specific political views and values were widespread, a kind of ideological terrorism. A direct casualty of cold war repression was the leftist Photo League, placed on the attorney general's list of subversive organizations in 1947 and forced to disband in 1951.[30] Even though, as Serge Guilbaut has argued, it was the artists' rebellion against cold war "political exploitation" that led a "progressively disillusioned" Abstract Expressionist movement to "suppress...emotional content, social commentary, [and a once intended] discourse" in their work, the movement's social disengagement and apoliticism were cautionary and compelling examples for wide audiences. Not only in journalism but in high art as well, as Eva Cockcroft has pointed out, "objectivity" was specifically valued as a "free world" attribute.[31]

In 1955, the year that Steichen mounted "The Family of Man," Robert Frank began the journey "on the road around practically forty-eight states in an old used car (on Guggenheim Fellowship)" that would result in the publication of *The Americans* in 1959.[32] Frank's solitary tour marked a departure in his own career (Steichen used several Frank photographs in "The Family of Man"), and it also addressed, in specifically photographic terms, the manifestations of an image and information order rapidly reorganizing in response to the domination of television. Exploiting neither the privileged "class tourism" of documentary nor the comforting "proximity" to viewers and their social world recommended by Bayer, Frank used banal subjects and a grainy, high contrast style to foreground both social and technological mediations. Though the photographs offer a subversive alternative to the emptiness of mediated, consumer culture, they do not hesitate to place their own medium under indictment, proposing that photographic realism, like any other mediation, can proliferate distortion and falsification as readily as transparency and verisimilitude. Openly spurning any engagement with photography's long-cherished aspirations to immediacy and transparency, Frank's iconoclasm was not welcomed in all quarters; reviewer Bruce Downes called him "a liar, perversely basking in the kind of world and the kind of misery he is perpetually seeking and persistently creating."[33] But even to sketch out the distin-

147

guishing features of Frank's photography is to point to the beginning of a new chapter in photographic expression, one with its own logic and direction. This, a different chronicle from the one told here, deserves, and is receiving, its own discrete history.

NOTES

Introduction

1. *Collected Papers of Charles Sanders Peirce*, ed. Charles Hartshorne and Paul Weiss (Cambridge, Mass.: Harvard University Press, 1934), V, pp. 50–51.
2. Christopher Phillips, "The Judgment Seat of Photography," *October*, 22 (Fall 1982), p. 45, n. 43.
3. Phillips, "Judgment Seat," p. 46.
4. Roy Stryker, "Official Notice of Resignation," September 14, 1943, Roy Stryker Collection, Photographic Archives, University of Louisville.
5. Ulrich Keller, *The Highway as Habitat: A Roy Stryker Documentation, 1943–1955* (Santa Barbara: University Art Museum, 1986), p. 26.

Chapter One

1. Jacob A. Riis, *The Making of an American* (1901; rpt. New York: Harper & Row, 1966), p. 203.
2. Jacob A. Riis, *How the Other Half Lives: Studies Among the Tenements of New York* (New York: Charles Scribners Sons, 1890); Riis, *The Making*, p. 265; Alexander Alland, Sr., *Jacob A. Riis: Photographer & Citizen* (Millerton, N.Y.: Aperture, 1974), pp. 4, 45. Alland notes that the collection also holds 324 lantern slides and 193 prints, many of them duplicates of the negatives.
3. As recently as 1981, a photographic historian seeking to link Riis's ideology to his photographic practice claimed that it was "difficult to learn of Riis's ideology and philosophical development" and described Riis, in terms familiar from his several biographers, as "a sentimental, loveable romantic [who] ... loved flowers, small animals, and most of all, people." See Robert J. Doherty, ed., *The Complete Photographic Work of Jacob A. Riis* (New York: Macmillan, 1981), p. 6.

 An important revisionist essay is Sally Stein, "Making Connections with the Camera: Photography and Social Mobility in the Career of Jacob Riis," *Afterimage* (May 1983), pp. 9–16. The work of Martha Rosler, Allan Sekula,

John Tagg, and others proposes grounds for criticism of the documentary tradition. See Martha Rosler, "In, around, and afterthoughts (on documentary photography)," *3 Works* (Halifax: The Press of the Nova Scotia College of Art and Design, 1981); Allan Sekula, *Photography Against the Grain: Essays and Photo Works 1973–1983* (Halifax: The Press of the Nova Scotia College of Art and Design, 1984); John Tagg, "Power and Photography: Part One. A Means of Surveillance: The Photograph as Evidence in Law," *Screen Education*, 36 (Autumn 1980), pp. 17–55, and "The Currency of the Photograph," in Victor Burgin, ed., *Thinking Photography* (Atlantic Highlands, N.J.: Humanities Press, 1982), pp. 110–141.

 Peter Bacon Hales, *Silver Cities: The Photography of American Urbanization, 1839–1915* (Philadelphia: Temple University Press, 1984) deals extensively with Riis's work. Biographies are James B. Lane, *Jacob A. Riis and the American City* (Port Washington: Kennikat Press, 1974); Edith Meyer, *"Not Charity but Justice": The Story of Jacob A. Riis* (New York: Vanguard, 1974); Louise Ware, *Jacob A. Riis: Police Reporter, Reformer, Useful Citizen* (New York: Appleton-Century, 1938). Lewis Fried and John Fierst, *Jacob A. Riis: A Reference Guide* (Boston: G. K. Hall, 1977), provide an extensive bibliography of works by and about Riis.

4. The Washington *Post*, October 19, 1891; Lewis Hine, "Social Photography," in *Classic Essays on Photography*, ed. Alan Trachtenberg (New Haven: Leete's Island Books, 1980), p. 11. All contemporary accounts of Riis's lectures were found in the Riis scrapbooks and clipping file in the Jacob A. Riis Papers, Manuscript Division, Library of Congress, Washington, D.C. (hereinafter cited as LC).

5. William Welling, *Collectors' Guide to Nineteenth-Century Photographs* (New York: Collier Books, 1976), p. 111, describes the technology. Riis, *The Making*, pp. 180–183, offers a humorous account of dealing with the gas.

6. Louis Walton Sipley, "Philadelphia Presents – ," *Pennsylvania Arts and Sciences*, vol. 1 (1935), pp. 41, 66. Ference M. Szasz and Ralph F. Bogardus, "The Camera and the American Social Conscience: The Documentary Photography of Jacob A. Riis," *New York History*, vol. 4, no. 4 (October 1974), pp. 412–413, comments on the vogue for lantern slides, and many reports of slide exhibitions and demonstrations can be found in magazines such as the *Photographic Times* during the 1880s and 1890s.

7. Hone is quoted in Richard Altick, *The Shows of London* (Cambridge, Mass: The Belknap Press, 1978), p. 233. For an account of magic lantern craft in the early nineteenth century, see Eileen Yeo and E. P. Thompson, eds., *The Unknown Mayhew* (New York: Pantheon Books, 1971), pp. 295–298.

8. Valerie Lloyd, "The Camera and Dr. Barnardo," *The Camera and Dr. Barnardo* (Hertford, England: Barnardo School of Printing, n.d.), p. 16; Altick, *The Shows*, p. 220.

9. Lloyd, *The Camera*, p. 16.

10. *The Photographic Times* (February 17, 1888), p. 81.
11. See Alan Trachtenberg, *The Incorporation of America* (New York: Hill and Wang, 1982), pp. 91, 40.
12. Riis, *The Making*, pp. 186–190.
13. Jacob A. Riis, *How the Other Half Lives: Studies Among the Tenements of New York* (1890; rpt. New York: Hill and Wang, 1957), p. 4.
14. Riis, *The Other Half*, pp. 216, 266.
15. Riis, *The Other Half*, p. 225.
16. Robert W. DeForest and Lawrence Veiller, eds., *The Tenement House Problem*, vols. 1 and 2 (1903; rpt. New York: Arno Press & The New York Times, 1970), I, p. 386.
17. Riis, *The Other Half*, p. 220. Trachtenberg discusses urban reform as "concerted, collective efforts on the part of homeowners and property holders, newly aroused to their potential metropolitan powers, to take control of urban reality" (*The Incorporation*, p. 104). Stuart M. Blumin, in "The Hypothesis of Middle-Class Formation in Nineteenth-Century America: A Critique and Some Proposals," *American Historical Review*, 90 (1985), pp. 299–338, offers an important examination of hypotheses concerning class, ethnicity, and social and political behavior, always with an eye to the question "whether, and in what ways, classes were significant in the development of modern American society" (p. 338).
18. The New Haven *Palladium* (July 20, 1891), LC. Szasz and Bogardus, "The Camera and the American Social Conscience," pp. 409–436, offers an important early discussion of Riis's slide lectures.
19. The Buffalo *Express* (March 26, 1889), LC; The Washington *Post* (November 10, 1891), LC.
20. The New York *Tribune* (January 26, 1888), LC.
21. The Washington *Star* (November 10, 1891), LC; see also the New York *Evening Post* (February 28, 1888), LC.
22. "Flashes from the Slums. Pictures Taken in Dark Places by the Lightning Process," The New York *Sun* (February 12, 1888), p. 10.
23. See the *Photographic Times* (October 21, 1887), p. 531, for Lawrence's committee chairmanship, and p. 532, for a report of Piffard's paper.
24. The New York *Morning Journal* (February 12, 1888), LC. In the Riis collection, two slides, both of women lodgers, are actually credited to Lawrence (in Lawrence's handwriting) on their slide mounts; one slide (again in Lawrence's hand) is credited to Piffard for the "pistol flash negative" and Lawrence for the slide; it bears out Piffard's interest in flash applications. One print in the Riis collection is credited to Piffard, again in Lawrence's hand. Hales, *Silver Cities*, pp. 171–174, notes that early pictures must be attributed to either Piffard or Lawrence and credits *Bandit's Roost* and *A Black and Tan Dive* accordingly.
25. Riis, *The Making*, p. 269. Hales, in *Silver Cities*, repeats and interprets Riis's

version, suggesting that the amateurs were "tinkerers, not revolutionaries" (pp. 171, 174–175).

26. Lawrence was elected treasurer of the society in a special meeting two days after Riis's slide talk in January. Lawrence was almost certainly present at the talk – as lantern slide chairman, he probably arranged it – and, if not, other society members must have known of his collaboration with Riis. However, according to reports of the occasion in the *Photographic Times* and other journals, Riis makes no mention of him. The election is reported in the *Photographic Times* (February 3, 1888), p. 58. See New York *Tribune* (January 26, 1888), LC, and New York *News* (January 27, 1888), LC, for reports of the lecture.

27. Dan Schiller, *Objectivity and the News: The Public and the Rise of Commercial Journalism* (Philadelphia: University of Pennsylvania Press, 1981), reproduces the image (p. 114).

28. All the engravings discussed here are reproduced in John Grafton, comp., *New York in the Nineteenth Century: 321 Engravings from "Harper's Weekly" and Other Contemporary Sources* (New York: Dover, 1977).

29. Brooklyn *Times* (March 8, 1888), LC.

30. *Photographic Times* (February 3, 1888), p. 58, gives Riis's lecture narrative; the published version is in Riis, *The Other Half*, pp. 57–58. Miles Orvell, "Almost Nature: The Typology of Late Nineteenth Century American Photography," *Views: The Journal of Photography in New England*, vol. 8, no. 1 (Fall 1986), discusses the ways that Riis "manipulated his representation of poverty to reflect a preconceived image of the poor," mentioning the tramp story (p. 17, supplement). Roland Barthes, "Rhetoric of the Image," *Image–Music–Text*, trans. Stephen Heath (New York: Hill and Wang, 1977), pp. 40–41, discusses the use of "linguistic messages" as either "anchorage" or (as in the next paragraph of my text here) "relay" for photographic images.

31. The Buffalo *Express*, LC.

32. *Photographic Times* (February 3, 1888), p. 60. Paul Boyer, *Urban Masses and Moral Order in America, 1820–1920* (Cambridge, Mass.: Harvard University Press, 1978), explains that "Elbridge Gerry's Society for the Prevention of Cruelty to Children ... combated not only the physical abuse of the young but their moral degradation as well" (pp. 143–144).

33. The Washington *Star*; Charles Loring Brace, *The Dangerous Classes of New York, and Twenty Years' Work Among Them* (New York: Wynkoop & Hallenbeck, 1872).

34. For discussion of narrative strategies in fiction, see Wayne C. Booth, *The Rhetoric of Fiction*, 2nd ed. (Chicago: University of Chicago Press, 1983). For a provocative discussion of narrative devices in visual art, see Lisa Tickner, "Sexuality and/in Representation: Five British Artists," in *Difference: On Representation and Sexuality* (New York: The New Museum of Contemporary Art, 1985), pp. 19–30.

35. The New York *Morning Journal* (December 12, 1888), LC.

36. Howells is quoted in Alan Trachtenberg, "Experiments in Another Country: Stephen Crane's City Sketches," in Eric Sundquist, ed., *American Realism: New Essays* (Baltimore: Johns Hopkins University Press, 1982), pp. 138–154.
37. Angela Miller, " 'The Imperial Republic': Narratives of National Expansion in American Art, 1820–1860," unpublished Ph.D. dissertation, Yale University, 1985, pp. xix, 325, 367.
38. Miller, " 'The Imperial Republic,' " p. 342.
39. *Photographic Times* (February 3, 1888), p. 59; Brooklyn *Times*, August 8, 1888, LC. A crucial text establishing the links between surveillance and the "human sciences" is Michel Foucault, *Discipline and Punish: The Birth of the Prison* (New York: Vintage Books, 1979); see also Michel Foucault, *Power/Knowledge: Selected Interviews and Other Writings 1972–1977* (New York: Pantheon Books, 1980). Allan Sekula, "The Body and the Archive," *October* (Winter 1986), pp. 3–65, surveys the use of photography in various forms of criminal and social surveillance throughout the nineteenth century.
40. Riis is quoted in Stamford, Conn., *News*, LC; Brooklyn *Times*, LC.
41. Thomas Byrnes, *Professional Criminals of America* (1885; rpt. New York: Chelsea House, 1969), p. 54; New York *Morning Journal* (April 23, 1883), LC.
42. See the advertisement for *Professional Criminals* in Julian Hawthorne, *The Great Bank Robbery. From the Diary of Inspector Byrnes* (New York: Cassell & Company, 1887); *The Inspector's Model* is reproduced in Byrnes, *Professional Criminals*, p. 55; *Photographic Times* (February 3, 1888), p. 59.
43. Lloyd, "The Camera," discusses nineteenth-century documentary and record photography used by philanthropic agencies in England; John Tagg, "Power and Photography: Part One," subjects such photography to a Foucauldian scrutiny and analysis. Tagg's "The Currency of the Photograph" continues his discussion of documentary. On the Gerry Society, see Boyer, *Urban Masses*, (p. 331, n. 3); Joseph M. Hawes, *Children in Urban Society: Juvenile Delinquency in Nineteenth-Century America* (New York: Oxford University Press, 1971), pp. 138–142; for a revisionist view, critical of the society, see David Nasaw, *Children of the City: At Work and at Play* (New York: Oxford University Press, 1986).
44. Helen C. Campbell, Thomas W. Knox, and Thomas Byrnes, *Darkness and Daylight, or Lights and Shadows of New York Life* (Hartford, Conn.: Hartford Publishing Co., 1899), p. 179; see, for example, Nellie Brady, "As found by Society's Officers" and "After a day in Society's care," in New York Society for Prevention of Cruelty to Children, *Fourteenth Annual Report* (December 31, 1888; published 1889), following p. 34.
45. Campbell, Knox, Byrnes, *Darkness and Daylight*, pp. 176–177. The book provides an extensive account of the society's activities, often quoting verbatim from its annual reports.
46. Riis, *The Making*, p. 268.
47. *Photographic Times* (February 3, 1888), p. 59; Jamaica, Long Island [title illegible] (March 28, 1889), LC.

48. "Vividness and accuracy" is from the temperance orator previously quoted (see note 10); Ansel Adams, "Preface," in Alland, *Jacob A. Riis*, pp. 7, 6.

49. "Flashes from the Slums."

50. Riis, *The Making*, p. 309.

51. Riis, *The Other Half*, pp. 37, 122.

52. Riis, *The Making*, pp. 265–266.

53. Riis, *The Making*, p. 265.

54. On photographic technology, see Robert Taft, *Photography and the American Scene: A Social History, 1839–1889* (1938; rpt. New York: Dover, 1964). The standard history of photography is Beaumont Newhall, *The History of Photography from 1839 to the Present Day*, rev. ed. (New York: Museum of Modern Art, 1982); a newer history is Naomi Rosenblum, *A World History of Photography* (New York: Abbeville, 1984). On early film, see *Before Hollywood: Turn-of-the-Century American Film* (New York: American Federation of Arts, 1986); Daniel Czitrom, *Media and the American Mind: From Morse to McLuhan* (Chapel Hill: University of North Carolina Press, 1982); James Monaco, *How to Read a Film: The Art, Technology, Language, History and Theory of Film and Media*, rev. ed. (New York: Oxford University Press, 1981); Robert Sklar, *Movie-Made America: A Cultural History of American Movies* (New York: Vintage Books, 1975).

55. Margaret Byington, quoted in Hales, *Silver Cities*, pp. 253–254. Turn-of-the-century art photography is currently the subject of much scholarly activity that reconsiders the work and reputation of Alfred Stieglitz and places his work and that of the Photo-Secession in a broader perspective. See, for example, Estelle Jussim, *Slave to Beauty: The Eccentric Life and Controversial Career of F. Holland Day, Photographer, Publisher, Aesthete* (Boston: David R. Godine, 1981), and Mary Panzer, *In My Studio: Rudolph Eickemeyer, Jr. and the Art of the Camera 1885–1930* (Yonkers, N.Y.: Hudson River Museum, 1987).

56. De Forest and Veiller, eds., *The Tenement House Problem*, I, p. 115. See Roy Lubove, *The Professional Altruist: The Emergence of Social Work as a Career, 1880–1930* (Cambridge, Mass.: Harvard University Press, 1965), and *The Progressives and the Slums: Tenement House Reform in New York City 1890–1917* (Pittsburgh: University of Pittsburgh Press, 1962).

57. Lawrence Veiller, "The Tenement-House Exhibition of 1899," *The Charities Review*, 10 (March 1900), p. 22; I. N. Phelps Stokes, "Proposal to the Tenement House Committee of the Charity Organization Society, New York City," April 11, 1899, Community Service Society (CSS) Papers, Rare Book and Manuscript Library, Columbia University (hereinafter referred to as CU). The CSS was formed in 1939 by the merger of the Charity Organization Society and the Association for Improving the Condition of the Poor.

58. De Forest and Veiller, *The Tenement House Problem*, reprints the codes and

regulations of the "new law" in II, appendix 2, and details the necessity for a separate tenement house department, pp. 29–36.

59. Robert Hunter, "The Relations between Social Settlements and Charity Organization," *Journal of Political Economy*, 11 (1902), p. 76; De Forest and Veiller, *The Tenement House Problem*, I, p. 112; "Tenement House Show," *New York Times* (February 10, 1900), p. 7.

60. The details of Citizens' Union campaigns are laid out in Gerald Kurland, *Seth Low: The Reformer in an Urban and Industrial Age* (New York: Twayne, 1971); see also Michael G. Kammen, "Richard Watson Gilder and the New York Tenement House Commission of 1894," in Gerald W. McFarland, ed., *The Mugwumps, 1884–1900* (New York: Simon and Schuster, 1975), pp. 100–118, and Edward T. Devine, "Municipal Reform and Social Welfare in New York. A Study of the Low Administration in its Relation to the Protection of the Tenement House Population," *Review of Reviews*, 28 (October 1903), pp. 432–448.

61. *The Philanthropic Work of Josephine Shaw Lowell*, ed. William R. Stewart (New York: Macmillan, 1911), pp. 123–124. For biographical information on Lowell see Stewart, pp. 1–71; George M. Fredrickson, *The Inner Civil War: Northern Intellectuals and the Crisis of the Union* (New York: Harper & Row, 1965), chapters 10–14, argues that northern Civil War leadership and the "scientific" efficiency of the Civil War Sanitary Commission provided models for charity organization.

62. *Philanthropic Work*, pp. 122–123, 216. Two books that offer useful current perspectives on the COS and urban philanthropy are M. Christine Boyer, *Dreaming the Rational City: The Myth of American City Planning* (Cambridge, Mass.: The Massachusetts Institute of Technology Press, 1983), and Paul Boyer, *Urban Masses*.

63. S. Humphreys Gurteen, *A Handbook of Charity Organization* (Buffalo: privately printed, 1882), p. 30; Amos G. Warner, *American Charities: A Study in Philanthropy and Economics* (New York: Thomas Y. Crowell & Co., 1894), p. 383. Gurteen reproduces sample forms on pages 160–162 and "hints and suggestions" for reports on page 225; see also Paul Boyer, *Urban Masses*, chapter 10 for discussion of COS methods and philosophies.

64. Warner, *American Charities*, pp. 382–383.

65. "Suing to Avoid Charity," New York *Sun* (February 20, 1888), p. 1. The article recounts the claim of one Bertram Hugh Fitzhugh Howell that he was libeled when the COS published his name among the "unworthy" in its monthly bulletin. Even today the Rare Book and Manuscript Library at Columbia University, where COS papers are held, forbids researchers to quote the real names and addresses of families named in casework files, according to Paul Boyer, *Urban Masses*, p. 332, n. 20.

66. On events in the 1890s, see Philip S. Foner, *From the Founding of the A. F. of L.*

to the Emergence of American Imperialism, vol. 2 of *History of the Labor Movement in the United States,* 2nd ed. (New York: International Publishers Co., 1975), chapters 16, 17, and 18; see Trachtenberg, *The Incorporation,* esp. chapter 7. Paul Boyer, *Urban Masses,* contrasts COS and settlement workers (p. 157); Hunter, "The Relation," pp. 81–82.

67. Paul Boyer, *Urban Masses,* pp. 156–157; Agnes Sinclair Holbrook, "General Comments," *Hull-House Maps and Papers* (1895; rpt. New York: Arno Press & The New York Times, 1970), p. 11.

68. See Paul Boyer, *Urban Masses,* p. 157; Holbrook, "General Comments," pp. 13–14.

69. Charles H. Parkhurst, *Our Fight with Tammany* (1895; rpt. New York: Arno Press, 1975); William T. Stead, *If Christ Came to Chicago* (1894; rpt. New York: Living Books, 1964); Josiah Strong, *Our Country: Its Possible Future and Its Present Crisis,* rev. ed. (New York: The Baker & Taylor Co., for the American Home Mission Society, 1891); Robert A. Woods, ed., *The City Wilderness: A Settlement Study by Residents and Associates of the South End House* (1898; rpt. New York: Garrett Press, 1970); United States Department of Labor, *A Special Investigation of the Slums of Great Cities* (Washington, 1893); New York State, *Report of the Tenement House Committee* (Albany, 1895); Charles Booth, ed., *Labour and Life of the People. Volume I: East London,* 2nd ed. (London: Williams and Norgate, 1889); B. Seebohm Rowntree, *Poverty: A Study of Town Life* (New York: Macmillan, 1901).

70. Warner, *American Charities,* p. 392; Veiller, "Reminiscences," Oral History Collection, CU, p. 9. Hunter, "The Relation," p. 86; Roy Lubove, "Lawrence Veiller and the New York State Tenement House Commission of 1900," *Mississippi Valley Historical Review,* 47 (March 1961), p. 662. Donald Fleming, "Social Darwinism," in Arthur M. Schlesinger, Jr., and Morton White, eds., *Paths of American Thought* (Boston: Houghton Mifflin, 1970), p. 145, attributes to COS general secretary Edward Devine the "profound reorientation" of the agency that resulted in its leadership in tenement regulation and tuberculosis prevention. Devine was a disciple of the economist Simon Patten, who is discussed in chapter 3 of this volume in connection with the ideas of another of his disciples, Rexford Tugwell. It is interesting to note that Phelps Stokes's "Proposal," as late as April 11, 1899, proposes either to "make permanent" the work of the COS's Tenement House Committee or, "if it is found to be more expedient," to found a new society, thus suggesting that debate on the issue continued.

71. Hunter, "The Relation," pp. 87, 83.

72. Hunter, "The Relation," p. 87; John M. Glenn, Lillian Brandt, and F. Emerson Andrews, *Russell Sage Foundation, 1907–1946* (New York: Russell Sage Foundation, 1947), p. 6.

73. M. Christine Boyer, *Dreaming the Rational City,* p. 164.

74. E. G. Routzahn discusses "new professions" in "The Value of the Tuberculosis

Exhibition," *Survey*, 23 (November 20, 1909), pp. 252–256, quoted in Cathy Alexander, "Propaganda Professionalizes: Photo Exhibits in the Progressive Era," unpublished paper delivered at the 1986 meeting of the Organization of American Historians; Richard E. Foglesong, *Planning the Capitalist City: The Colonial Era to the 1920s* (Princeton: Princeton University Press, 1986), p. 84, describes late–nineteenth-century housing reformers as "planners-in-embryo."

75. Foglesong, *Planning the Capitalist City*, pp. 217–225, discusses zoning; M. Christine Boyer, *Dreaming the Rational City*, p. 156. Veiller's work on the East Side Relief Work Committee, formed in 1892, convinced him that "the improvement of the homes of the people was the starting point of everything," Veiller, "Reminiscences," p. 3.

76. Lubove, "Lawrence Veiller," p. 677; Foglesong, *Planning the Capitalist City*, p. 88.

77. Veiller, "Reminiscences," p. 11; Lawrence Veiller, "The Tenement House Exhibition," *Charities*, 4 (February 17, 1900), clipping in the CSS papers, provides a thorough description of the exhibition from the perspective of a visitor strolling through it. In addition to Veiller's own articles and reports, the CSS papers include newspaper clippings, all laudatory, from the Boston *Transcript*, *Commercial Advertiser*, *Herald*, *Jewish Messenger*, *Mail and Express*, *Post*, *Sun*, *Times*, *Tribune*, and others. Important contemporary discussions of the exhibition are Jacob Riis, "The New York Tenement House Commission," *Review of Reviews*, 21 (June 1900), pp. 689–698, and an article of the same title in *The Nation*, 72 (April 18, 1901), pp. 310–311; see also Jacob Riis, *The Battle with the Slum* (New York: Macmillan, 1902), pp. 140–148, and Lillian Betts, "The Tenement House Exhibition of New York," *The Outlook*, 64 (March 10, 1900), pp. 589–592.

78. De Forest and Veiller, eds., *The Tenement House Problem*, I, pp. 112–113; see also Lawrence Veiller, "Tenement House Exhibition of 1899," *Charities Review*, 10 (March 1900), p. 22. Veiller, "Reminiscences," pp. 14–18, describes the maps and their making.

79. Veiller, "Reminiscences," p. 11; Veiller's letter soliciting photographs, dated October 14, 1899, is in CSS Papers, Box 166.

80. Veiller, "The Tenement House Exhibition," CSS Papers; Alexander, "Propaganda Professionalizes," pp. 3–4. Sixteen original prints from the exhibition are now held in the Local History Room of the New York Public Library.

81. Veiller, "The Tenement House Exhibition," CSS Papers. This panel is one of seven on tenement subjects now held by the Museum of the City of New York; each is stamped "Community Service Society" on the back and most – though not this one – are stamped "Tenement House Committee."

82. Jacob Riis, *How the Other Half Lives*, p. 134.

83. It is interesting to consider the implications of the gridlike structure of the exhibition in relation to the meaning of the grid as a figure in avant-garde

art, as described by Rosalind Krauss: "The absolute stasis of the grid, its lack of hierarchy, of center, of inflection, emphasizes not only its antireferential character, but – more importantly – its hostility to narrative. This structure, impervious both to time and to incident, will not permit the projection of language into the domain of the visual, and the result is silence." Rosalind Krauss, "The Originality of the Avant-Garde: A Postmodernist Repetition," in Brian Wallis, ed., *Art After Modernism: Rethinking Representation* (New York and Boston: The New Museum of Contemporary Art and David R. Godine, 1984), p. 18.

84. Paul Boyer, *Urban Masses*, p. 150; Byington, quoted in Hales, *Silver Cities*, p. 253. See Sekula, "The Body and the Archive"; Sekula points out (pp. 55–58) that "between 1880 and 1910, the archive became the dominant institutional basis for photographic meaning," and that "bibliographic science," emerging in those same years as "a grandiose clerical mentality [took] hold," provided a "utopian" model for classifying expanding and potentially "unruly" collections of photographs. Sekula's powerful argument implies many parallels between the bureaucratic handling of written and visual information and links both to explicit surveillance and "scientific policing."

85. Hunter, "The Relation," p. 84; Foglesong, *Planning the Capitalist City*, pp. 170–171, describes the Congestion Exhibit; Evart G. Routzahn and Mary Swain Routzahn, *The ABC of Exhibit Planning* (New York: Russell Sage Foundation, 1918), p. 77; Alexander, "Propaganda Professionalizes," p. 11.

86. Shelby M. Harrison, "Editor's Preface," in Routzahn and Routzahn, *The ABC*, p. iv; Routzahn and Routzahn, *The ABC*, pp. 110–112.

87. Alexander, "Propaganda Professionalizes," pp. 17, 11; Routzahn and Routzahn, *The ABC*, pp. 119–123, discuss the use of advertising and design professionals; photography is discussed on pp. 70–72.

88. See Alexander, "Propaganda Professionalizes," p. 14, and Daile Kaplan, *Lewis Hine in Europe: The "Lost" Photographs* (New York: Abbeville, 1988), chapter 4.

Chapter Two

1. New York *Tribune*, February 11, 1900, Community Service Society (CCS) Papers, Rare Book and Manuscript Library, Columbia University.

2. New York *Tribune*, April 3, 1900, CSS Papers.

3. Research for the Pittsburgh Survey was initiated in the summer of 1907; although two articles were published in 1908 in the weekly *Charities and the Commons* (formerly *Charities*), and some were published in trade journals and popular magazines such as *Collier's*, the majority of the research appeared in three special issues of *Charities and the Commons* in January, February, and March 1909. The findings, somewhat expanded by additional research, were then published in six volumes by the Russell Sage Foundation. They were:

Volume 1: *Women and the Trades*, by Elizabeth Beardsley Butler, published in December 1909; Volume 2: *Work-Accidents and the Law*, by Crystal Eastman, published in May 1910; the complementary Volumes 3 and 4: *The Steel Workers*, by John A. Fitch (December 1910) and *Homestead: The Households of a Mill Town*, by Margaret Byington (January 1911); and Volumes 5 and 6: *The Pittsburgh District: Civic Frontage*, and *Wage-Earning Pittsburgh*, both of which appeared in 1914. These two final volumes gathered twenty-two articles, including short reports on particular topics such as typhoid, taxes, and schools, as well as analyses of the growth, labor force, and civic development of the Pittsburgh District, evaluation of changes in the district in the seven years since the survey began, and recommendations for further reform measures. See John M. Glenn, Lilian Brandt, and F. Emerson Andrews, *Russell Sage Foundation 1907–1946* (New York: Russell Sage Foundation, 1947), pp. 212–213.

4. Edward T. Devine, "Pittsburgh the Year of the Survey," *The Pittsburgh District: Civic Frontage*, p. 4.
5. Kellogg, "The Pittsburgh Survey of the National Publication Committee of Charities and the Commons," *Charities and the Commons*, 19 (March 7, 1908), pp. 1665–1667.
6. Paul U. Kellogg, "Appendix E. Field Work of the Pittsburgh Survey," *The Pittsburgh District: Civic Frontage*, ed. Paul U. Kellogg (New York, 1914), pp. 496–497.
7. Kellogg, "The Pittsburgh Survey," p. 1667.
8. Alan Trachtenberg, "Lewis Hine: The World of His Art," unpublished manuscript, p. 42.
9. Paul U. Kellogg and Neva R. Deardorff, "Social Research as Applied to Community Progress," *First International Conference of Social Work* (Paris: Imp. Union, 1929), I, pp. 792–793.
10. Elizabeth McCausland, "Portrait of a Photographer," *Survey Graphic* (October 1938), p. 503.
11. Daile Kaplan, *Lewis Hine in Europe: The "Lost" Photographs* (New York: Abbeville, 1988), chapter 1.
12. Walter Rosenblum, Naomi Rosenblum, and Alan Trachtenberg, *America & Lewis Hine* (Millerton, N.Y.: Aperture, Inc., 1977), p. 25.
13. Kaplan, *Lewis Hine*, p. 19.
14. Trachtenberg, "Essay," in *America & Lewis Hine*, p. 122.
15. *Ibid.*, p. 124.
16. Elizabeth McCausland, "A Generation Rediscovered Through Camera Shots of Pioneer in 'Photo-Stories,' " Springfield *Sunday Union and Republican*, September 11, 1938, p. 5E.
17. McCausland, "Portrait," p. 502.
18. McCausland, "Generation"; Rosenblum, Rosenblum, and Trachtenberg, *America & Lewis Hine*, p. 138.

19. Kaplan, *Lewis Hine*, p. 34; McCausland, "Generation"; Trachtenberg, "Essay," in *America & Lewis Hine*, p. 138.
20. McCausland, "Portrait," p. 502.
21. Kaplan, *Lewis Hine*, chapter 3.
22. Trachtenberg, "Essay," in *America & Lewis Hine*, p. 130.
23. Kellogg, "Appendix E," p. 492.
24. Paul U. Kellogg, "The Pittsburgh Survey of the National Publication Committee of Charities and the Commons," *Charities and the Commons*, 19 (March 7, 1908), p. 1665.
25. Devine, "Pittsburgh," p. 4.
26. *Ibid.*, pp. 4–5.
27. *Wage-Earning Pittsburgh*, ed. Paul U. Kellogg (New York: Russell Sage Foundation, 1914), p. 115.
28. See David Brody, *Steelworkers in America: The Nonunion Era* (Cambridge, Mass: Harvard University Press, 1960), chapter 13. Brody contends that 1907, the year of the Pittsburgh Survey, was the nadir of hour and wage conditions as the result of management's concerted efforts to reduce costs. By 1910, strikes, public indignation aroused by publicity, and government investigations had put sufficient pressure on the industry that it had begun to shorten the work day and the work week.
29. John A. Fitch, *The Steel Workers* (New York: Russell Sage Foundation, 1910), pp. 17–18.
30. *Ibid.*, chapter 13; and see charts, pp. 300–305.
31. *Ibid.*, pp. 139–140.
32. *Ibid.*, p. 143.
33. Allen T. Burns, "Coalition of Pittsburgh's Civic Forces," *The Pittsburgh District: Civic Frontage*, pp. 47–48.
34. Fitch, *Steel Workers*, chapter 13, and Margaret F. Byington, *Homestead: The Households of a Mill Town* (New York: Russell Sage Foundation, 1911), p. 40.
35. Byington, *Homestead*, p. 175.
36. Elizabeth Beardsley Butler, *Women and the Trades, Pittsburgh, 1907–1908* (New York: Russell Sage Foundation, 1909), pp. 337–340.
37. *Ibid.*, chapter 23.
38. Crystal Eastman, *Work-Accidents and the Law* (New York: Russell Sage Foundation, 1910), p. 11.
39. *Ibid.*, p. 131.
40. Robert A. Woods, "Pittsburgh: An Interpretation of its Growth," *The Pittsburgh District: Civic Frontage*, pp. 21–22.
41. *Ibid.*
42. *Ibid.*, p. 42.
43. *Ibid.*, p. 55.
44. *Ibid.*, p. 24.
45. *Ibid.*, pp. 24–25.

46. *Ibid.*, p. 21.
47. Clarke A. Chambers, *Paul U. Kellogg and the Survey: Voices for Social Welfare and Social Justice* (Minneapolis: University of Minnesota Press, 1971), pp. 23–27. See also Edward T. Devine, *When Social Work Was Young* (New York: Macmillan, 1939), pp. 108–112.
48. Devine, *When Social Work*, p. 110. Among well-known CPC members were Jane Addams from Chicago, Daniel Coit Gilman (of Johns Hopkins and the COS) from Baltimore, John M. Glenn from Baltimore (soon to be director of the Russell Sage Foundation), William Guggenheim from New York, Simon Patten from Philadelphia, Jacob Riis from New York, and Robert Treat Paine from Boston. The first CPC-directed "journalistic research" project was carried out in Washington in 1906 and resulted in a special number of *Charities and the Commons*, "Next Door to Congress," March 3, 1906. This issue included Charles Weller's housing investigations, which were eventually published as *Neglected Neighbors in our National Capital*, with additional photographs by Lewis Hine that had not appeared in the article. A next step toward the Pittsburgh Survey was a request from a chief probation officer of the Allegheny Court, Mrs. Alice B. Montgomery, who had been impressed by the Washington number and wanted to see a similar investigation of the Pittsburgh District. See Chambers, *Kellogg and the Survey*, p. 33.
49. Kellogg, "Field Work," p. 497.
50. Glenn et al., *Russell Sage*, p. 11.
51. *Ibid.*, pp. 27–28. The foundation continued until 1916 to use the CPC and its successor, Survey Associates, as its publishing agent, "[attending] to all the business of production and distribution of the Foundation's books and of such of its pamphlets as were not handled by the departments individually" (p. 50).
52. *Ibid.*, p. 211.
53. Kellogg, "Field Work," p. 510.
54. *Ibid.*, p. 511. The report on housing, by Elizabeth Crowell, a member of Lawrence Veiller's staff, was printed in pamphlet form (even before its magazine publication) and circulated by the housing committee of the Pittsburgh Chamber of Commerce and "made use of...in the campaign of the past month to secure an adequate force of tenement-house inspectors for the Municipal Bureau of Health." It was also given national exposure by an editorial in *Collier's Weekly*. The article on liability helped to publicize a recent Supreme Court decision that had put responsibility for enactment of employers' liability legislation upon the states. See Kellogg, "The Pittsburgh Survey," *Charities and the Commons*, p. 1665.

In the period between the completion of fieldwork in the spring of 1908 and the beginning of magazine publication in January 1909, the survey, in keeping with its plan to establish "relations which would project its work into the future," contributed to an exhibition that was part of Pittsburgh's celebration of Civic Week, in November 1908. Civic Week coincided with the joint annual

meeting of the American Municipal League and the National Civic Association in Pittsburgh, which was the occasion for addresses by Robert DeForest, Robert Woods, and Paul Kellogg, as well as by Pittsburgh officials. Civic Week also celebrated Pittsburgh's sesquicentennial – the one-hundred fiftieth anniversary of its founding.

The Civic Exhibition filled four halls of the Carnegie Institute. Local organizations presented exhibitions on aspects of their work; these included the Bureau of Health, the Bureau of Filtration, which had just completed construction of a new water filtration plant, the Tuberculosis League, the new Pittsburgh Associated Charities, the Kingsley House Settlement, the Juvenile Court, the Playground Association, and others. Exhibits pertaining to social work, town planning, and workers' housing from other American cities and from Europe were also displayed.

The Pittsburgh Survey exhibit, organized by associate director Frank Wing, comprised seventeen sections. "Perhaps the most striking feature was a frieze, 250 feet long, which ran above practically the entire exhibit, and which represented the number of persons who died last year from typhoid fever in Greater Pittsburgh," wrote an anonymous contributor to *Charities and the Commons*. The exhibit consisted

> ...of a collection of maps and charts prepared in the office of the Survey, together with enlarged photographs, crayon drawings and pastels framed and mounted for the most part on black backgrounds.... the exhibit offered an opportunity of bringing out in their local bearings certain suggestive lines of inquiry.

The maps, charts, photographs and text, all published later, generally explained the purposes of the survey, analyzed "the physical, administrative and social geography of Pittsburgh and the make-up of the population," and included exhibits on housing, on women in industry, and on industrial accidents and deaths. See "Civic Week in Pittsburgh," *Charities and the Commons*, 21 (November 28, 1908), pp. 331–332.

55. Trachtenberg, "Essay," in *America & Lewis Hine*, p. 127.
56. W. D. Haywood, "Working Class Commission of the Whole," *Survey*, 30 (August 2, 1913), p. 580.
57. Kellogg and Deardorff, "Social Research as Applied to Community Progress," I, p. 793; "Ever – the Human Document to keep the present and future in touch with the past," wrote Hine, quoted in Trachtenberg, "Essay," in *America & Lewis Hine*, p. 118. Hine calls for "intelligent interpretation" in his "Social Photography," in Alan Trachtenberg, ed., *Classic Essays on Photography* (New Haven, Conn.: Leete's Island Books, 1980), p. 113. For a bibliography of articles by Hine, see Rosenblum, Rosenblum, and Trachtenberg, *America & Lewis Hine*, pp. 138–142.
58. Robert H. Wiebe, *The Search for Order, 1877–1920* (New York: Hill and Wang, 1967), p. 222; Samuel P. Hayes, "The Politics of Reform in Municipal Gov-

ernment in the Progressive Era," *Pacific Northwest Quarterly*, 55 (October 1964), p. 168. See also James Gilbert, *Designing the Industrial State: The Intellectual Pursuit of Collectivism in America, 1880–1940* (Chicago: Quadrangle Books, 1972). In this study of "collectivist intellectuals," Gilbert suggests that this important element of the pre-war reform coalition was not really concerned to strengthen democratic political processes at all: "...one impulse for reform before World War I was far from democratic in the ordinary sense of proposing more political control over social decisions. The issue was to make not representative decisions but correct ones. This view of society was the essence of an industrial democracy, but it was not generally broadcast in the guise of political slogans because it was inherently antipolitical. It meant, in the words of economist John R. Commons, the creation of objective social laws out of the best existing practices. Sometimes collectivist intellectuals warmly supported programs such as the referendum and the legislative initiative because they accorded with plans to substitute commissions or panels for elected representatives. But there is nothing substantial in their writings, nor in the structures of the organizations they formed, to suggest that they wished to involve people in the day-to-day decisions which affected the course of their lives.... The very nature of reform, directed as it was toward efficiency and problem-solving, militated against citizen involvement in the minutiae with which self-government is inevitably preoccupied" (pp. 35–36).

59. "Hail to Hine," *Survey*, 63 (November 15, 1929), pp. 236–237.
60. McCausland, "Portrait," p. 503.
61. James Weinstein, *The Corporate Ideal in the Liberal State: 1900–1918* (Boston: Beacon Press, 1968), p. 200. The phrase belongs to Frank P. Walsh.
62. Hine, "Social Photography," in Trachtenberg, ed., *Classic Essays*, p. 111.
63. *Ibid.*; *Collected Papers of Charles Sanders Pierce*, ed. Charles Hartshorne and Paul Weiss (Cambridge, Mass.: Harvard University Press, 1934), V, pp. 50–51.
64. Rosalind Krauss, "Tracing Nadar," *October*, 5 (Summer 1978), p. 34.
65. Hine, "Social Photography," in Trachtenberg, ed., *Classic Essays*, p. 110.
66. Kellogg and Deardorff, "Social Research," p. 793.
67. Elizabeth McCausland, "Lewis W. Hine," *The Complete Photographer*, gen. ed. Willard D. Morgan (New York: National Educational Alliance, Inc., 1942), pp. 1980–1981.
68. Kaplan, *Lewis Hine*, pp. 34, 42; Rosenblum, Rosenblum, and Trachtenberg, *America & Lewis Hine*, p. 18.
69. McCausland, "Lewis W. Hine," pp. 1981–1982.
70. *Lewis Wickes Hine's Interpretive Photography: The Six Early Projects*, comp. Jonathan L. Doherty (Chicago: University of Chicago Press, 1978), p. 21.
71. Lewis W. Hine, "The Child's Burden in Oyster and Shrimp Canneries," *Child Labor Bulletin* (May 1913), p. 106.
72. Hine, "Social Photography," in Trachtenberg, ed., *Classic Essays*, pp. 112–113.

73. Kaplan, *Lewis Hine*, p. 44.
74. Byington, *Homestead*, pp. 70–73.
75. *Ibid.*, p. 66.
76. Fitch, *The Steel Workers*, p. 59.
77. Butler, *Women and the Trades*, pp. 190–191.
78. Byington, *Homestead*, p. 41.
79. Fitch, *The Steel Workers*, pp. 143–145.
80. Alan Trachtenberg, "Camera Work: Notes Toward an Investigation," *Massachusetts Review*, 19 (Winter 1978), p. 839.
81. Hine, "Social Photography," in Trachtenberg, ed., *Classic Essays*, p. 113. My argument in the foregoing pages is indebted to terms established in recent critical discussion of the visual arts. See Roland Barthes, *Image–Music–Text*, trans. Stephen Heath (New York: Hill and Wang, 1977); *Difference: On Representation and Sexuality* (New York: The New Museum of Contemporary Art, 1985); Hal Foster, ed., *The Anti-Aesthetic: Essays on Postmodern Culture* (Port Townsend, Washington: Bay Press, 1983); and Brian Wallis, ed., *Art After Modernism: Rethinking Representation* (New York and Boston: The New Museum of Contemporary Art and David R. Godine, 1984).
82. Hine, "Social Photography," p. 111.

Chapter Three

1. David F. Noble, *America by Design: Science, Technology and the Rise of Corporate Capitalism* (New York: Oxford University Press, 1979), p. 254; see also Ellis W. Hawley, *The Great War and the Search for a Modern Order: A History of the American People and Their Institutions, 1917–1933* (New York: St. Martin's Press, 1979).
2. Frederick Winslow Taylor, "Testimony before the Special House Committee," *Scientific Management, Comprising Shop Management, The Principles of Scientific Management, Testimony before the Special House Committee* (New York: Harper & Brothers, 1947), p. 48; Noble, *America by Design*, p. 254.
3. David Montgomery, *Workers' Control in America: Studies in the History of Work, Technology, and Labor Struggles* (New York: Cambridge University Press, 1979), p. 113; R. G. Tugwell, *The Brains Trust* (New York: Viking, 1968), p. 20. See Charles R. Van Hise, *Concentration and Control: A Solution of the Trust Problem in the United States*, rev. ed. (New York: Macmillan, 1921).
4. Rexford Guy Tugwell, Thomas Munro, and Roy E. Stryker, *American Economic Life and the Means of Its Improvement* (New York: Harcourt, Brace, 2nd ed., 1924), p. xii.
5. Rexford G. Tugwell, *To the Lesser Heights of Morningside: A Memoir* (Philadelphia: University of Pennsylvania Press, 1982), pp. 160, x; Tugwell, *American Economic Life*, p. ix.
6. Interview with Roy Stryker by Richard Doud, December 23, 1965, pp. 10–11,

Archives of American Art, Smithsonian Institution, Washington, D.C., New York, Boston, Detroit and San Francisco (hereinafter cited as AAA); F. Jack Hurley, *Portrait of a Decade: Roy Stryker and the Development of Documentary Photography in the Thirties* (Baton Rouge: Louisiana State University Press, 1974), pp. 15–16.

7. Quoted in Alan Trachtenberg, "Essay," in Walter Rosenblum, Naomi Rosenblum, and Alan Trachtenberg, *America & Lewis Hine* (Millerton, N.Y.: Aperture, 1977), p. 134; Lewis Hine, "Social Photography," in *Classic Essays on Photography*, ed. Alan Trachtenberg (New Haven: Leete's Island Books, 1980), p. 110.

8. Trachtenberg, ed., *Classic Essays*, p. 110.

9. Tugwell, *American Economic Life*, p. ix.

10. Lewis W. Hine, "Photography in the School," *The Photographic Times*, 40, No. 8 (August 1908), pp. 227–232; Lewis W. Hine, "The School Camera," *The Elementary School Teacher* (March 1906), pp. 343–347.

11. Roy Stryker to Rexford G. Tugwell, December 13, 1938, Series I, The Roy Stryker Papers, Photographic Archives, University of Louisville (hereinafter cited as UL).

12. Quoted in Rosenblum, Rosenblum, and Trachtenberg, *America & Lewis Hine*, p. 134.

13. Tugwell, *American Economic Life and the Means of Its Improvement* (New York: Harcourt, Brace, 3rd ed., 1930), p. 74; see also Hamlin Garland, *Son of the Middle Border* (New York: Macmillan, 1922).

14. Tugwell, *American Economic Life*, 3rd ed., p. 94.

15. Michel Foucault, *Discipline and Punish: The Birth of the Prison*, trans. Alan Sheridan (New York: Vintage Books, 1979), p. 200. Foucault, regarding punishment "as a complex social function," and "as a political tactic," suggests that both the history of penal law and the history of the human sciences spring from a common matrix and "both derive from a single process of 'epistemologico-juridical formation,' " so that "the technology of power [may be made] the very principle both of the humanization of the penal system and of the knowledge of man" (p. 23). By such an "analysis of penal leniency as a technique of power," one might come to understand (among other things) "in what way a specific mode of subjection was able to give birth to man as an object of knowledge for a discourse with a 'scientific' status" (p. 24).

In such a humanized discipline, Foucault maintains, "observation makes each individual a 'case,' " description is "a means of control and a method of domination" (p. 191), and description is "no longer a procedure of heroicization; it functions as a procedure of objectification and subjection" (p. 192). The panopticon, originally Jeremy Bentham's design for a model prison, is "the architectural figure of this composition" (p. 200). It must be seen as "in fact a figure of political technology that may and must be detached from any specific use," serving "to reform prisoners, but also to treat patients, to

instruct schoolchildren, to confine the insane, to put beggars and idlers to work" (p. 205). The panoptic building places prisoners alone in well-lighted cells ranged in circular tiers around a central watchtower whose possible inhabitants are invisible to the prisoners – "each individual, in his place, is securely confined to a cell from which he is seen from the front by the supervisor; but the side walls prevent him from coming into contact with his companions. He is seen, but he does not see: he is the object of information, never a subject in communication" (p. 200).

16. Judith Mara Gutman, *Lewis W. Hine, 1870–1940: Two Perspectives* (New York: Grossman, 1974), p. 50.
17. Lewis Hine, "The High Cost of Child Labor," *Child Labor Bulletin* (February 1915), p. 34.
18. *Ibid.*
19. Hurley, *Portrait of a Decade*, pp. 3–4.
20. Tugwell, *Lesser Heights*, pp. 35, 184, 188.
21. Hawley, *The Great War*, pp. 88, 89; see Lawrence Goodwyn, *The Populist Moment: A Short History of the Agrarian Revolt in America* (New York: Oxford University Press, 1978); see Grant McConnell, *The Decline of Agrarian Democracy* (Berkeley and Los Angeles: The University of California Press, 1953).
22. See McConnell, *The Decline*, chapter 4.
23. Tugwell, *Lesser Heights*, pp. 181–182; Rexford Guy Tugwell, "Reflections on Farm Relief," *Political Science Quarterly*, 43 (1928), pp. 490–491, quoted in Paul Conkin, *Tomorrow A New World: The New Deal Community Program* (Ithaca: Cornell University Press, 1959), p. 86; see Richard S. Kirkendall, *Social Scientists and Farm Politics in the Age of Roosevelt* (Columbia: University of Missouri Press, 1966), chapters 1 and 2, for discussion of social scientists' plans to reorganize argiculture along industrial lines.
24. Arthur M. Schlesinger, Jr., *The Crisis of the Old Order, 1919–1933* (Boston: Houghton Mifflin Company, 1957), p. 194; Rexford Guy Tugwell, *Industry's Coming of Age* (New York: Harcourt, Brace, 1927), p. 2.
25. Simon N. Patten, *The New Basis of Civilization* (New York: Macmillan, 1907), p. 10, quoted in Daniel M. Fox, *The Discovery of Abundance* (Ithaca: Cornell University Press, 1967), pp. 97–98.
26. Tugwell, *American Economic Life*, 3rd ed., p. 558.
27. Fox, *The Discovery*, pp. 100, 98; Rexford G. Tugwell, "Notes on the Life and Work of Simon N. Patten," *Journal of Political Economy* (April 1923), p. 203. Fox's biography and Tugwell's article provide the most complete accounts of Patten's life and work, but see also Conkin, *Tomorrow A New World*, chapter 4, and Mary O. Furner, *Advocacy and Objectivity: A Crisis in the Professionalization of American Social Science, 1865–1905* (Lexington: The University Press of Kentucky, 1975). At the Wharton School of Business and Commerce, Tugwell was the last to take his doctorate under the eccentric economist, whom Tugwell acknowledged as "the greatest single influence on my thought" and

whom he "quoted...at every opportunity," according to Stuart Chase (Fox, p. 163; p. 225, n. 5). The "discoverer of abundance," as his biographer has named him, Patten could attribute his original insights to his American ancestry and to his youth on an Illinois farm – circumstances which, Tugwell asserted, had led Patten early on to conclude that the generosity of nature, exploited by intelligence and mechanical invention, had enabled humankind to create a surplus economy now ushering Americans into a new age of abundance they had not yet learned to enjoy.

A founder of both the Wharton School and the American Economic Association, Patten was one of the final generation of American economists to be trained in Germany; "in the 1880's these first-generation professional economists began to take their places in the colleges and new universities of the United States" (Furner, p. 57). Influenced by German historicism and by the example of German intellectuals "in service to the state" (Tugwell, p. 176), these American "institutionalists" rejected classical laissez-faire economic theories and advocated the view that the state, strengthened by the expertise of a professional, socially dedicated, and outspoken cadre, could and should take a positive and greatly enlarged role in social and economic planning. Economists, "specialists in the material basis of civilization" and its "main organizers" (Tugwell, p. 206), should be at the center of modern life and "on the firing line of civilization"; their vehicle of expression "should be the newspaper and magazine, not the scientific journal" (Fox, pp. 40–41).

Though the implications of the new abundance were significant both for economists and for producers, perhaps most original was Patten's theoretical conception of the relation between social reform and consumption, then a barely defined economic and social force. Abundance obviated overwork and exploitation, so that, Patten believed, constructive social change in an age of surplus was best accomplished by reform in consuming habits – rather than by mere "distributive reforms" or utopian schemes (Tugwell, p. 204) – and thus he argued not only for management techniques, corporate monopolies, and inventions that increased productive efficiency, but also for what amounted to the social engineering of a new morality and a new culture in which would inhere a new motive to consume. Patten wished worker-consumers not only to see that progress (synonymous with abundance) depended on continual advances achieved through better technology and management, but also to identify their own new wants and desires with the technical and social improvements wrought by economists and engineers. Aided by social workers and progressive educators, Americans could eliminate the "cultural lag" that created a growing contrast between "the surfeited and the exploited." Developing "new ideals of human behavior" that favored variety in consumption and activity, expansion of personality, increased efficiency, and a view of culture as the "perfecting of intercourse with one's group" – instead of abstinence, thrift, economy, and repression – worker-consumers would

167

oppose their exploitation on moral and cultural grounds (Fox, pp. 51, 96–101). But they would simultaneously realize that their newly achieved desires for these finer things of life depended on the operations of trained technical and social experts. Such a reorientation of working-class values to resemble and reinforce, rather than to oppose, those of the technocratic elite would be manifest in changes in individual lives and, perhaps more important, in aspirations passed on to future generations. This "real reform," by creating more participants in the efficient production and consumption of abundance, would in the long run speed the pace of progress toward even greater abundance.

Little read, according to Tugwell, Patten "preached his philosophy of prosperity for forty years," although "there were few to listen." Americans preferred classical economic theory, "our heritage of dismal thought that 'grew up beside the meager turnip fields of England,' " Tugwell wrote, and "Herbert Spencer, Karl Marx, even Henry George, enjoy a greater vogue in America – the America of three and a half billion bushel corn crops – than does Patten who, unlike those others, came straight out of the fecund mid-century soil of Illinois" (Tugwell, *American Economic Life*, 3rd ed., p. 722). However, it was Patten's influence on COS general secretary Edward Devine that prompted his acceptance of Lawrence Veiller's proposal for a Tenement House Committee (see Chapter 1, pp. 34–36 and note 70, this volume), and some have credited Patten with the original use of the term "social work" (Fox, p. 96). The influence of Patten's ideas, like Dewey's, is evident in New Deal community and cultural programs. Warren I. Susman, *Culture as History: The Transformation of American Society in the Twentieth Century* (New York: Pantheon, 1984) is a series of important essays that "see America through the notion of the 'culture of abundance' " (p. xx); Richard Wightman Fox and T. J. Jackson Lears, eds., *The Culture of Consumption: Critical Essays in American History, 1880–1980* (New York: Pantheon, 1983) examines manifestations of consumer culture from mass magazines to the space program.

28. Tugwell, *Industry's Coming of Age*, pp. 32, 202.
29. Tugwell, *American Economic Life*, 3rd ed., pp. 297, 350.
30. See Noble, *America By Design*; Thorstein Veblen, *The Engineers and the Price System*, intro. Daniel Bell (New York: Harcourt, Brace, Inc., 1963).
31. Tugwell, *American Economic Life*, 3rd ed., p. xii.
32. Morton White, *Social Thought in America: The Revolt against Formalism* (Boston: Beacon Press, 1957), pp. 201, 47.
33. Tugwell, *Lesser Heights*, p. 157.
34. Oscar Handlin, *John Dewey's Challenge to Education: Historical Perspectives on the Cultural Context* (New York: Harper & Brothers, 1959; rpt. Westport, Conn.: Greenwood Press, 1971); John Dewey, "My Pedagogic Creed," number 9 of a series under this title in *The School Journal*, 54, no. 3 (January 1897); John Dewey, *Selected Educational Writings*, introduction and commentary by F. W. Garforth (London: Heinemann Educational Books, 1966), p. 48.

35. Dewey, *Selected Educational Writings*, p. 57.
36. Lewis S. Feuer, "John Dewey and the Back to the People Movement in American Thought," *Journal of the History of Ideas*, 20, no. 4 (October–December 1959), p. 552; F. W. Garforth, "Introduction," in Dewey, *Selected Educational Writings*, p. 24; see Alfred Kazin, *On Native Grounds: An Interpretation of Modern American Prose Literature* (New York: Harcourt Brace Jovanovich, 1942, 1970), chapter 5. Kazin writes that Dewey "created an agent, a moral hero for the times, the progressive teacher; he even proposed a heroic milieu, the new experimental classroom which he had been among the first to develop at Chicago in the nineties" (p. 142).
37. John Dewey, *Experience and Education* (New York: Collier Books, 1963), p. 43, in Dewey, *Selected Educational Writings*, p. 259.
38. John Dewey, *Democracy and Education* (New York: Macmillan, 1961), p. 139, in Dewey, *Selected Educational Writings*, p. 13; John Dewey, *Reconstruction in Philosophy* (Boston: Beacon Press, 1948), pp. 83–87, 90–96, in Dewey, *Selected Educational Writings*, p. 291; John Dewey, "The Need for a Recovery of Philosophy," in *John Dewey on Experience, Nature and Freedom*, ed. R. J. Bernstein (Liberal Arts Press, 1960), pp. 22–28, in Dewey, *Selected Educational Writings*, p. 282.
39. Tugwell, *Lesser Heights*, pp. 159, 157.
40. Dewey, *Selected Educational Writings*, p. 292.
41. *Ibid.*, p. 290.
42. Tugwell, *American Economic Life*, 3rd ed., p. 651.
43. See John A. Fitch, *The Steel Workers* (New York: Russell Sage Foundation, 1910), p. 238.
44. See Werner Sollors, "Theory of American Ethnicity, or: "? S ETHNIC?/TI AND AMERICAN/TI, DE OR UNITED (W) STATES S SI AND THEOR?," *American Quarterly*, 33, no. 3 (1981), pp. 257–283, and John Ibson, "Virgin Land or Virgin Mary? Studying the Ethnicity of White Americans," *American Quarterly*, 33, no. 3 (1981), pp. 284–308, for a compendium of ideas and sources on the melting pot.
45. Samuel Haber, *Efficiency and Uplift: Scientific Management in the Progressive Era, 1890–1920* (Chicago: University of Chicago Press, 1964), p. 25. See Foucault, *Discipline and Punish*; as Foucault points out, quoting Jeremy Bentham in his discussion of the panopticon, any individual, animated by whatever motive, "can operate the machine: in the absence of the director, his family, his friends, his visitors, even his servants" (p. 202). Thus the main effect of this ingenious supervisory arrangement is to obviate the necessity for actual continuous observation by inducing in the prisoner "a state of conscious and permanent visibility that assures the automatic functioning of power." "The inmate will constantly have before his eyes the tall outline of the central tower from which he is spied upon"; he "must never know whether he is being looked at at any one moment; but he must be sure that he may always be so"

(p. 201). Such a visible, yet unverifiable power effects a "politics of the gaze": such a mechanism "automizes and disindividualizes power" (p. 202), so that the person who is "subjected to a field of visibility, and who knows it, assumes responsibility for the constraints of power"; he "inscribes in himself the power relation in which he simultaneously plays both roles; he becomes the principle of his own subjection" (pp. 202–203). Michel Foucault, "The Eye of Power," in *Power/Knowledge: Selected Interviews & Other Writings, 1972–1977*, ed. Colin Gordon (New York: Pantheon Books, 1979), especially pp. 162–165, specifically links panoptical principles and politics to those of the Taylorist system of factory control.

46. John Dewey, *The Public and Its Problems* (New York: Henry Holt, 1927), p. 142.
47. Sidney Baldwin, *Poverty and Politics: The Rise and Decline of the Farm Security Administration* (Chapel Hill: University of North Carolina Press, 1968), p. 88; Kirkendall, *Social Scientists and Farm Policy*, p. 44; Bernard Sternsher, *Rexford Tugwell and the New Deal* (New Brunswick, N.J.: Rutgers University Press, 1964), p. 265.
48. Resettlement Administration, *First Annual Report of the Resettlement Administration* (Washington: U.S. Government Printing Office, 1936), p. 2.
49. *Ibid.*, pp. 2–3.
50. Rexford G. Tugwell, "The Place of Government in a National Land Program," *Journal of Farm Economics*, 16 (January 1934), pp. 64, 65.
51. Dewey, *Public and Its Problems*, p. 184.
52. See James Agee and Walker Evans, *Let Us Now Praise Famous Men* (Boston: Houghton, Mifflin, 1941), p. 11. See Susman, " 'Personality' and the Making of Twentieth-Century Culture," in his *Culture as History*, pp. 271–285.
53. Dewey, *Public and Its Problems*, p. 184.
54. Wilson Hicks, *Words and Pictures: An Introduction to Photojournalism* (New York: Harper & Brothers, 1952), pp. 57, 61. Institutional studies of American photojournalism are just beginning to emerge. See Susan Moeller, "Shooting War: Photography and the American Experience of Combat," unpublished Ph.D. dissertation, Harvard University, 1987; Carol Squiers, "Looking at Life," *Artforum*, 20 (December 1981), pp. 59–66; also *Picture Magazines Before LIFE* (Woodstock, N.Y.: Catskill Center for Photography, 1982); Karin B. Ohrn and Hanno Hardt, "Camera Reporters at Work: The Rise of the Photo Essay in Weimar Germany and the United States," unpublished paper presented at the Eighth Biennial Convention of the American Studies Association, Memphis, Tennessee, October 1981; Steven Wright Plattner, "How the Other Half Lived: The Standard Oil Company (New Jersey) Photography Project, 1943–1950," unpublished M.A. Thesis, George Washington University, 1981.
55. Wilson Hicks, "What is Photojournalism?" in R. Smith Schuneman, ed., *Principles, Problems and Challenges of Photojournalism* (New York: Hastings House, 1972), p. 56. The principles of *Life*'s picture stories, wrote Hicks, were "orderly

arrangements," and "continuous flow"; each of *Life*'s refinements of photo-journalistic form "contributed something more to the formalizing of the picture medium" (pp. 52–56). Ohrn and Hardt, in "Camera Reporters at Work," point out that constructivist Alexander Rodchenko and documentarist Sergei Tretiakov found revolutionary potential in the picture story; it was a "methodological necessity" in which, to quote Tretiakov, the "more or less accidental images of objects in movement are changed into a precise, systematic record of the history of individual and collective lives and circumstances" (p. 4). See David Elliott, ed., *Alexander Rodchenko 1890–1956* (Oxford: Museum of Modern Art, 1979).

56. Picture distribution figures, and book and magazine titles for 1937 and 1938, are from monthly and biweekly reports from the Historical Section–Photographic to John Fischer, Director of Information, Box 4, Farm Security Administration, Historical Section Textual Records, Prints and Photographs Division, Library of Congress, Washington, D.C. (hereinafter cited as LC); Resettlement Administration, *First Annual Report*, pp. 97–98; see also Hurley, *Portrait*, chapter 6.

57. See Hurley, *Portrait*, chapter 6; see also Elizabeth McCausland, "How Our People Live: Rural Life in America as the Camera Shows It," Springfield (Mass.) *Sunday Union and Republican*, September 11, 1938, p. 6E, for a review of the traveling exhibition.

58. Agee and Evans, *Famous Men*; Sherwood Anderson, *Home Town: The Face of America*, photo ed. Edwin Rosskam (New York: Alliance Book Corporation, 1940); Walker Evans, *American Photographs* (New York: Museum of Modern Art, 1938); Dorothea Lange & Paul Schuster Taylor, *An American Exodus: A Record of Human Erosion* (New York: Reynal & Hitchcock, 1939); Archibald MacLeish, *Land of the Free* (New York: Harcourt, Brace, 1938; rpt. New York: Da Capo Press, 1977); Herman C. Nixon, *Forty Acres and Steel Mules* (Chapel Hill: University of North Carolina Press, 1938); Arthur F. Raper and Ira DeA. Reid, *Sharecroppers All* (Chapel Hill: University of North Carolina Press, 1941); Richard Wright, *12 Million Black Voices*, photo ed. Edwin Rosskam (New York: Viking Press, 1941; rpt. New York: Thunder's Mouth Press, 1988).

59. Edwin Rosskam, "Not Intended for Framing: The FSA Archive," *Afterimage*, 8, no. 8 (March 1981), p. 11.

60. Grace E. Falke to Jonathan Garst, December 21, 1936, Field Correspondence, Box 2, LC; see also Hurley, *Portrait*, chapter 6; and correspondence between Roy Stryker and photographers in the field in Roy Stryker Papers, AAA.

61. Karin Becker Ohrn, *Dorothea Lange and the Documentary Tradition* (Baton Rouge: Louisiana State University Press, 1980), chapter 6; see also Milton Meltzer, *Dorothea Lange: A Photographer's Life* (New York: Farrar, Strauss & Giroux, 1978), pp. 205–208.

62. John Szarkowski, "Introduction" and "Selected Bibliography," in *Walker Evans* (New York: Museum of Modern Art, 1971), pp. 9–20, 183–189; Paul

171

Cummings, "Walker Evans," in his *Artists in Their Own Words* (New York: St. Martin's Press), pp. 88–91.

63. Ben Shahn, *Ben Shahn*, ed. John D. Morse (New York: Praeger Publishers, 1972), pp. 19–20.

64. Shahn, *Ben Shahn*, p. 31.

65. Paul Cummings, *Artists in Their Own Words*, pp. 95, 99.

66. Walker Evans, *Walker Evans at Work* (New York: Harper & Row, 1982), p. 151.

67. Interview with Ben Shahn by Richard Doud, April 14, 1964, AAA, pp. 19, 7.

68. Evans, *Walker Evans at Work*, p. 112.

69. *Ibid.*, see also Shahn–Doud interview, p. 14.

70. Shahn, *Ben Shahn*, p. 136.

71. *Ibid.*, p. 137; Shahn–Doud interview, p. 22; interview with Ben Shahn by Forrest Selvig, September 27, 1968, AAA, p. 5; Shahn–Doud interview, pp. 26, 6.

72. Shahn–Doud interview, pp. 17, 6–7, 12, 4, 26, 13.

73. Paul Vanderbilt, "Reorganization Reports," typescript in Paul Vanderbilt papers, AAA, p. 12.

74. Lewis W. Hine, "Photography in the School," *The Photographic Times*, 40, no. 8 (August 1908), p. 231.

75. Dick and Shahn captions from "General Captions" folder, Box 13, LC; Lange captions from Box 9, LC.

76. Letter from Paul Taylor to Thomas C. Blaisdell, Jr., June 3, 1937, Series I, The Roy Stryker Papers, Archives, UL.

77. United States Department of Agriculture, *Toward Farm Security, The Problem of Rural Poverty and the Work of the Farm Security Administration, Prepared Under the Direction of the FSA Personnel Training Committee, for FSA Employees, by Joseph Gaer, Consultant, Farm Security Administration* (Washington: U.S. Government Printing Office, 1941), pp. 66–67. Since its establishment, historians have debated the merits of the FSA. For essentially favorable accounts and explanations of Tugwell's ideas and of FSA programs, see Baldwin, *Poverty and Politics*; Conkin, *Tomorrow a New World*; Richard S. Kirkendall, *Social Scientists and Farm Politics in the Age of Roosevelt*; and Sternsher, *Rexford Tugwell*. For more specifically critical perspectives, see Pete Daniel, *Breaking the Land: The Transformation of Cotton, Tobacco and Rice Cultures since 1880* (Urbana: University of Illinois Press, 1985), pp. 65–236; Walter J. Stein, *California and the Dust Bowl Migration* (Westport, Conn.: Greenwood Press, 1973); William J. Brophy, "Black Texans and the New Deal," and Stephen S. Strausberg, "The Effectiveness of the New Deal in Arkansas," both in Donald W. Whisenhunt, ed., *The Depression in the Southwest* (Port Washington, N.Y.: Kennikat Press, 1980), pp. 117–133, 102–116. These critics claim that the FSA offered too little too late to have any real effect on economic trends (Whisenhunt, p. 115); that New Deal agricultural policies as a whole encouraged mechanization that displaced small farmers (Whisenhunt, pp. 113, 126; Dan-

iel, pp. 155–183); that the FSA promoted a "visionary and antiquated Jeffersonianism" and that its plans were "poorly funded, inadequate, and outdated" (Whisenhunt, pp. 126–127); and that the notions of democracy and community cooperation that it fostered in migrant camps and resettlement communities were naive and unrealistic (Stein, chapters 6, 7; Conkin, chapters 8, 9).

78. Roy Emerson Stryker and Nancy Wood, *In This Proud Land: America 1935–1943 as Seen in the FSA Photographs* (Boston: New York Graphic Society, 1973), p. 7; Elizabeth McCausland, "Documentary Photography," *Photonotes* (January 1939), p. 7.

79. Russell Lee to Roy Stryker, December 24, 1936, and January 2, 1937, Roy Stryker Papers, AAA.

80. Dewey, *Public and Its Problems*, p. 142.

81. Shahn–Doud interview, p. 6.

82. Memo, John Fischer, Director of Information, to All Regional Information Advisers, May 4, 1938, Box 2, LC.

83. Richard Doud, "An American Portrait: Photodocumentation by the Farm Security Administration," unpublished typescript, 1965, AAA, p. 73.

84. Agee and Evans, *Famous Men*, p. 11; Vanderbilt, p. 12.

85. Rexford G. Tugwell, diary entry, May 7, 1935, Box 17, Tugwell Collection, Franklin D. Roosevelt Presidential Library, Hyde Park, N.Y.

86. Interview with Rexford and Grace Falke Tugwell by Richard Doud, January 21, 1965, AAA, p. 10.

87. Elizabeth McCausland, "Documentary Photography," pp. 6–9; Beaumont Newhall, "Documentary Approach to Photography," *Parnassus* (March 1938), pp. 3–6.

88. Tugwell–Doud interview, p. 10.

Chapter Four

1. See my " 'The Record Itself': Farm Security Administration Photography and the Transformation of Rural Life," in Pete Daniel, Merry A. Foresta, Maren Stange, and Sally Stein, *Official Images: New Deal Photography* (Washington, D.C.: Smithsonian Institution Press, 1987), p. 4. Christopher Phillips, "Steichen's *Road to Victory*," *Exposure*, 18, no. 2 (1981), p. 41, notes that "the huge photomurals which were constructed from enlarged FSA photographs and raised in Grand Central Station in December 1941" probably mark "the first instance after Pearl Harbor in which documentary photographs were adapted to purposes of propaganda."

2. Stange, "The Record Itself," p. 4.

3. Edward Steichen, ed., *The Bitter Years, 1935–1941: Rural America as Seen by the Photographers of the Farm Security Administration* (New York: Museum of Modern Art, 1962), p. iii.

4. David Hunter McAlpin to Roy E. Stryker, May 22, 1942, "Road to Victory"

file, Department of Photography, Museum of Modern Art, New York (hereinafter cited as MOMA).

5. Eva Cockcroft, "Abstract Expressionism, Weapon of the Cold War," *Artforum*, 12, no. 10 (June 1974), pp. 39, 40; see Christopher Lasch, *The Agony of the American Left* (New York: Vintage, 1969), chapter 3.

6. Monroe Wheeler, "A Note on the Exhibition," *Bulletin of the Museum of Modern Art*, 9, no. 5–6 (June 1942), p. 19; Christopher Phillips, "The Judgment Seat of Photography," *October*, 22 (Fall 1982), p. 46. Although "The Family of Man" will not be examined in detail here, my understanding of Steichen's postwar work has greatly benefited from recent criticism of that exhibition, including Roland Barthes, "The Great Family of Man," in his *Mythologies*, trans. Annette Lavers (New York: Hill and Wang, 1970), pp. 100–102; Jonathan Green, *American Photography: A Critical History 1945 to the Present* (New York: Abrams, 1984), chapter 2; Eric J. Sandeen, *"The Family of Man* at the Museum of Modern Art: The Power of the Image in 1950s America," *Prospects*, 11 (1987), pp. 367–391; Allan Sekula, "The Traffic in Photographs," in his *Photography Against the Grain: Essays and Photo Works 1973–1983* (Halifax: The Press of the Nova Scotia College of Art and Design, 1984), pp. 76–101. On other aspects of Steichen's career, see Christopher Phillips, comp., *Steichen at War* (New York: Abrams, 1981), see Allan Sekula, "The Instrumental Image: Steichen at War," in his *Photography Against the Grain*, and see Patricia Johnston, "Edward Steichen's Advertising Photographs: The Visual Strategies of Persuasion," unpublished Ph.D. dissertation, Boston University, 1988.

7. Phillips, "Judgment Seat," p. 48; pp. 39–40; p. 41, n. 35; p. 45, n. 43.

8. Unattributed quotation, *Bulletin of MOMA*, p. 21.

9. *Bulletin of MOMA*, pp. 19, 20; H. M. Carleton to editor, New York *Herald Tribune*, May 25, 1942, MOMA.

10. Phillips, "Steichen's *Road*," p. 42; *Bulletin of MOMA*, p. 20. See Phillips, "Judgment Seat," p. 46, n. 46.

11. Phillips, "Judgment Seat," pp. 43, 46.

12. Phillips, "Steichen's *Road*," p. 38; *Bulletin of MOMA*, p. 21; Phillips, "Judgment Seat," p. 43. On "The Family of Man," see Green, *American Photographs*, pp. 47–51. Roland Marchand, *Advertising the American Dream: Making Way for Modernity 1920–1940* (Berkeley: University of California Press, 1985), chapter 5, discusses the ways that advertising used "modern art forms" to associate products with the " 'smartness' of novelty, fashion, and the latest mode" (p. 142).

13. Cockcroft, "Abstract Expressionism," pp. 39–40.

14. *Ibid.*, p. 41; Gary O. Larson, *The Reluctant Patron: The United States Government and the Arts, 1943–1965* (Philadelphia: University of Pennsylvania Press, 1983), p. 57; Cockcroft, "Abstract Expressionism," p. 40; Russell Lynes, quoted in Cockcroft, "Abstract Expressionism," p. 40. On the topic of U.S. government

promotion of Abstract Expressionism, see also Max Kozloff, "American Painting during the Cold War," *Artforum*, 11 (May 1973), pp. 43–54, and Serge Guilbaut, *How New York Stole the Idea of Modern Art*, trans. Arthur Goldhammer (Chicago: University of Chicago Press, 1983).

15. Larson, *Reluctant Patron*, p. 58.
16. Guilbaut, *How New York*, pp. 55–56, 91–92, 86–87.
17. Alexander Cockburn, "Can Capitalism Be Saved? A Chat with Sweezy and Magdoff," *The Nation* (June 9, 1984), p. 704.
18. John Morton Blum, quoted in Steven W. Plattner, "How the Other Half Lived: The Standard Oil Company (New Jersey) Photographic Project, 1943–1950," unpublished M.A. thesis, George Washington University, 1981, p. 7. On the SONJ project, see also Ulrich Keller, *The Highway as Habitat, A Roy Stryker Documentation, 1943–1955* (Santa Barbara: University Art Museum, 1986), which includes a very useful essay, and Nicholas Lemann, *Out of the Forties* (Austin: Texas Monthly Press, 1983). Steven W. Plattner, *Roy Stryker: U.S.A., 1943–1950: The Standard Oil (New Jersey) Photography Project* (New York: International Center of Photography and Austin: University of Texas Press, 1983) includes a condensed version of Plattner's thesis.
19. Plattner, "How the Other Half," pp. 7, 13–14, 15–16, 42, 254.
20. The Rosskams are quoted in Plattner, "How the Other Half," p. 108; George Freyermuth, head of SONJ's public relations department, is quoted in Plattner, "How the Other Half," p. 19. For extensive discussion of the philosophy of New Deal arts projects, see Karal Ann Marling, *Wall-to-Wall America: A Cultural History of Postoffice Murals in the Great Depression* (Minneapolis: University of Minnesota Press, 1982). On CIA cultural activities, see Lasch, *Agony*, chapter 3, and see Frances K. Pohl, "An American in Venice: Ben Shahn and United States Foreign Policy at the 1954 Venice Biennale, or Portrait of the Artist as an American Liberal," *Art History*, 4, no. 1 (March 1981), pp. 80–108.
21. The phrase is used by Terence Edwin Smith in his "Making the Modern: The Visual Imagery of Modernity, U.S.A., 1908–1939," unpublished Ph.D. dissertation, University of Sydney, Australia, 1985, p. 357. David E. Nye, *Image Worlds: Corporate Identities at General Electric* (Cambridge, Mass.: MIT Press, 1985) discusses the uses that the General Electric corporation made of its commercially produced photographic archives from 1890 to 1930 and touches on corporate use of other forms of art.
22. Plattner, "How the Other Half," pp. 17, 27, 28. Despite problems with official sponsorship, "by the mid to late 1940s, abstract expressionists were lauded not only in *Partisan Review, The Nation, Magazine of Art* and *Art News*, but also in popular magazines such as *Life*," writes historian Jane deHart Mathews in "Art and Politics in Cold War America," *American Historical Review*, 81 (October 1976), p. 783. William Stott, *Documentary Expression and Thirties*

America (New York: Oxford University Press, 1973) surveys literature, theater, and the media during the 1930s and early 1940s in terms of a "documentary movement" characteristic of the time.

23. "A Portrait of Oil – Unretouched," *Fortune* (September 1948), pp. 102, 104; Edwin Rosskam, quoted in Plattner, "How the Other Half," p. 3. See Stuart Ewen, *Captains of Consciousness: Advertising and the Social Roots of the Consumer Culture* (New York: McGraw-Hill, 1976) on relations between "consumer culture" and industrialization; see also Richard Wightman Fox and T. J. Jackson Lears, eds., *The Culture of Consumption: Critical Essays in American History, 1880–1980* (New York: Pantheon Books, 1983).

24. Plattner, "How the Other Half," pp. 51, 52; Barthes, *Mythologies*, p. 101.

25. Plattner, "How the Other Half," pp. 62, 96, 119–127.

26. Arthur Calder-Marshall, *The Innocent Eye: The Life of Robert J. Flaherty* (New York: Harcourt, Brace, 1963), pp. 211, 238, 223; Plattner, "How the Other Half," p. 96. According to SONJ project librarian Sally Forbes, "the company's interest began to turn toward television" after the success of *Louisiana Story*; quoted in Plattner, "How the Other Half," p. 124.

27. Roy E. Stryker, "Documentary Photography," *The Complete Photographer*, Willard D. Morgan, gen. ed. (New York: National Educational Alliance, 1942), pp. 1368, 1369.

28. Michael Schudson, *Discovering the News: A Social History of American Newspapers* (New York: Basic Books, 1978), pp. 157, 156.

29. Alfred H. Barr, "Is Modern Art Communistic?" *New York Times Magazine* (December 14, 1952), pp. 22–23, 28–30. An interesting gloss on the issue is Walker Evans's 1971 remark: "The word 'documentary' is a little misleading. Literally, documentary is a police photograph of an automobile accident which says nothing and is not supposed to say anything. What we conscious photographers now think of as documentary has a personal style to it, in this guise of objectivity which some of us fell in line with." In *Still/3* (Rochester, N.Y.: dist. Light Impressions, 1973), p. 2; see also Leslie Katz, "Interview with Walker Evans," *Art in America*, 59 (March 1971), p. 87.

30. On the Photo League, see Ann Tucker, "Photographic Crossroads: The Photo League," a special supplement to *Afterimage*, no. 25 (April 6, 1978); *Photonotes* (Rochester, N.Y.: A Visual Studies Reprint Book, 1977).

31. Serge Guilbaut, "The New Adventures of the Avant-Garde in America: Greenberg, Pollock, or from Trotskyism to the New Liberalism of the 'Vital Center,'" trans. Thomas Repensek, *October*, 15 (1980), pp. 77–78; Cockcroft, "Abstract Expressionism," p. 41.

32. Jack Kerouac, "Introduction" to Robert Frank, *The Americans* (Millerton, N.Y.: Aperture, 1978), p. 5. Recent critical work on Frank includes Anne Wilkes Tucker, ed., *Robert Frank, New York to Nova Scotia* (Boston: Little, Brown, 1986), John Brumfield, "'The Americans' and The Americans," *Afterimage*

(Summer 1980), pp. 8–15, and Jno Cook, "Robert Frank's America," *Afterimage* (March 1982), pp. 9–14. See also Alan Trachtenberg, "Camera Work: Notes toward an Investigation," *Massachusetts Review*, 10 (Winter 1978), p. 858.

33. Green, *American Photography*, p. 85.

INDEX

179

vey; Riis, Jacob A.;
Veiller, Lawrence
Thompson, E. P., 150
n7
Tickner, Lisa, 152 n34
Time, 108, 144
Today, 108
Trachtenberg, Alan, 50,
52, 85, 150 n4, 151
n11, n17, 153 n36,
156 n66, 159 n8,
n12, n14–15, n18,
160 n19, 162 n57,
164 n80, 177 n31
Tretiakov, Sergei, 171
n55
Tucker, Ann, 176 n30
Tucker, Frank, 63
Tugwell, Rexford, xvi,
50, 90, 92, 96, 156
n70; and agricul-
ture, 97, 98, 103–4,
105–6, 123, 129, 130;
and education, 98–
101 (*see also* Dewey,
John); and Lewis
Hine, 92; and the
Resettlement
Administration,
105–6, 129–30, 134,
172 n77; *American
Economic Life and
the Means of Its Im-
provement*, 90–1, 93–
4, 97, 99, 101, 103–4;
The Brains Trust, 90,
164 n3; *Industry's
Coming of Age*, 98–9,
166 n24; "Notes on
the Life of Simon N.
Patten," 99, 166–8
n27; "The Place of
Government in a

National Land Pro-
gram," 106; "Reflec-
tions on Farm
Relief," 98, 166 n23;
*To the Lesser Heights
of Morningside*, 90,
97, 98, 100, 164 n5

United Hebrew Chari-
ties, 37, 41; *see also*
Charity Organiza-
tion Society, the
Tenement House
Exhibition
U.S. Camera, 109
United States Depart-
ment of Labor: *Spe-
cial Investigation of
the Slums of Great
Cities*, 34
United States Steel Cor-
poration, 56–7

Vachon, John, 108, 133
Vanderbilt, Paul, *see*
Farm Security
Administration,
archives
Van Hise, Charles R., 90,
164 n3
Veblen, Thorstein, 50,
90, 99; *The Engineers
and the Price System*,
168 n30
Veiller, Lawrence, 29,
83, 161 n54; East
Side Relief Work
Committee, 157 n75;
housing and zoning
codes, xiv, 36; Tene-
ment House Com-
mittee, xiv, 35, 168
n27; and the Tene-

ment House Depart-
ment, 32, 154–5 n58;
and tenement re-
form, 29, 30–2, 35,
37–46, 47 (*see also*
Charity Organiza-
tion Society, the
Tenement House Ex-
hibition); use of cap-
tions, 40, 41–2, 44–5,
74; use of maps, 37,
41, 47; use of
models, 37, 40; use
of photographs, xv,
37–8, 40–1, 42, 43,
44–5, 74, 157–8 n83;
*The Tenement House
Problem*, 30, 31, 38,
39, 40, 41
Vogue, 144

Wage-Earning Pittsburgh,
see Pittsburgh
Survey
Wallis, Brian, 158 n83,
164 n81
Walsh, Frank P., 163 n61
Ware, Louise, 150 n3
Warner, Amos G., 155
n63–4, 156 n70
Weinstein, James, 163
n61
Weller, Charles: *Ne-
glected Neighbors in
Our National Capital*,
161 n48
Welling, William, 150
n5
Wharton School, 90,
166–8 n27
Wheeler, Monroe, 174
n6